OUTBOUND

Passages from the 90's

Janine Antoni

Matthew Barney

Cai Guo-Qiang

Robert Gober

Ann Hamilton

Jim Hodges

William Kentridge

Rick Lowe & Deborah Grotfeldt

Shirin Neshat

Fred Wilson

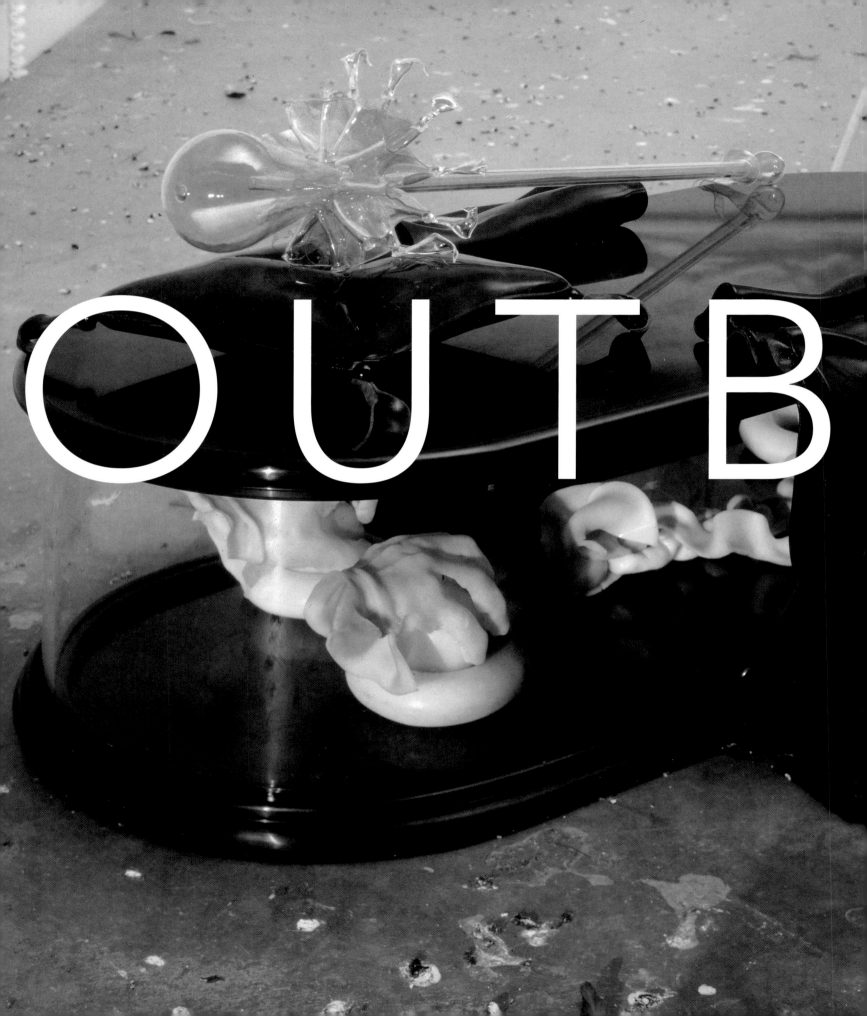

OUND

Passages from the 90's

Dana Friis-Hansen

Lynn M. Herbert

Marti Mayo

Paola Morsiani

Contemporary Arts Museum, Houston

This catalogue has been published to accompany the exhibition *Outbound: Passages from the 90's* organized by Dana Friis-Hansen, Senior Curator, Lynn M. Herbert, Curator, Marti Mayo, Director, and Paola Morsiani, Assistant Curator, for the Contemporary Arts Museum, Houston, March 4–May 7, 2000.

Outbound: Passages from the 90's has been supported by grants from El Paso Energy Corporation, the Susan Vaughan Foundation, and Mr. and Mrs. Michael Zilkha.

The exhibition catalogue is supported by The Brown Foundation, Inc. Additional support has been provided by the Contemporary Arts Museum's Major Exhibition Fund contributors:

MAJOR EXHIBITION FUND

MAJOR PATRON
Fayez Sarofim & Co.

PATRONS
Mr. and Mrs. A.L. Ballard
George and Mary Josephine Hamman Foundation
Mr. and Mrs. I.H. Kempner III
Ms. Louisa Stude Sarofim

BENEFACTORS
Max and Isabell Smith Herzstein
Rob and Louise Jamail
Mary Lawrence Porter
Mr. and Mrs. Marvin H. Seline
Susan Vaughan Foundation

DONORS
American General
Dr. and Mrs. Bernard Arocha
Arthur Andersen LLP
Baker & Botts L.L.P.
Mary Lynch Kurtz
Shell Oil Company Foundation
Stephen D. Susman
Herbert Wells
Mr. and Mrs. Wallace S. Wilson

Library of Congress Catalogue Card Number
 99-76202
ISBN 0-936080-57-4

Distributed by:
Distributed Art Publishers, Inc. (D.A.P.)
155 Sixth Avenue
New York, New York 10013
212-627-1999
www.artbook.com

Cover: Robert Gober, *Untitled*, 1997 (detail, see plates 22–26)
Collection the artist

Frontispiece: Matthew Barney, *The Ehrich Weiss Suite*, 1997 (detail, see plates 11–14)
Courtesy the artist and Barbara Gladstone Gallery, New York

Contemporary Arts Museum
5216 Montrose Boulevard
Houston, Texas 77006-6598
phone: 713/284-8250
fax: 713/284-8275
www.camh.org

CONTENTS

FOREWORD AND ACKNOWLEDGMENTS

As the 1990's, the final decade of the twentieth century, and the last decade of the millennium, drew to a close, even the most cynical among us found ourselves reflecting on the state of art—to say nothing of other weighty matters, such as the state of the environment, the general condition of humanity, and even the individual disposition of our hearts and minds. While many of us grew bored with the endless hype about Y2K, none of us, I suspect, was able to completely ignore the opportunity the approach of the year 2000 invited to assess the past and take a stab at prognosticating the future.

As a museum with a mission to focus on art of the last forty years, the Contemporary Arts Museum is hardly the logical choice to consider the art of the last thousand years or even of the twentieth century, yet it still seemed appropriate to review the past decade, especially since the art of the nineties might well inform or presage the art of the new millennium. The origins of *Outbound* therefore can be found in the question, "When we look back at the 1990's, what will we remember; what will characterize for us—the staff of the Contemporary Arts Museum—this decade?"

This seemingly simple question occasioned many long and lively discussions. After numerous productive and frank sessions (as they might be characterized by political spin doctors), the museum's curatorial staff and I settled on the approach that has resulted in *Outbound: Passages from the 90's.* We decided to make a list of pivotal works, rather than artists, from the nineties, works that had produced for each of us profound moments and significant insights when we first encountered them. We then agreed (no small task) on ten

works of art that had evoked in us this proverbial "moment"—something of a contemporary equivalent to the nineteenth-century's "Stendhal syndrome," a state of swooning rapture produced by an encounter with a great work of art.

The ten works of art that comprise this exhibition address fundamental questions and universal truths—life, death, love, and the spiritual—rather than art or current culture. Their power lies in their ability to deal with these large issues while drawing on the artist's own experience, culture and concerns. They also have in common the ability to produce in us, the viewer, an initial very personal and powerful emotional bond, followed by a more general intellectual and cosmic response. Most of the work in the exhibition *is* topical. It addresses many of the major social and political issues of the late 1990's, but it does this so skillfully and beautifully that we believe these works, like Francisco de Goya's *Disasters of War* (1810–14), will remain meaningful long after their *raison d'être*—concerns related to sexual and cultural identity, this decade's obsession with the body, colonial imperialism, AIDS, the "culture wars," feminism, racism, and the like—will have vanished.

Each of the works of art, although emblematic of the 1990's, shows the way—is "outbound" to a new century, a new millennium, a new world. They all employ gripping strategies designed to capture our eyes and hearts before the work reaches our minds. These works reflect, too, a new kind of *international* audience, speaking across language, culture, locale, and time. All ten of the works are symbolic of what is positive about today's art: these artists refuse to be silenced by the forces of fashion, conservatism, repression,

economic prosperity, or the status quo. Above all, the exhibition is about our humanness, our commonality, and our ability to see right in the face of wrong. While these ten works bring into sharp focus the ills of our world, they do so poetically, with great sensitivity and beauty, seizing our attention on the most simple and visceral levels.

Outbound: Passages from the 90's has been organized by Senior Curator Dana Friis Hansen, Curator Lynn M. Herbert, Assistant Curator Paola Morsiani, and myself. Working as a team has been an extremely rewarding experience for all of us; we have been able to share our knowledge and experience of art of the 1990's with each other in exciting and meaningful discussions as a shared vision came to fruition. Important conceptual roles were played—especially in the initial planning stages—by Director of Education and Public Programs Meredith Wilson and former Education Assistant Paula Newton; they served, frankly, as both contributors and mediators. And, with Education Assistant Peter Precourt, they organized the exciting public programs that accompany the show.

The exhibition is made possible by many individuals in the Houston community—members of former and current audiences, past and present staff members, and those who have served on the Board of Trustees of the Museum since it was founded in 1948. All have sustained the institution and its unique mission across the half century of its existence. Without this longtime tripartite union of disparate individuals determined to support the best, most timely, and liveliest contemporary art being made, the Museum would not be here to organize Outbound or to look forward to the new millennium.

Outbound: Passages from the 90's especially benefits from the adventurousness and dedication of the Board of Trustees, which for the last five years has lent its unstinting and enthusiastic support to the staff and me, to this project, and to the entire curatorial program. Their guardianship of the Museum's mission and assets has produced for us the freedom to pursue ambitious and wide-ranging interests.

The project is supported by extraordinary grants from the Susan Vaughan Foundation and by Mr. and Mrs. Michael Zilkha. They have been joined by a new friend of the Museum, the civic-minded, culturally supportive El Paso Energy Corporation. This generosity has allowed our ideas and aspirations for the exhibition to become reality.

All major exhibitions at the Contemporary Arts Museum are supported by the enlightened individuals, foundations, and corporations who participate in the Museum's *Major Exhibition Fund*, established in 1986 to assure the institution's ability to plan and operate at levels conducive to projects such as *Outbound*. These supporters, listed on page 4, are there to underpin project funding and to assure presentation of shows that do not carry specific support. Without the "MEF," our schedule would be far more restricted, less ambitious, and less satisfying to our audiences.

The Brown Foundation, Inc., which has been a faithful supporter of the Museum and its programs for many years, made an exceptional grant to the institution supporting all exhibition publications for a three year period. This catalogue owes its existence to the foundation's enlightened support of our scholarly purposes. We are grateful as well to the Institute of Museum and Library Services, Washington, D.C. for awarding the Museum a general operating support grant for this year and next. The City of Houston and the Texas Commission on the Arts through the Cultural Arts Council of Houston/Harris County and the Houston Endowment also provide the museum with that most elusive and necessary of funding—operating support. Continental Airlines, based here in Houston, is a true collaborator in this project, having made possible much of the travel that allowed us to first discover these marvelous works of art, and then enabling the Museum to bring the artists and their assistants to Houston to install them.

Because the Museum is a non-collecting institution, lenders of works of art are our (and our audiences') lifeline. We thank—in addition to the artists and galleries listed on page 6 who loaned work for the exhibition—The Dakis Joannou Collection, Athens; Marion B. Stroud, The Fabric Workshop and Museum, Philadelphia; the Musée d'art contemporain de Montréal; the Whitney Museum of American Art, New York; and Mr. and Mrs. William A. Wise, Houston, for their generosity and for sharing these wonderful works with all of us.

The artists' representatives and galleries provided critical tactical and research support for the exhibition. We would like to acknowledge in particular Barbara Gladstone, Jessica Frost and Tom Gleeson of Barbara Gladstone Gallery, New York; Carla Chammas, Richard Desroche, and Glenn McMillan of CRG, New York; Marian Goodman, Jill Sussman, Linda Pellegrini, and Avi Spira of Marian Goodman Gallery, New York; Kirsty McKeen of The Goodman Gallery, Johannesburg; Helene Winer, Janelle Reiring, and Jeff Gauntt of Metro Pictures, New York; Sean Kelly, Lilli-Mari Andresen, and Susan Kelly of Sean Kelly Gallery, New York; and Lawrence Luhring, Roland Augustine, and Michele Maccarone of Luhring Augustine, New York, for their invaluable assistance.

The artists' assistants and colleagues were ever gracious and helpful in preparing the exhibition and catalogue—often speaking with Museum staff on a daily basis. We are grateful to Jody Hanson (Janine Antoni); Mary Farley and Matthew D. Ryle (Matthew Barney); Jennifer Ma (Cai Guo-Qiang); Claudia Carson and Daphne Fitzpatrick (Robert Gober); Kristine Miller Helm (Ann Hamilton); Anne McIlleron (William Kentridge); William Williams and the University of Virginia Department of Architecture, Wes Sandel, Jan Johnson, City of Houston Department of Planning and Development, Project Row Houses, and Larry Dromgoole (Rick Lowe and Deborah Grotfeldt); and Don Patrick (Shirin Neshat).

Curator Lynn M. Herbert installed the exhibition with her usual (unusual) grace and

skill, working closely with Registrar Tim Barkley, who oversaw the transport and safety of the loans, and Head Preparator Peter Hannon who has supervised both the Museum's crew and the seeming army of artists' assistants who arrived to assist in the installation of these complicated works.

Assistant Curator Paola Morsiani coordinated the production of this publication, no easy task when working with three other strong minded (and procrastinating) curators. She was an efficient and supportive presence throughout the process, and her persistence, patience, and good cheer requires special recognition. Morsiani was assisted by Laura Lark, an intern from the University of Houston, who provided research assistance and (along with Ms. Morsiani) pursued photographic sources to the ends of the earth.

Outbound: Passages from the 90's is Senior Curator Dana Friis-Hansen's last project for the Museum; he will assume his new role as Chief Curator of the Austin Museum of Art on a full-time basis early this year. Friis-Hansen has made an enormous contribution to this project, to our program and to the Houston community over the past four and a half years, and he will be greatly missed. We are gratified, however, that he will remain a Texas colleague, and we know that our collaborations and collegial interchange will not cease with his departure from the Contemporary Arts Museum.

Assistant Director Michael B. Reed made sure we all could do our jobs—he is an especially gifted and patient troubleshooter—and as viewers of the exhibition will note, was not daunted by even the most arcane installation requirements—including subterranean tide pools. Karen Skaer Soh, Director of Development, procured needed resources, and Director of Public Relations and Marketing Kelli Dunning made our audiences aware of the project. Head Gallery Attendant Diane Bulanowski and her staff have assured the safety and well-being of the art on view and will provide significant assistance to the audiences who come to see it.

This superb publication was designed by Don Quaintance of Public Address Design. Over the many years Quaintance has worked with the Contemporary Arts Museum, he has assumed a larger role than that of book designer, becoming our sounding board, col-league, and collaborator, and we are grateful for his considerable contributions. He was ably assisted by Elizabeth Frizzell. Polly Koch edited the publication with sensitivity and attention.

William R. Thompson, a writer from El Paso and former Houston colleague, performed the heroic task of chronicling the important art-related events of the decade, and the resulting compendium beginning on page 76 shows the fine result. Thompson also researched and edited the artists' documentation.

We are especially indebted to our many colleagues and friends who provided advice, counsel, and encouragement throughout the organization of *Outbound:* Director Maxwell Anderson, Associate Director for Curatorial Affairs Eugenie Tsai, Curatorial Assistant Veronica Roberts, and Manager, Rights and Reproductions Anita Duquette, Whitney Museum of American Art, New York; Director Richard Armstrong and Curator of Contemporary Art Madeleine Grynsztejn, Carnegie Museum of Art, Pittsburgh; art critic David Bonetti, *San Francisco Examiner;* Director Marcel Brisebois, Musée d'art contemporain de Montréal; Director Kerry Brougher, Oxford Museum of Art, England; art consultant Diane Brown, New York; former curator Sheryl Conkelton, Henry Art Gallery, University of Washington, Seattle; Paula Cooper, Paula Cooper Gallery, New York; Director Amada Cruz, Center for Curatorial Studies, Bard College, Annandale-on-Hudson, New York; Linda D'Anjou of the photo rights department, Musée des Beaux-Arts de Montréal; Director Kim Davenport, Rice University Art Gallery, Houston; Curator Elizabeth Finch, The Drawing Center, New York; independent curator and Director Emeritus of the Walker Art Center, Martin Friedman, New York; former Chief Curator of the San Francisco Museum of Modern Art, Gary Garrels; Ian Glennie, Texas Gallery, Houston; Vice President and Director Manuel Gonzalez, Art Program, The Chase Manhattan Bank; Director Kathy Halbreich, Walker Art Center, Minneapolis; independent curator Nora Halpern, Oxford, England; the staff of the Hamon Arts Library at Southern Methodist University, Dallas; the staff of the Hirsch Library, the Museum of Fine Arts, Houston; Fredericka Hunter, Texas Gallery, Houston; Assistant Curator Hitomi Iwasaki, Queens Museum of Art, New York; art critic and independent curator Susie Kalil, Houston; art collector Sissy Kempner, Houston; Director Katy Kline, Bowdoin College Museum of Art, Brunswick, Maine; Director John R. Lane and the staff of the Mayer Library, Dallas Museum of Art; Doug Lawing, Lawing Gallery, Houston; Associate Professor Hamid Naficy, Film and Media Studies, Rice University, Houston; Director Ann Philbin, UCLA at The Armand Hammer Museum of Art and Cultural Center, Los Angeles; Curator Ron Platt, Weatherspoon Art Gallery, Greensboro, North Carolina; Elisabeth Rahbari, Atelier Hollein, Vienna; Associate Curator of Contemporary Art James Rondeau, Art Institute of Chicago; Curator Dana Self, Kemper Museum of Contemporary Art, Kansas City, Missouri; photographer Suzanne Shaker, New York; Associate Curator Stephanie Smith, Alfred and David Smart Museum of Art, University of Chicago; independent curator and art writer Jay Tobler, New York; Assistant Curator of Painting and Sculpture Anne Umland, The Museum of Modern Art, New York; Director Gordon VeneKlasen, Michael Werner Gallery, New York; Curator of 20th Century Art Lynn Zelevansky, Los Angeles County Museum of Art; and Marie-Luise Ziegler, Museum für Moderne Kunst, Frankfurt am Main.

Finally, we thank the artists who have been involved, more than in most projects, in every aspect of the exhibition. We are grateful for their interest and generosity but most of all we are grateful for their work. Along with many others, we stand in awe of their talent, insight, perseverance, and sheer brilliance.

—Marti Mayo
Director

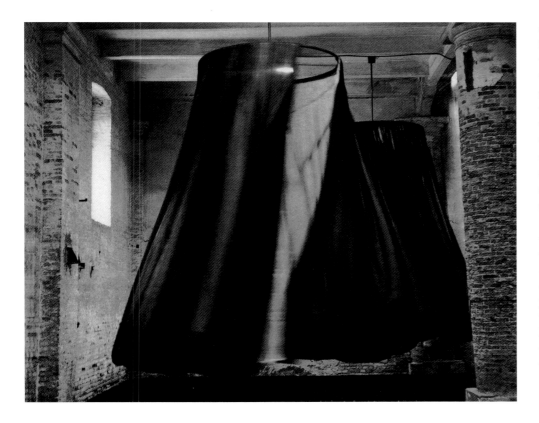

Ann Hamilton
(bearings), 1996
Installation view, XLVII Biennale di Venezia, 1997
Collection Musée d'art contemporain de Montréal

O utbound: Passages from the 90's pre-
sents ten major works of art by
ten artists that for us have partic-
ularly resonated across the last
decade. After the initial choices were made, it
became clear that these works provide a view
of the art of the past ten years in which we
find a renewed humanism, a rigorous intelli-
gence, a rich and rewarding sensuality, and a
sincere engagement with social, polemical,
and spiritual issues. The resulting exhibition
is not didactic; these ten artists do not try to
save the world—just invite us to change it.
Nor does it celebrate internationalism for its
own sake (as so many biennials today seem to

do); it instead offers ten encounters with work
by artists from all over the world, encounters
that are profoundly engaging. In organizing
the project, we sought to share with others the
rich, powerful and enduring responses we felt
when we initially encountered these marvelous
works of art. We believe that viewers—both
those who are informed about contemporary
art and those who are less knowledgeable—
approaching these works with openness,
imagination, and curiosity will also be
rewarded with remarkable experiences.

The roots of Outbound lie in the daunting
question posed by the Director, "Who are the
artists who defined the 90's?" At a series of
meetings over the course of the last year, the
curatorial and education staff gathered to pro-
pose names, share ideas about the key issues of
the time, recount aesthetic experiences that
had been significant to them, and discuss how
we might best celebrate and communicate to a
varied audience the depth and breadth of the
contemporary art of the decade drawing to a
close. We compiled lists—the first one had
over a hundred extremely diverse names, in-
cluding deceased but still influential artists
such as Marcel Duchamp and Andy Warhol,
creative innovators outside the visual arts such
as filmmaker Jean-Luc Godard and architects
Rem Koolhaas and Frank O. Gehry, and a few
very young and emerging artists whose work
seems to presage the next decade.

We quizzed our artist and curator col-
leagues for their opinions on who and what
had shaped this decade in art, and what influ-
ence those people and ideas are likely to have
on the twenty-first century. These discussions
always brought us back to the question of what
makes a work of art influential, important,
powerful? Is it something special that resides

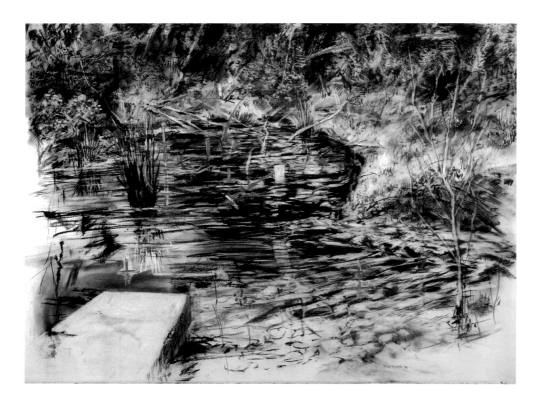

William Kentridge
Swimming Hole, 1996
Charcoal and pastel on paper
48 1/2 x 62 1/2 inches
Collection Mr. and Mrs. William A. Wise, Houston

in the art itself, or in the intention of the artist, or in ourselves, the viewers? Is it the graceful articulation of ideas and issues already "in the air"? Is it breaking the rules to create something completely new? Can importance be quantified, counted, or assessed—from the number of times, say, an artist is on the cover of an art magazine, or included in one of the growing number of international biennial/triennial expositions? Is it about "positioning"—being collected by highly visible individuals and institutions, championed by museum curators, covered by widely read critics, and represented by influential dealers? Or is it the kind of magic that occurs when we see (in our eyes and our minds) a work of art that has achieved a particular brilliant union of idea, form, content, and timeliness that speaks across culture and place on a level beyond the immediate? As curators, we are all aware of the complexities of the artist-dealer-collector-magazine-museum system and how today's taste can either inform or be forgotten by tomorrow's art history. We know too well that as museum professionals we are part of this matrix and that—like our colleagues—we try to use the system as a tool, both to discover

and to share developments in the history of contemporary art, but we hope we are not bound by it.

No doubt, each of us has had unique experiences with the art of the 1990's, and your experiences may be as passionate as ours. But we've made an exhibition from ours, and like passages from a journal, this project reflects on *our* most memorable encounters. We know that inherent in any choice is an alternate and that our judgments may not be yours, but we hope that this exhibition will offer an opportunity not only to reflect upon these ten works but also to consider others that have meant the most to you over the past ten years.

Each of us came to the table with heartfelt commitments to particular artists, ideas, and aesthetics that we believe define both contemporary art and the past decade. Eventually, we realized we had to move beyond lists of names to consider art from a different point of view. We began to weigh our profound encounters—spine-tingling epiphanies or transformative moments of grace—with works of art that had changed the way we think and feel about ourselves, about art, and about our world. Each curator proposed works about

which he or she felt passionate, and a final list was eventually distilled. The works of art in this exhibition, and the artists who made them, are deeply respected by all four of us, so the result is a unanimous—but contentious—consensus.

There were, we found, some very real strictures on our final list. The unavailability of some works led to deeply felt sacrifices. And there were some dreams that due to physical limitations, had to remain dreams. For example, we could hardly install Richard Serra's magisterial *Torqued Ellipses* (1996–97) in our building and have room for other work. Though the bayous of Houston would benefit from Frank O. Gehry's marvelous Guggenheim Bilbao Museoa, it would certainly be missed by the Spanish people and other cultural pilgrims. To remedy this situation, and to recap other high (and low) points of the 1990's, we have included an illustrated chronology, found on page 76, that documents the events that shaped the art of the past decade.

Although our process of organization focused on individual works of art rather than on themes, some general observations can be extrapolated from the exhibition and perhaps used to describe much of the art of the 1990's. In 1993, art critic and writer Dave Hickey proposed that beauty would be "the issue of the Nineties." Writing in what has come to be one of the most important critical essays of the decade, he declared, "I direct your attention to . . . the rhetoric of how things look—to the iconography of desire—in a word, to *beauty!*"[1]

Hickey cited the importance of "rhetoric" and "iconography" to remind us that this emphasis on beauty does not necessarily signal an anti-intellectual shift away from rigorous examination, seriousness of purpose, or intelligent

Selven O'Keef Jarmon's fashion show,
Project Row Houses, Houston, 1996

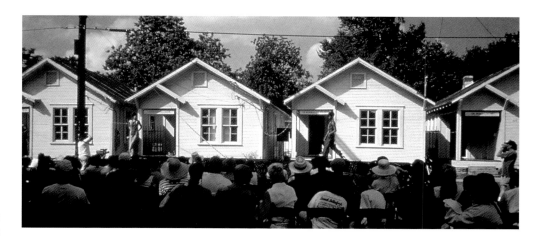

and meaningful thought on the part of the artists or their audiences. But still, today we seem less fearful of beauty—in all its sensuality and spectacle—regardless of the vehicle of its delivery: desirable imagery, delectable materials, careful craft, technical virtuosity, or high production values. Hickey pointed out that beauty is the great seducer, that through the pleasing and amazing formal attributes that various societies have called "beautiful," the artist is able to draw the viewer close to the work and invite consideration and contemplation, thereby allowing the art to do its work, its "job." Its work is to convey *meaning*, a message that is illuminating and transformative. In Hickey's words, ". . . The vernacular of beauty, in its democratic appeal, remains a potent instrument for change"[2]

One of art's greatest gifts is its ability to change us—to transform us and to invite us to transform our world. The best art speaks to us directly and profoundly, as if in an unknown yet eloquent tongue we somehow instantly recognize. The artists whose work was chosen for *Outbound*, and many others working throughout the 90's, reach out to us—they allow their art to do its work—through the language of beauty. And unlike some work from earlier decades that directed our attention to art, the art world, or art history, these works provoke a heightened awareness of the real world in all its glory and horror. They are subversive: they call out for change—political, social, cultural change.

Some of these *Outbound* artists have created intimate situations for the viewer in order to address (or redress) problems within society or cultural institutions. Others put the viewer in a more social context, and one collaborative team has literally reinvented art by making it

into an organization close to the streets, the neighborhood, and the people who live in it. But this work is not didactic, we don't take this art like medicine, because it's "good for us." We experience it as beautiful and transformative, not curative. That doesn't mean these works are reactionary; they don't ignore the legacies of modernism and postmodernism. In fact, they all pivot around the natural tension between "art" and "life," an issue with which artists have grappled throughout the centuries and certainly in the last one of this millennium.

In the 90's, however, the boundary between art and life became more transparent, was felt more lightly, than when Robert Rauschenberg first pointed it out to us by marking it off as his working territory in the 60's. These artists, and others working in the 90's, feel free to tap into the more postmodern and metaphorical resonances of traditional and nontraditional art materials, or into the multilayered meanings of objects, images, ideas, and actions, mining them for their own creative needs and messages.

There is a material, physical, technological, and narrative sophistication to these works, due in part to the 1990's move away from the solitary art object to embrace the expressive possibilities of environmental installations, interventions in the site, or time-based media such as film and video. These works, perhaps more warmly, invite the viewer's physical, perceptual, and emotional participation, directing our gaze inward to ourselves and outward to our world. They elicit wonder, bewilderment, fear, embarrassment, desire, and release, all the while affirming the power of art.

The short essays that follow provide a brief consideration of each of the ten works of art that comprise the exhibition and relate each work to a larger context: the art of our time. As we introduce these wonderful works of art to you, it is with the hope that you, the viewer, will also experience this personal, intimate, and rather astonishing connection with them that we did—the connection that prompted their selection for, and celebration in, *Outbound: Passages from the 90's*.

—Dana Friis-Hansen, Lynn M. Herbert, Marti Mayo, Paola Morsiani

1. Dave Hickey, "Enter the Dragon: On the Vernacular of Beauty," in *The Invisible Dragon* (Los Angeles: Art Issues Press, The Foundation for Advanced Critical Studies, 1993), p. 12.
2. Ibid., p. 24.

PASS

AGES

from the 90's

JANINE ANTONI
Swoon, 1997
Mirror, velvet curtains, theatrical lights, and
 video projection with sound
Overall dimension: approximately
 26 x 44 x 16 feet
Originally produced by Capp Street Project,
 San Francisco
Courtesy the artist and Luhring Augustine
 Gallery, New York

MATTHEW BARNEY
The Ehrich Weiss Suite, 1997
Acrylic; prosthetic plastic; Vivak; Pyrex;
 internally lubricated plastic; sterling sil-
 ver; Type C prints in acrylic frames;
 gelatin silver print in acrylic frame;
 graphite, acrylic and petroleum jelly on
 paper in acrylic and prosthetic plastic
 frame; and Jacobin pigeons
Overall dimension: approximately $17^{1/2}$ x
 $14^{1/4}$ x $13^{3/4}$ feet
Courtesy the artist and Barbara Gladstone
 Gallery, New York

CAI GUO-QIANG
The Dragon Has Arrived!, 1997
Wood, electric fans, flags, and lights
$6^{1/2}$ x $6^{1/2}$ x $25^{3/4}$ feet
The Dakis Joannou Collection, Athens

ROBERT GOBER
Untitled, 1997
Leather, wood, forged iron, cast plastics,
 bronze, silk, satin, steel, beeswax, human
 hair, brick, fiberglass, urethane, paint,
 lead, motors, and water
Overall dimension: $10^{1/4}$ x $8^{3/4}$ x $6^{1/4}$ feet
Above ground: $2^{7/8}$ x $2^{7/8}$ x $3^{1/3}$ feet
Below ground: $7^{1/4}$ x $8^{3/4}$ x $6^{1/4}$ feet
Collection the artist

ANN HAMILTON
(bearings), 1996
Two black silk organza curtains with white
 organza lining, motor, and steel mounts
 with electronic controller
14 feet high; 6 feet in diameter at top
 (approximately 13 feet in diameter when
 rotating)
Collection Musée d'art contemporain de
 Montréal

JIM HODGES
with The Fabric Workshop and Museum,
 Philadelphia
You, 1997
Silk flowers and thread
16 x 14 feet
Collection The Fabric Workshop and
 Museum, Philadelphia

pages 12–13: Shirin Neshat
Still from *Rapture*, 1999
see plates 51–56
Courtesy the artist and Barbara Gladstone Gallery,
New York

WILLIAM KENTRIDGE
History of the Main Complaint, 1996
Video and sound installation
35mm animated film transferred to DVD
5 minutes and 50 seconds
Room: 19 x 26 feet; projection: 10 x 11½ feet
Drawing, Photography, and Direction:
 William Kentridge
Editors: Angus Gibson and Catherine
 Meyburgh
Sound: Wilbert Schübel
Music: *Ardo*, madrigal by Claudio
 Monteverdi
Courtesy the artist and Marian Goodman
 Gallery, New York

Swimming Hole, 1996
Charcoal and pastel on paper
48½ x 62½ inches
Collection Mr. and Mrs. William A. Wise,
 Houston

RICK LOWE & DEBORAH GROTFELDT
Sharing the Wealth, 1999–2000
Mixed-media art action (installation
 in museum includes desk, chair, computer
 terminal, website, site maps, and photo
 and text collages)
Courtesy the artists and Project Row Houses,
 Houston

SHIRIN NESHAT
Rapture, 1999
Video and sound installation
13 minutes
Room: 25 x 35 feet; projections: 9 x 12 feet
 each
Director: Shirin Neshat
Director of Photography:
 Ghasem Ebrahimian
Script: Shirin Neshat and
 Shoja Youssefi Azari
Producer (Morocco): Hamid Farjad
Producer (United States): Bahman Solitani
Music and Sound Design: Sussan Deyhim
Editors: Shirin Neshat, Shoja Youseffi Azari,
 and Bill Buckendorf
Production Manager (Morocco):
 Jane Loveless
Production Manager (United States):
 Tamalyn Miller
Costume Designer: Nourreddine Amir
Still Photography: Larry Barns
Camera Assistant: Mustapha Marjane
Key Grip and Dolly:
 Abdelaziz Makramani
Second Grip: Abderahmane Fahim
Assistants to Director: Mamoun, Zineb
 Charhourh, Fatima Bahmani, and
 Mustapha Sbia
Courtesy the artist and Barbara Gladstone
 Gallery, New York

FRED WILSON
Guarded View, 1991
Wood, paint, steel, and fabric
6¼ x 4 x 13⅞ feet
Whitney Museum of American Art, New
 York; Gift of the Peter Norton Family
 Foundation

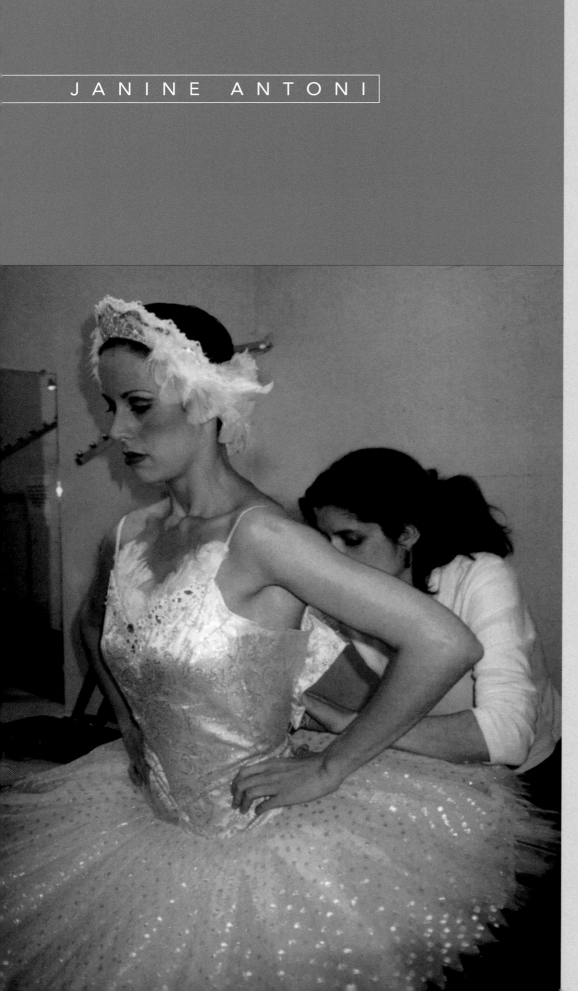

JANINE ANTONI

1. (left) Janine Antoni adjusting ballerina's costume during the production of *Swoon* (1997), Capp Street Project, San Francisco, 1997

2–9. *Swoon*, 1997 (details)
Installation views, Capp Street Project, San Francisco, 1997, and Whitney Museum of American Art, New York, 1998
Mirror, velvet curtains, theatrical lights, and video projection with sound
Overall dimension: approximately 26 x 44 x 16 feet
Originally produced by Capp Street Project, San Francisco
Courtesy the artist and Luhring Augustine Gallery, New York

Swoon
1997

Janine Antoni's work is informed by an uncommon tension between corporeal presence and the sublimated elegance of historical forms. Addressing the artistic past—far or near—from both a personal and a political angle, Antoni infuses art history with issues that heighten our awareness of its psychological and social legacy. Despite its deep conceptual roots, the involved physical manipulation that characterizes Antoni's work may be seen as evidence of the labor the artist has undertaken to challenge tradition. Specifically, Antoni's meditation concerns self-representation and identity—as a woman, as a female artist, and as an individual. Form, labor, and experience substantiate Antoni's concept of self-identity.

Antoni's first large video installation, however, addresses the viewer's identity. *Swoon* explores the relevance of our experience when defining the meaning of a work of art and refers to the eruption of desire that occurs in the process of interpretation. Antoni has been discreetly looking at her audience throughout her previous production. *Swoon* finally reveals her voyeurism.

Swoon is built like a theater, comprising a large dimly lit raw space in which we already hear stage voices and noises; a curtained stage where a projected image from Tchaikovsky's *Swan Lake* ballet faces a room-size mirror; and a backstage area that exposes the projection equipment.

Referencing classical ballet and a popular romantic epic, the artist has rechoreographed *Swan Lake* to focus only on its three pas de deux, revealing the complex dynamism involving desire, interplay, and conflict between the two protagonists, the Swan-Queen Odette and Prince Siegfried. The ballet's story mirrors the viewer's own experience of *Swoon*, which is marked by shifts between illusion and reality, suspense and release. Throughout the installation, in fact, we are never allowed a frontal view of the dancers: their figures are either concealed behind lowered curtains of luscious red velvet that leave only the dancers' feet visible, or projected in reverse in the backstage area, or elusively reflected in another smaller, mirror image.

As we enter the installation, the sound of bodies under physical stress—harsh breathing and thudding steps—makes an immediate impact. Intermittently the noise stops as *Swan Lake*'s musical motif plays. The shift is abrupt, the music sounding less natural to the dancers' bodies than their physical and vocal expressions: one appears illusory and implies a loss of consciousness; the other is real and comes with labor. According to Antoni, the sound of breathing suggests a primal scene—an experience that lies at the core of our imaginary activities, linked to both desire and fear, fundamental in our understanding of the outer and inner world.[1] This physical sound becomes our own as we struggle to relate our own bodies, moving through the meandering spaces of *Swoon*, to the emotions triggered by the music and images.

As we reach the video screen, sexual tension—always an important component in Antoni's work—is concentrated in the feet and shadows of the two dancers that impersonate the lovers, Odette and Siegfried. Antoni subverts the romanticism of their union and thwarts our desire to see it fulfilled. The partial view we are allowed suggests the proximate vision lovers have of each other. Although the dancers' shadows give the impression that their bodies are conjoined, in Antoni's choreography the dancers often simply mirror each other. At one point, for a brief moment, the dancers exchange male and female roles, as well. In the original *Swan Lake*, Odette is forced to step back and stand in the shadow of her impostor and evil counterpart, Odile, whom Siegfried foolishly courts. In Antoni's choreography of love, Siegfried for a short moment takes on Odile's willfully deceiving role. During a recent residency at a Shaker community, Antoni noticed how the prescribed separation of genders is accomplished in the community's architecture by creating distinct separate spaces that mirror each other: they are discrete and yet open, implying inward yet unceasingly reciprocal gazes, separate yet concerted commitments. As we look for ourselves in our partner's eyes, Antoni's point is not difference but proximity, a connection that implies a deeper view but also one that inevitably carries with it the interference of our most profound needs.

As we move through *Swoon*, the large mirror opposite the video screen and curtains grounds us in this layering of fragmented impressions and sensory experiences. The mirror —a dancer's practice tool par excellence—reinforces our view, returns our image, projects us out of the deception of shadows and sound. Our own image becomes central. We become the subject, the figure against the ground of a dance that flows endlessly around us. *Swoon* puts us on the stage with no other choreography than the one we build for ourselves.

—*Paola Morsiani*

1. Janine Antoni, in conversation with the author, October 22, 1999.

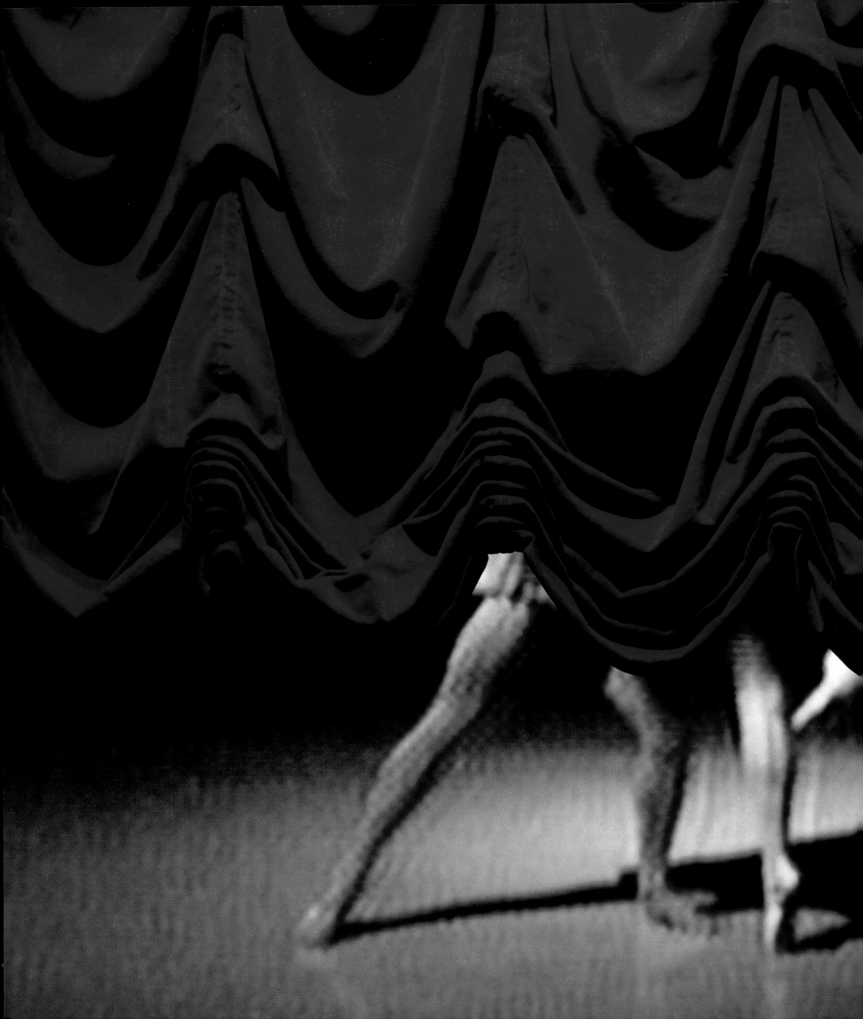

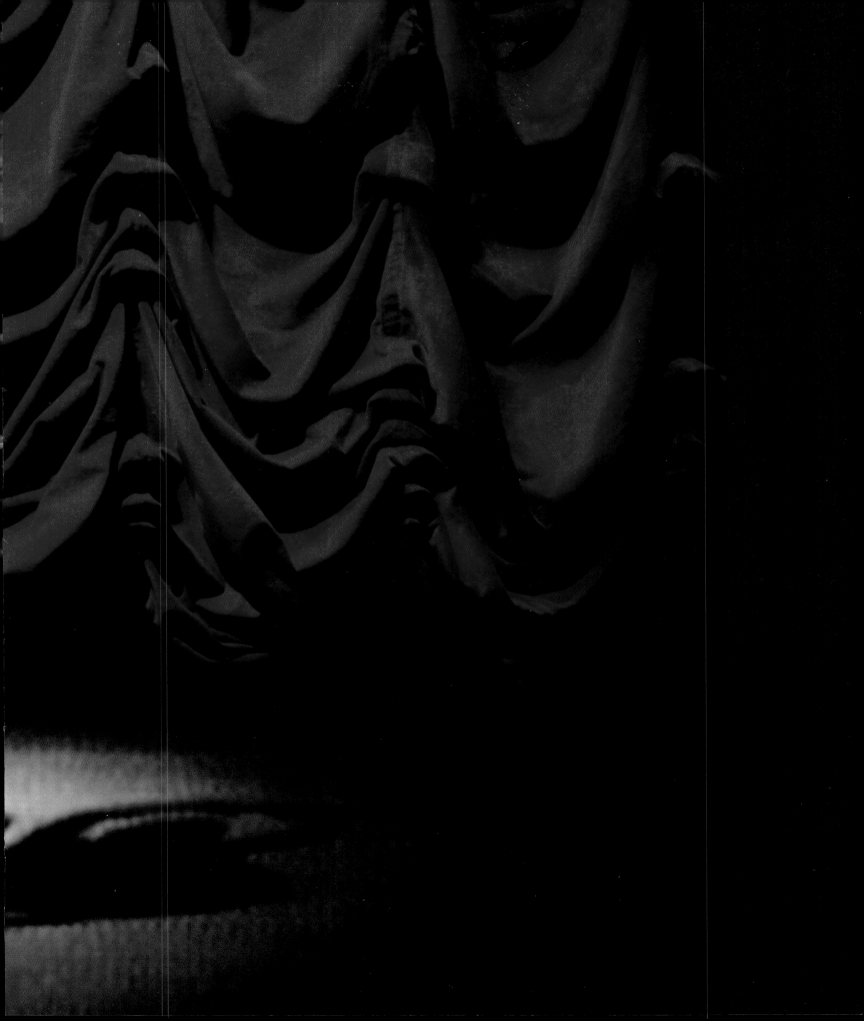

3

4

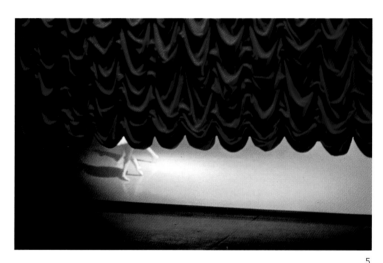

5

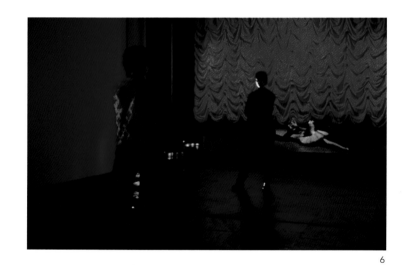

6

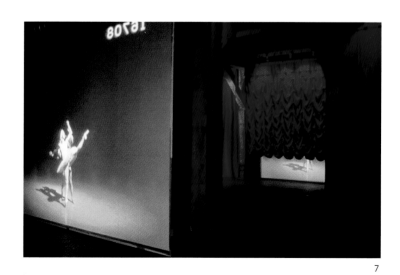

7

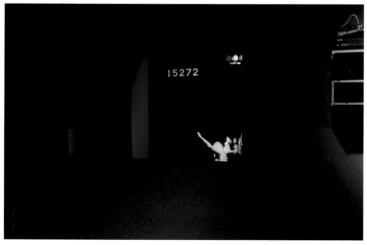

8

9 (opposite)

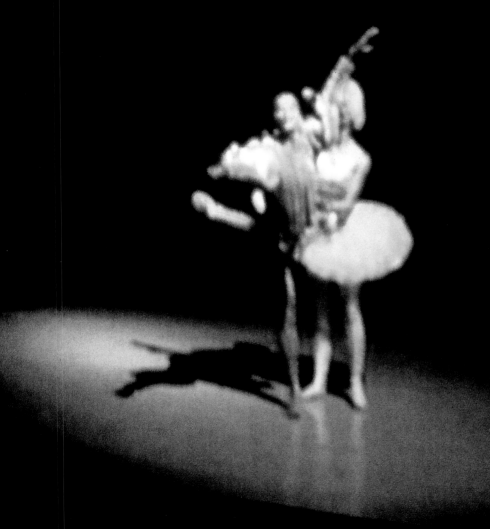

MATTHEW BARNEY

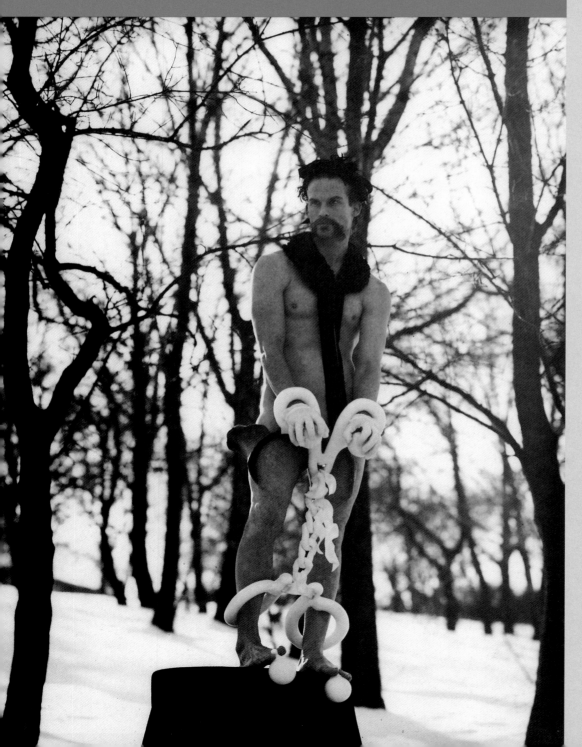

10. (left) Film still from *Cremaster 5*, 1997, with Matthew Barney as the "Magician"

11–14. *The Ehrich Weiss Suite*, 1997 (details)
Acrylic; prosthetic plastic; Vivak; Pyrex; internally lubricated plastic; sterling silver; Type C prints in acrylic frames; gelatin silverprint in acrylic frame; graphite, acrylic, and petroleum jelly on paper in acrylic and prosthetic plastic frame; and Jacobin pigeons
Overall dimension: approximately 17$^{1}/_{2}$ x 14$^{1}/_{4}$ x 13$^{3}/_{4}$ feet
Courtesy the artist and Barbara Gladstone Gallery, New York

The Ehrich Weiss Suite
1997

Matthew Barney's language is both abstract and flamboyantly figurative, symbolic and essentially open-ended. His work reflects the strength of personal mythologies expressed through a universal subject, the human body. Barney does not see the body as the fragile entity struggling against technology that has been promulgated throughout the past century. Instead, placed in a syncretic context that encompasses classic mythology, religion, history, American pop, and Hollywood culture, the body is referred to as a cultural product, a model for creative thinking that interacts in a meaningful way with the synthetic world we have built for ourselves.

The Ehrich Weiss Suite relates to Barney's film Cremaster 5, 1997. The film takes place in Budapest, where Ehrich Weiss was born in 1874, a magician and escape artist known by his stage name, Harry Houdini. Houdini also "appears" in the artist's early videos and in his other Cremaster films, 1994–2000. To Barney, Houdini's fascination with transcending physical limitations represents a discipline that leads to intellectual discovery. Houdini embodies intuitive knowledge and the concept that a contained self can be forever transforming and expandable.

The notion of metamorphosis is also implied in Barney's reference to the cremaster, the muscle that regulates the height of the testicles in the male body, based on outside temperature or inner emotions. In Barney's work, the term refers to the idea of gender undifferentiation which characterizes the fetus' first seven weeks in the uterus before the sexual organs ascend to form a female or descend to form a male body. Each one of Barney's Cremaster films enacts a dynamic that attempts to attain a coexistent or alternate sexual realization. According to Barney, Cremaster 5, the final film in the series, represents the "fully descended state" where, "in the process of defining itself as a differentiated form, the narrative begins to die."[1] In that film, the Magician dies during a shackled dive from the Bridge of Chain into the Danube's glacial waters (pl. 10). The Queen of Chain laments his death.

The Ehrich Weiss Suite transports this dynamic into a sculptural dimension and in the process intensifies the themes of death, separation, and loss.[2] We are presented with the moment that immediately follows a death, when the deceased's passage is acknowledged by the ones who are left. The Suite is an enclosed room. We look inside through a locked glass door. On the floor, the shackles that have bound the Magician lie in a transparent acrylic casket. On the casket, a scepter-like blown-glass form commemorates the Queen of Chain; we now understand that the Queen did not survive her sorrow. On the wall, a photographic triptych recalls the moment when the Queen and the Magician kissed for the last time, the grievous expressions of the Queen's Ushers in the two side-panels presaging the tragic end. A drawing of the Magician's horse with its empty side-saddle and the Queen of Chain's dropped scepter, depicts his fall and her simultaneous exhalation.

Emotions of mourning are expressed in the Suite in part through symbols of catharsis traditionally found in funerary sculpture. For instance, the Queen's Ushers with their expressions of melancholy are a source of consolation. While recalling the viscous substances seen in Barney's films, the wavy plastic wainscot along the Suite's walls also seems unbound by gravity, like a detail from the ecstatic characterization of heaven found in Baroque architecture.

Other elements in the Suite introduce us to a different relationship with death and modify our idea of a memorial. With its gloves and spherical forms, the complex configuration of the shackles at the center of the Suite conjoins male and female shapes both inside and outside of the body. A traditional symbol of the weight of mundane existence, these chains are also the emblem of Houdini's talent and transcendence. On the casket is the elongated blown-glass form; in Barney's words, it is a clear droplet that stands for the Queen's last breath. It continues on the floor where it splits into two droplets, alluding to a potential proliferation. Resembling a scrotum as well, it again fuses male and female worlds.

The Suite is inhabited by seven black Jacobin pigeons, the only live beings to have access to this room. In Cremaster 5, the feathered bodies and collars of the pigeons are white. In the Suite, they have turned black, partaking of the condition of death and mourning.[3] However, the fact that they remain alive in the room introduces a suspension of finality, transfiguring death into a process—not just an end but an event. Because we cannot step into the room, we are acutely aware of viewing the scene from a threshold, both sharing the birds' condition of life and observing their presence in death.

If The Ehrich Weiss Suite can be seen as a memorial, then it is a monument in which life itself functions as memento mori. At this millennial juncture, as we are forced to imagine a future, our connection to the past is put into question. The Ehrich Weiss Suite invites us to relate to endings in a different way, to look at them as an active part of life rather than as its resolution. Memory is uniquely represented as a function that, although formed from the past, evolves and generates our future.

—Paola Morsiani

1. Thyrza Nichols Goodeve, "Travels in Hypertrophia: Thyrza Nichols Goodeve Talks to Matthew Barney," Artforum (May 1995), p. 117; Matthew Barney, electronic mail to the author, December 4, 1999, from which all other quotes appearing in this essay are taken.
2. The Ehrich Weiss Suite was originally exhibited at Barbara Gladstone Gallery, New York, October 25–December 20, 1997, along with other works that reference different moments and characters from Cremaster 5.
3. In the symbology of Barney's Cremaster 5, black and red represent a "field of differentiation": these colors denote the resolution of a process.

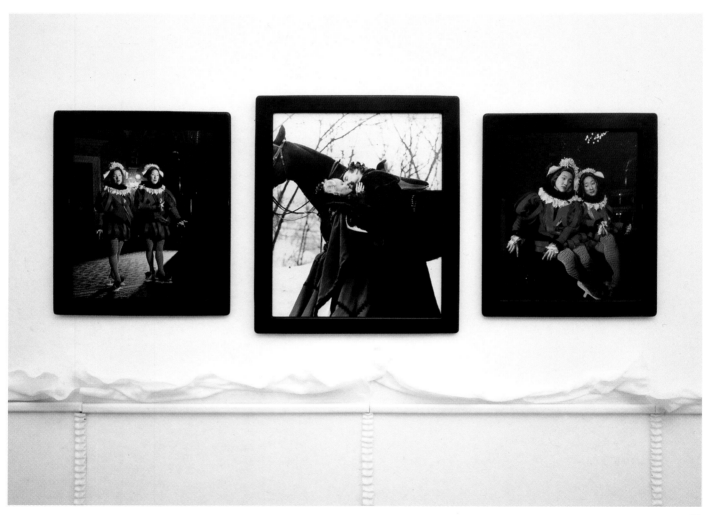

12 (opposite)

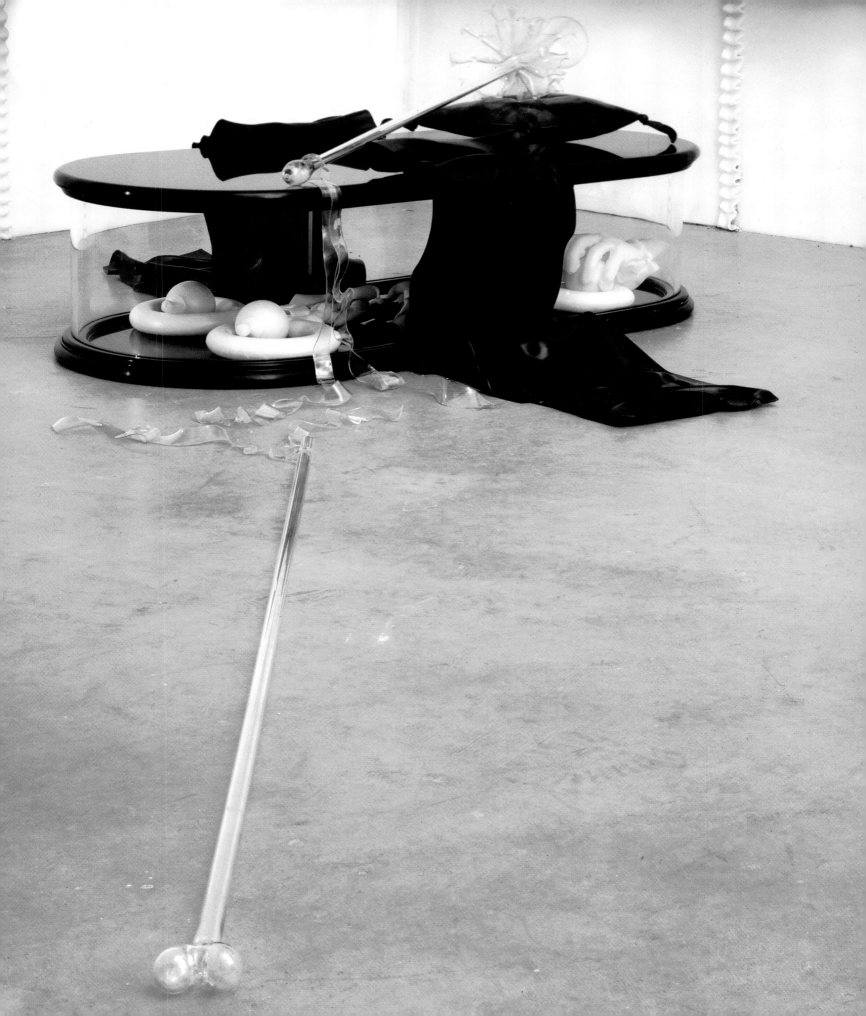

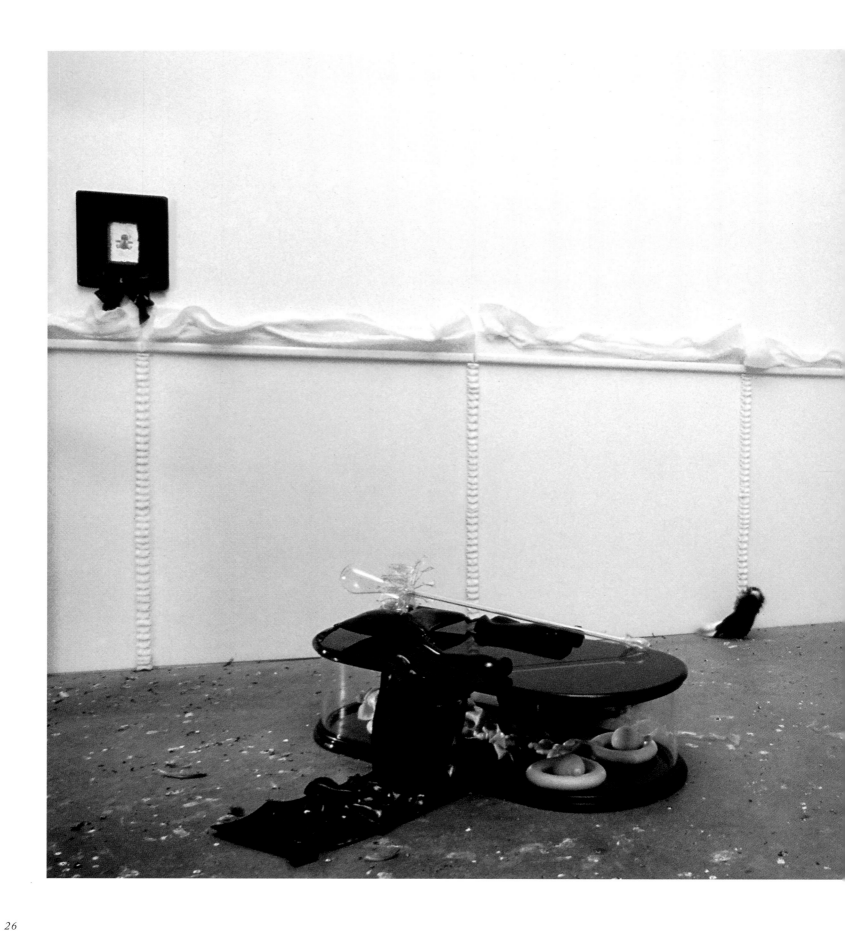

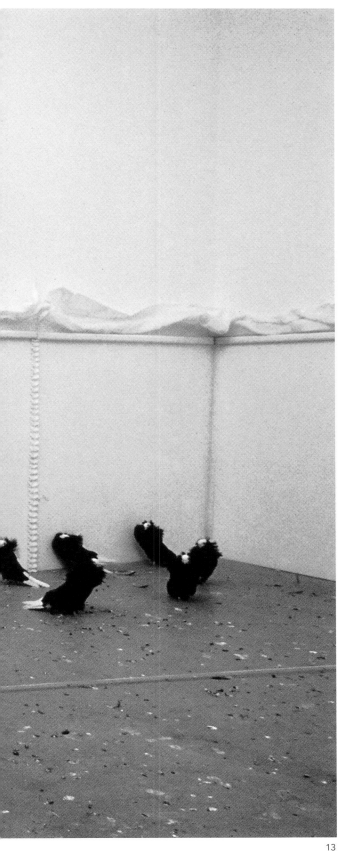

13

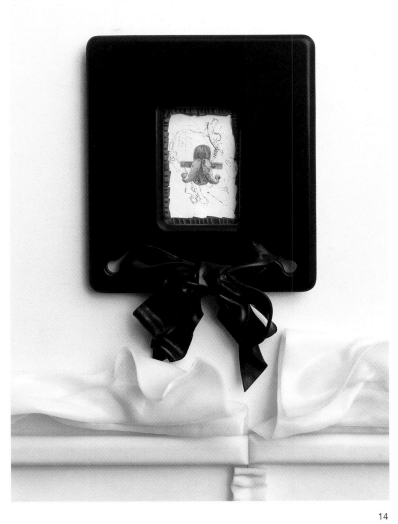

14

CAI GUO-QIANG

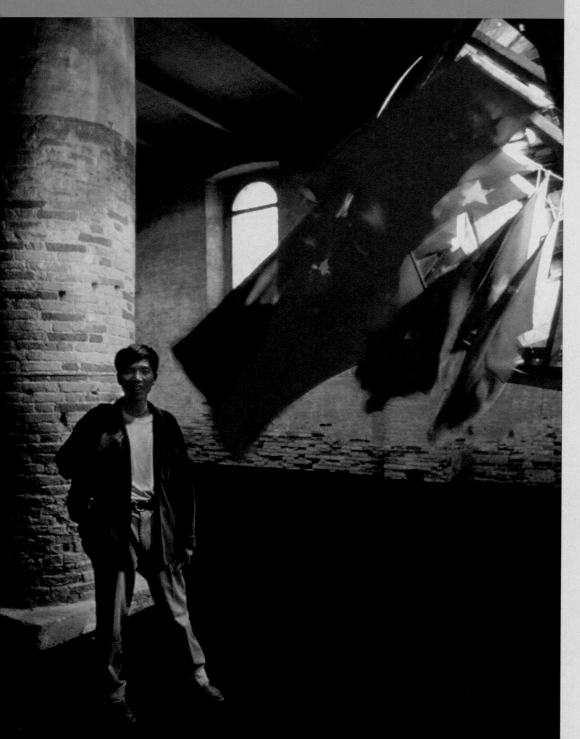

15. (left) Cai Guo-Qiang at the *XLVII Biennale di Venezia*, 1997

16. Shipwreck salvaged for materials, Iwaki City, Japan, 1994

17–18. *San-Jo Tower*, 1994–95, installation views, Museum of Contemporary Art, Tokyo

19–20. *The Dragon Has Arrived!*, 1997
Installation views, *XLVII Biennale di Venezia*, 1997
Wood, electric fans, flags, and lights
6^1/2 x 6^1/2 x 25^3/4 feet
The Dakis Joannou Collection, Athens

The Dragon Has Arrived!
1997

Cai Guo-Qiang's work is the product of a complicated equation of place, process, materials, and politics. Born in the city of Quanzhou, this Chinese artist studied stage design in Shanghai before leaving his native country in 1986 for further study in Japan. There he became known for his series *Projects for Extraterrestials*, his ambitious performance events, and large-scale drawings, that often used gunpowder, fireworks, and the imagery of space exploration. He follows in the path of earlier sky-gazing cultures that created myths to connect the heavenly with the earthly. As he explains, "The conceptual thrust of my projects is to create a dialogue between earth and cosmic space, considering both points of view."[1] Since 1995 the artist has lived and worked in New York City, and although his work still draws deeply upon his Asian roots, it also taps into—or pushes off from—Western ways and means. Making physical, conceptual, and spiritual gestures, often on an awe-inspiring scale, Cai's projects are as inextricably linked with ancient Chinese ideas, events, and traditions as they are radically innovative and forward-looking.

Hung from the space frame that forms the Contemporary Arts Museum's ceiling, *The Dragon Has Arrived!*, 1997, makes its first appearance in the United States. Debuted in the *Future, Past, Present 1965–1997* section of the 1997 Venice Biennale, and subsequently acquired and exhibited by The Deste Foundation of Athens, because the work features themes of celestial aspiration, Houston is perhaps the most appropriate locale for its American introduction. In the words of the artist, "The home base of any country's space program is a point where we are more closely linked to the rest of the universe."[2]

Although *The Dragon Has Arrived!* was completed in 1997, its lineage must be traced back to the artist's 1993–94 residency in the seaside city of Iwaki, Japan. Invited to create a project for the local museum, the artist worked with a team of volunteers to excavate a monumental twenty-year-old shipwreck found on a local beach (pl. 16). With the assistance of both shipwrights and traditional carpenters who specialize in shrine construction, he then assembled a giant sculptural hull inside the gallery, while building three pagoda-like forms outside from the excavated scrap wood (pls. 17–18). Writing about this outdoor work, entitled *San-Jo Tower*, curator Akihito Hirano observed that temples once served to protect Buddhist relics and that a tower on the coastline guides ships, concluding that this three-part tower was meant to "reach toward space."[3] Hirano touched upon the celestial metaphor again when he compared the earth-oriented imagery of Cai's explosive art events to the information plaques featuring human figures and earth's position in the solar system that were placed on NASA's Pioneer and Voyager missions into outer space.[4]

The three pavilions were assembled into one monumental tower by the artist on the occasion of the exhibition *Art in Japan Today 1985–1995* at the Museum of Contemporary Art, Tokyo. Installed in the new museum's light-filled atrium, the scrapwood skyscraper was fitted with seismographic sensors, all placed according to feng shui principles. Reflecting the important relationship between the earth and its human presence, both the deep vibrations of the planet's crust and the surface impact of museum visitors' footsteps on the floor were recorded by these instruments onto paper charts that hung on adjacent walls.

In 1997 the work was adapted again in the same spirit of recycling and renewal that is found throughout the artist's oeuvre. For a special installation at the Venice Biennale's corderie building, sections of the tower were fitted with fans, lights, and thirteen Chinese flags; when hung from the ceiling, it appeared to take flight (pls. 19–20). The title and the content of the work shifted with these changes to reflect the artist's new concerns that had emerged with his move to the United States. Because the American media at this time was trumpeting China's shift from communism to capitalism, this and other of Cai's work of the period were accompanied by magazine covers and front page stories addressing China as a new economic force with which to be reckoned. And although it was 1997 when the work took the form—in the artist's words—of a "Chinese missile," Cai recently commented upon the fortuitous but unexpected resonance added with the recent allegations of a Chinese theft of U.S. nuclear intelligence. Furthermore, in the fall of 1999, China launched the first rockets of its newly announced (and, to the Western world, largely unknown) space program. "Perhaps [*The Dragon Has Arrived!*] was meant to prophesize some of the twists and turns of Sino-American politics of the late 1990's."[5]

Connecting diverse cultures with references to our past, present, and future, Cai's projects reaffirm the artist's role as a visionary synthesizer.

—Dana Friis-Hansen

1. Cai Guo-Qiang, in conversation with the author, July 30, 1992.
2. Cai Guo-Qiang, electronic mail to the author, November 18, 1999.
3. Akihito Hirano, "Introduction of Works," in *Cai Guo-Qiang: From the Pan-Pacific* (Iwaki City, Japan: Iwaki City Museum of Art, 1994), p. 77. The three pagoda-like elements were clustered around a Henry Moore sculpture on the plaza rather than assembled into a tower that would cover it, as the artist had originally proposed.
4. Akihito Hirano, "A Story Produced by Fire, Ocean, and People," ibid., p. 15.
5. Cai Guo-Qiang, electronic mail to the author, November 18, 1999.

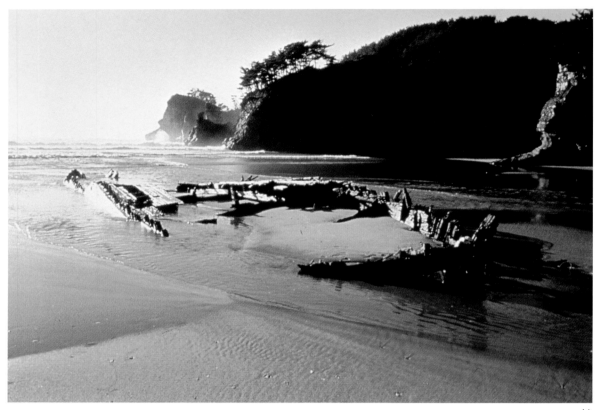

16

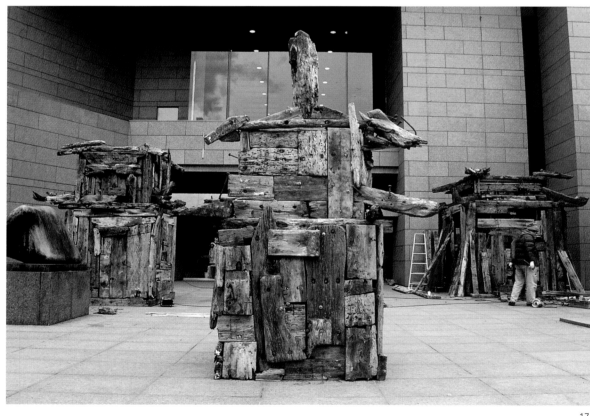

17

30

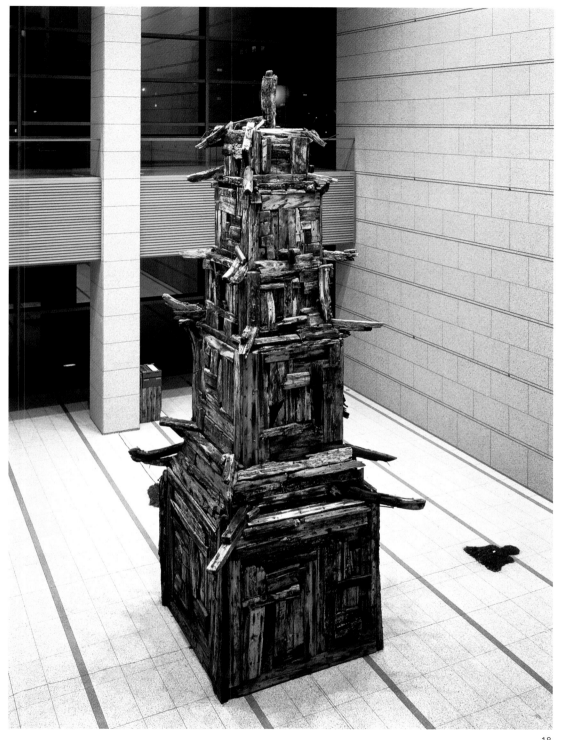

18

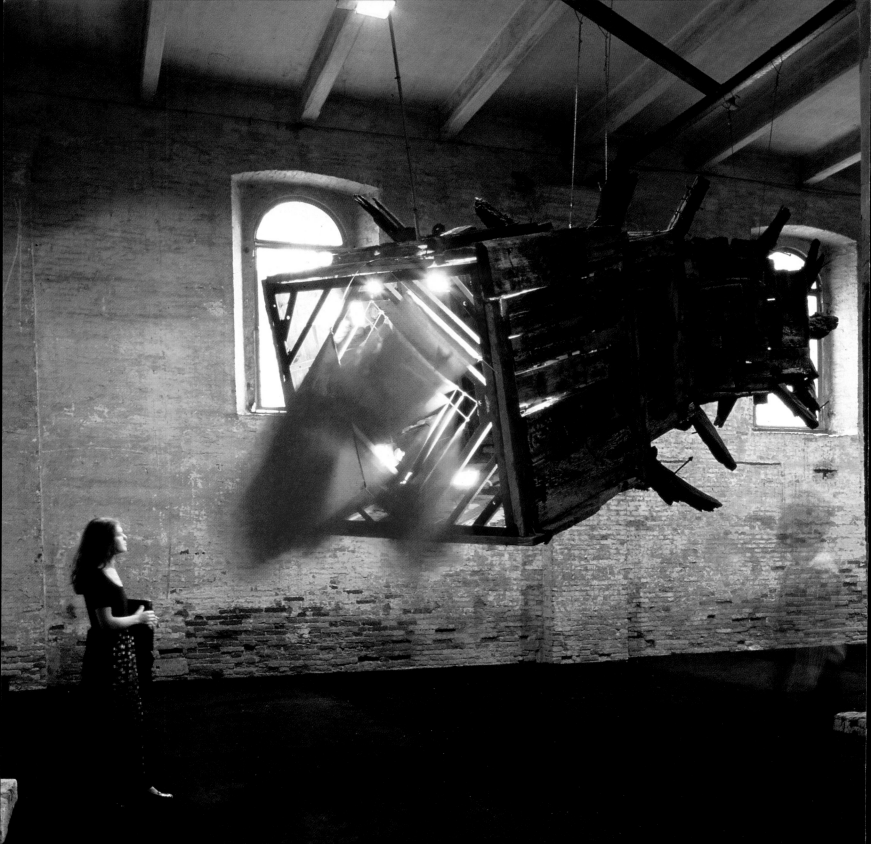

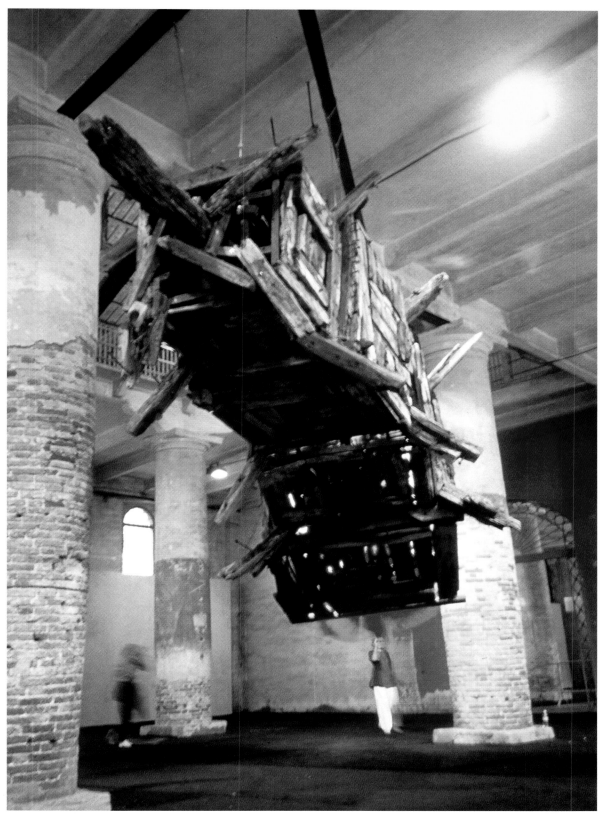

19 (opposite) 20

ROBERT GOBER

21. (left) Robert Gober working on *Untitled* (1997), Maine, 1996

22–26. *Untitled*, 1997 (details)
Leather, wood, forged iron, cast plastics, bronze, silk, satin, steel, beeswax, human hair, brick, fiberglass, urethane, paint, lead, motors, and water
Overall dimension: 10^{1}/$_{4}$ x 8^{3}/$_{4}$ x 6^{1}/$_{4}$ feet
Above ground: 2^{7}/$_{8}$ x 2^{7}/$_{8}$ x 3^{1}/$_{3}$ feet
Below ground: 7^{1}/$_{4}$ x 8^{3}/$_{4}$ x 6^{1}/$_{4}$ feet
Collection the artist

Untitled
1997

Deftly embedding personal and political undercurrents into straightforward, yet enigmatic, handmade objects—including dollhouses, cribs, sinks, urinals, dresses, doors, and doughnuts—Robert Gober gained prominence and influence in the 1980's. At the beginning of the 1990's, Gober incorporated his domestic and/or private objects into increasingly complicated architectural installations, and as this decade progressed, the figure was introduced (through pale wax limbs and torsos but never a body whole) where it had previously only been implied. These body parts carried at first sight a bizarre surreality. But the lingering, accumulative effect of these fragmented figures was one of a tragic melancholy, reflecting not only the devastation of the AIDS epidemic, but also more generally the psychological stresses of familial, gender, racial, and sexual conflict. The most powerful of Gober's 1990's work unshrouds our profound longing for pleasure without danger.

From across the room, *Untitled*, 1997, presents itself quite simply as an old-fashioned suitcase sitting open on the floor.[1] But the bottom of the suitcase has been removed, replaced by a heavy metal grate covering a brick-walled storm drain that drops ten feet beneath the gallery floor. This dark channel ends in a paradoxical, yet miraculous, spectacle: a sunny, seaside tide pool ripples in the breeze and teems with assorted sea life, while the legs of a man holding a baby are barely within view.

Each layer of the sculpture has resonances, within both Gober's world and our own. The suitcase—not a real, readymade one, but an object that Gober sculpted in wood, leather, metal, plastic, and fabric from a childhood memory—speaks of journeys, made out of duty or perhaps just from restlessness. It belongs to someone else, and were it not open, it would be improper to look inside, but

The grate is sturdy, made of heavy bronze, and would be unremarkable, but for the artist's history with waterworks.[2] The genesis of this type of drain grate can be traced back to the late 1980's, when Gober imagined a public sculpture allowing viewers to discover, through the bars of a storm drain in the middle of Manhattan, a daylit but subterranean stream and grassy plot. Such a storm grate was first implemented in a macabre 1993–94 work where one first heard, then viewed, the fast flushing of water over a wax male torso punctuated with a metallic kitchen sink drain.[3] A later double-grate work had beer cans and colored fall leaves sloshing around the bottom, while on the other side of a wall its opposite had a single lost letter floating tragically among the jetsam.[4]

The view through *this* grate, however, offers something wondrous to behold. Gober explains that he had once equated depth with darkness, but a visit to the Maine seacoast overturned this assumption. "Being out in this pristine water landscape . . . I had the kind of simple idea of flipping the project completely."[5]

Gober had framed the majesty of nature within an ambiguous transitional passageway like this in a previous work: a back room/antechamber led to a sun-dappled forest glade in his 1993 project for Dia Center for the Arts.[6] But a tide pool is more than an aquatic alternate given the fact that twice a day the tide pool undergoes dramatic transformation, flushed then drained by a surging sea. Here the emotional threat of being trapped, flooded, and drowned, which was dramatized in earlier work, is replaced by a gentle rippling.

About this work, intended to be more hopeful and optimistic, the artist observes, "My use of water here is connected to its ancient symbolism for life, renewal, and it is coupled with bright, clear daylight."[7]

The figures in this work, too, carry this positive message. Rather than discover someone pinioned prone or the overflow from our garbage bins, we see *upright* figures, an adult man holding a diapered baby. Sharing the wonders of the seashore with a child is a potentially profound experience. Suggesting that the man and the child represent two stages in the mutual cycle of life, Gober sees the figures separate and as one, always coexistent, the child forever a part of the adult.

Peering into the suitcase through the grate and down the drain, with enough maneuvering, we might see our way to a realm where we are better connected with the earth, one where the stages of our lives move in closer rhythm with nature's forces.

—*Dana Friis-Hansen*

1. Though it functions here as an independent sculpture, *Untitled* was originally created as part of an installation at the Los Angeles Museum of Contemporary Art that also included a stairway down which water cascaded, a cement Madonna sculpture pierced by a culvert pipe, and another parallel suitcase. See Paul Schimmel and Hal Foster, *Robert Gober* (Los Angeles: Museum of Contemporary Art, and Zurich, Berlin, and New York: Scalo, 1997) and other articles listed in the artist's bibliography, p. 111.
2. Gober's 1980's sinks, urinals, and basins were especially mute and unusually dry; they lacked faucets, drains, pipes, or any metallic connections to the source that makes a plumbing system functional. Drains did appear—isolated from their porcelain counterparts—in a 1989 cast multiple for wall installations (piercing the wall at the height of the artist's chest) or punctuating wax figures of the early 1990's.
3. *Untitled (Man in Drain)*, 1993–94, was first shown at Paula Cooper Gallery, New York, in spring 1994.
4. *Split Wall with Drains*, 1994–95, at the Museum für Gegenwartskunst, Basel. See "The Law of Indiscretions," pp. 34–35, and "Interview with Robert Gober," p. 131, in Richard Flood, Gary Garrels, and Ann Temkin, *Robert Gober: Sculpture + Drawing* (Minneapolis: Walker Art Center, 1999).
5. Robert Gober, quoted in "Interview with Robert Gober," ibid., p. 136.
6. See Dave Hickey, *Robert Gober* (New York: Dia Center for the Arts, 1993).
7. Robert Gober, telephone conversation with the author, December 13, 1999.

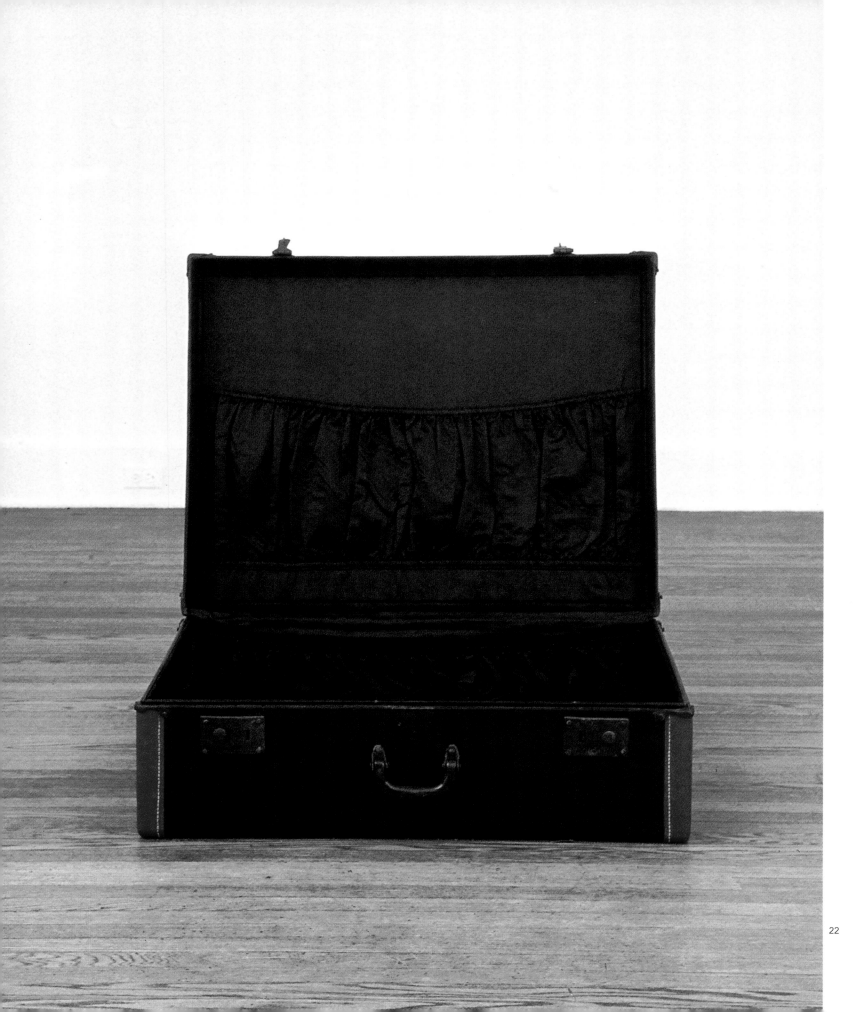

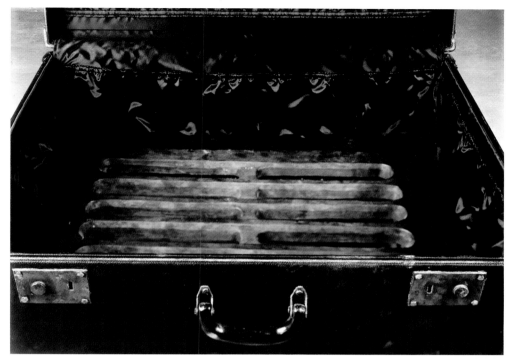

23

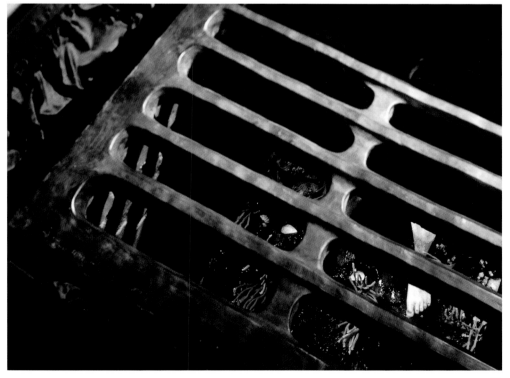

24

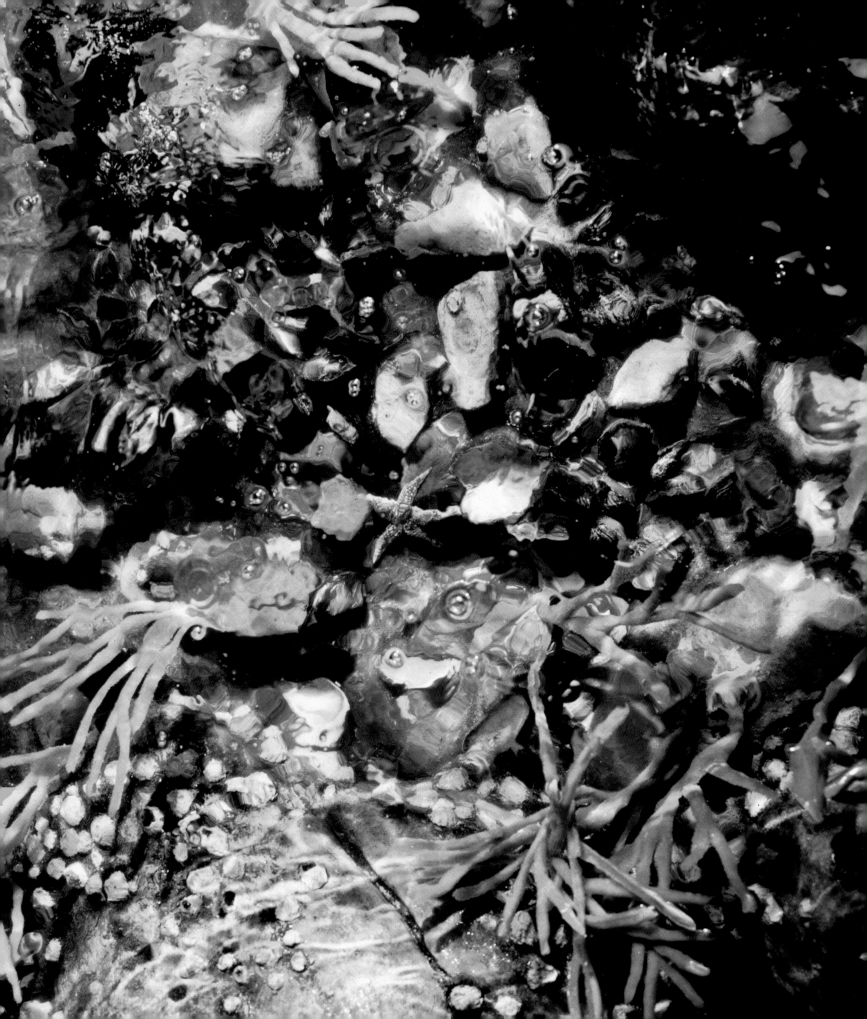

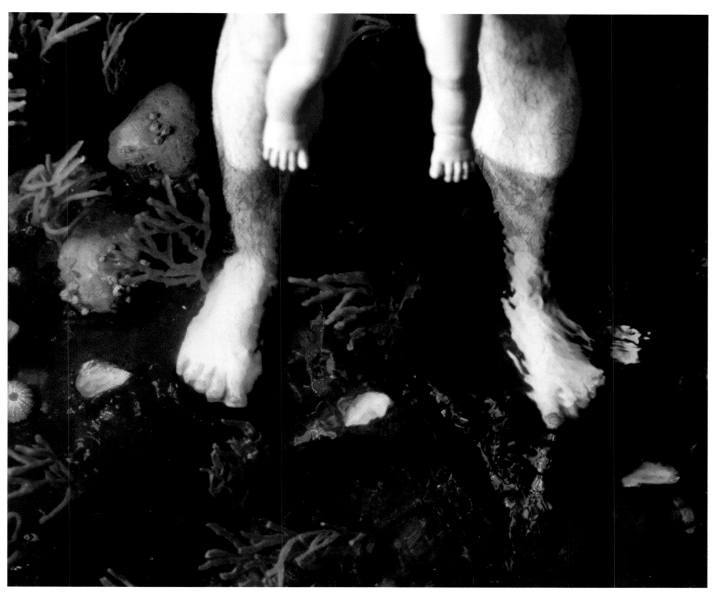

26

25 (opposite)

ANN HAMILTON

27. (left) Ann Hamilton at home making *filament*
(1996), Columbus, Ohio, 1996

28. *filament*, 1996
Installation view, Sean Kelly Gallery, New York
Silk organza curtains, motor, and steel mounts with
electronic controller, video projector and sound
12 feet high; 4½ feet in diameter at top (approxi-
mately 10 feet in diameter when rotating)

29–30. *(bearings)*, 1996
Installation views, *Tenth Biennale of Sydney*, 1996
Two black silk organza curtains with white organza
lining, motor, and steel mounts with electronic
controller
14 feet high; 6 feet in diameter at top (approximately
13 feet in diameter when rotating)
Collection Musée d'art contemporain de Montréal

(bearings)
1996

Over the past decade, we have come to expect Ann Hamilton to take a rather baroque approach to her work. An artist whose avowed intention is to overcome the viewer with a variety of sensations so as to force a pre-intellectual experience, she is perhaps best known for the sixty-plus complicated installations she has made since the mid 1970's. These site-specific installations generally depend to a greater or lesser degree on the architecture of their site and involve arresting visual, audio, olfactory, and palpatory experiences. They are so rich with the sensations produced by her combinations of nontraditional materials that we, as viewers, are forced to slow both the movement of our bodies and the response of our minds while we experience their complicated elements and our dreamlike responses to their multifaceted seduction.

While *(bearings)* does utilize some strategies and materials characteristic of her installations, its simple, elegant and discrete presence signaled a new approach by the artist to her practice. She has said that *(bearings)* benefited from a new freedom she had given herself when she discovered elements usually associated with her installations "falling away for some pieces" And when *(bearings)'* "sense of euphoria and lightness" achieved a power allowing a "suppression of an intellectual pose," when she felt its "movement and scale to be exactly right [as an] object in space," she decided to let it ". . . be the Sufi Spinner."[1]

Certainly, Hamilton's practice has been characterized by the use of fabric (her undergraduate degree is in textile design), and many writers have referred to its associations with "women's work." Yet there is something quite transformative about her use of black over white organza in *(bearings)*. The sheer scale, these transparent fabrics which, we experience as skirt, curtain and veil (hiding what? enveloping what?), their soft but powerful presence, their sense of mysterious perfection, and their erratic rotation cause us to become almost painfully aware of ourselves and of our place in time and space. For, as has been often noted, the physical form of Hamilton's work is its meaning.

Described by one writer as a work of "matriarchal majesty,"[2] (and the curtain works were conceived and executed by the artist soon after the birth of her son), *(bearings)'* two identical, graceful, even beautiful, columns—its skirts or curtains or veils of fabric—rotate in place, spinning themselves out to almost double their resting diameter. A split in each "skirt" invites us to enter their interior spaces but to do so takes a distinct act of will.

While *(bearings)* is a discrete work of art, it does have antecedents in Hamilton's installations that include text, sound, smell, video, the architecture of the site, and often implied or overt narratives. What the artist and others have termed the "curtain works" began with *mneme*, 1994, a major installation at the Tate Gallery Liverpool for which she curtained a selected space with fabric. In the catalogue accompanying the show, curator Judith Nesbitt wrote, "Beyond this curtain is another, and another, layered veil upon veil, so that in order to pass through, we have to part the curtains with our hands in an act of opening"[3]

Other antecedents include the rotating curtain in *volumen*, an installation for *About Place: Recent Art of the Americas* at The Art Institute of Chicago in 1995, and the huge, motorized, rotating fabric drum in *lumen* at the Institute of Contemporary Art in Philadelphia, also in 1995. And, visitors to her retrospective, *the body and the object*, at the Wexner Center for the Visual Arts in Columbus, Ohio, in 1996, were greeted by *filament*,[4] (pl. 28) a "rotating 20-foot high drapery that spun like a dervish as one entered"[5] the exhibition through it.

Often Hamilton's installations have included a human attendant—a worker—who performs some Sisyphean task. For example, in *kaph*, an installation at the Contemporary Arts Museum in 1998, a laborer removed blue numbers stitched onto silk organza gloves. In *(bearings)*, however, the viewers are the human presence: our entering the slit makes *us* the attendant, and our act of will, act of opening (or not) becomes a component in the emotional and physical construction of the work of art. We become enveloped and immersed by its interior—caught in the same totality of sensation we experience whenever we become participant and performer in Hamilton's work.

The curtains, or skirts, which are the only formal elements of *(bearings)*, divide the surrounding gallery into something similar to our own interior and exterior selves. The skirts' interiors bound and describe a space that is private and distinct from the surrounding public space and their rotation intrudes on and colonizes the surrounding territory. When we act to enter these private realms, we are separated from both the surrounding public space and from other viewers; the experience becomes singular—individual and intimate. When we view them from the outside, their swirling skirts enter our space, intruding on our physicality, making their presence public and self-conscious. These two separate and distinct possibilities of encounter contrast our will and spiritual experience with their dematerialization in our carelessly defined and unstable space. It heightens as well our awareness of time and touch, our social experience of the exhibition, and our presence as individuals. *(bearings)* produces a myriad of meaning from an experience that is far more than visual, making us more aware of the constantly shifting reality in which we live.

—*Marti Mayo*

1. Ann Hamilton, telephone conversation with the author, January 3, 2000.
2. Paul Krainak, "the body and the object," *Afterimage* (January–February 1997), p. 20.
3. Judith Nesbitt, *mneme* (London: Tate Gallery Publications, 1994), p. 31.
4. This curtain was first included in the installation, *filament*, at Sean Kelly Gallery, New York.
5. Krainak, p. 20.

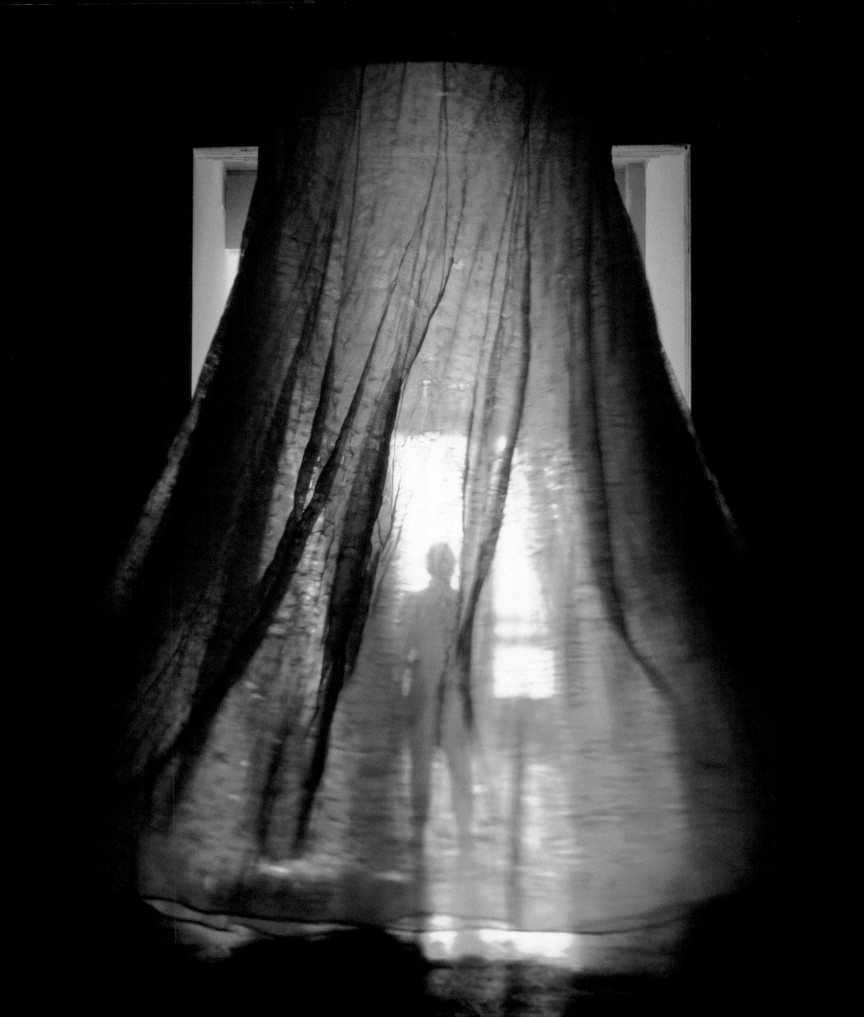

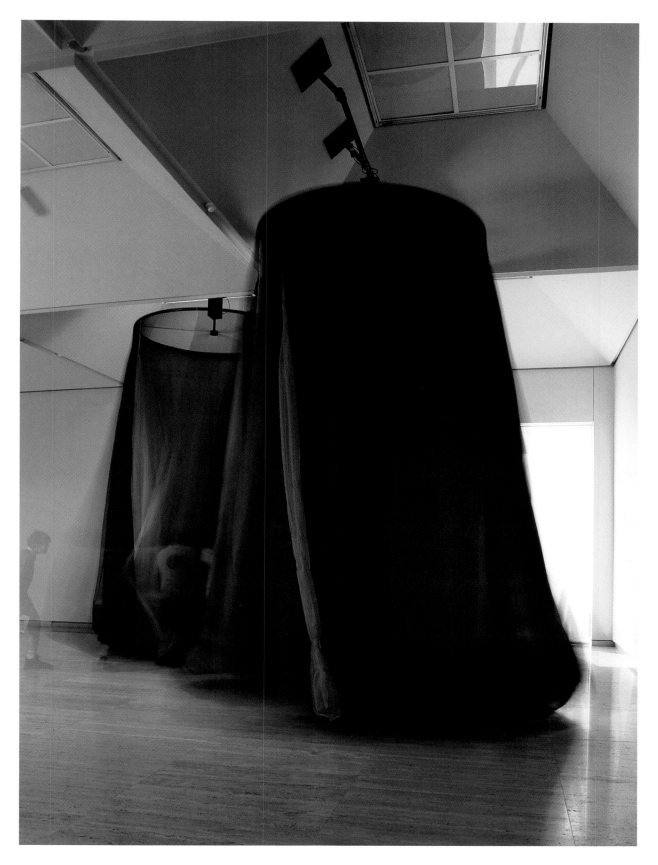

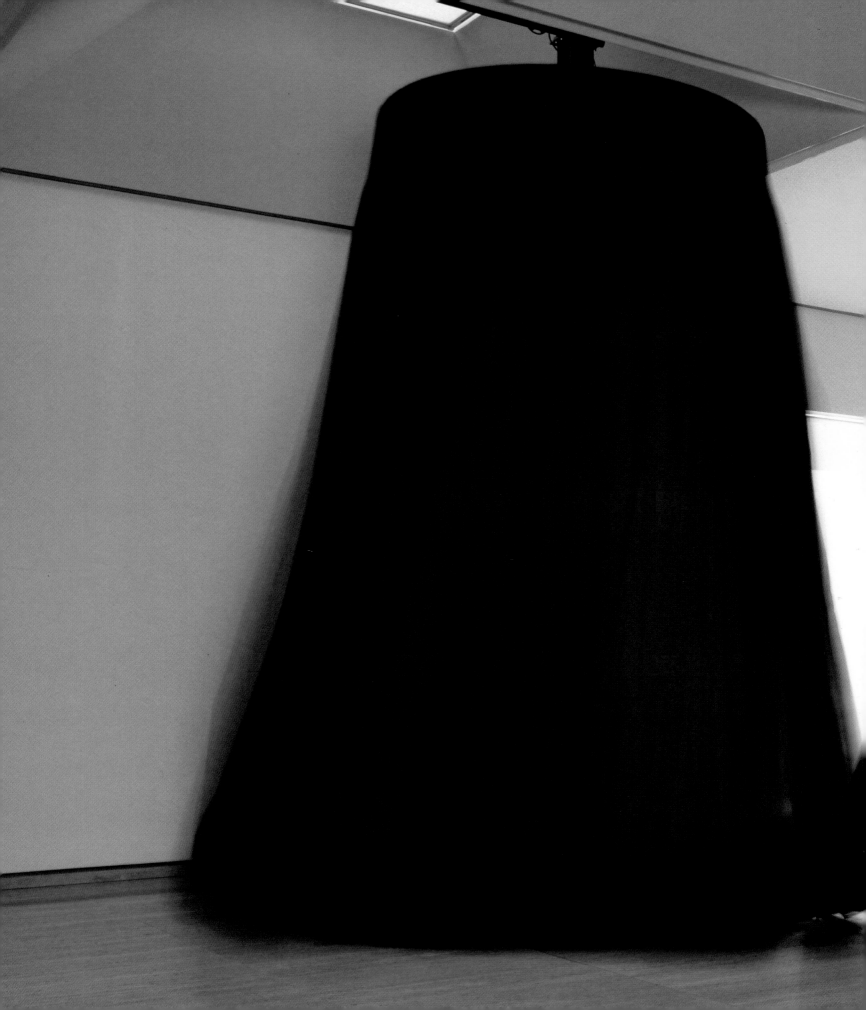

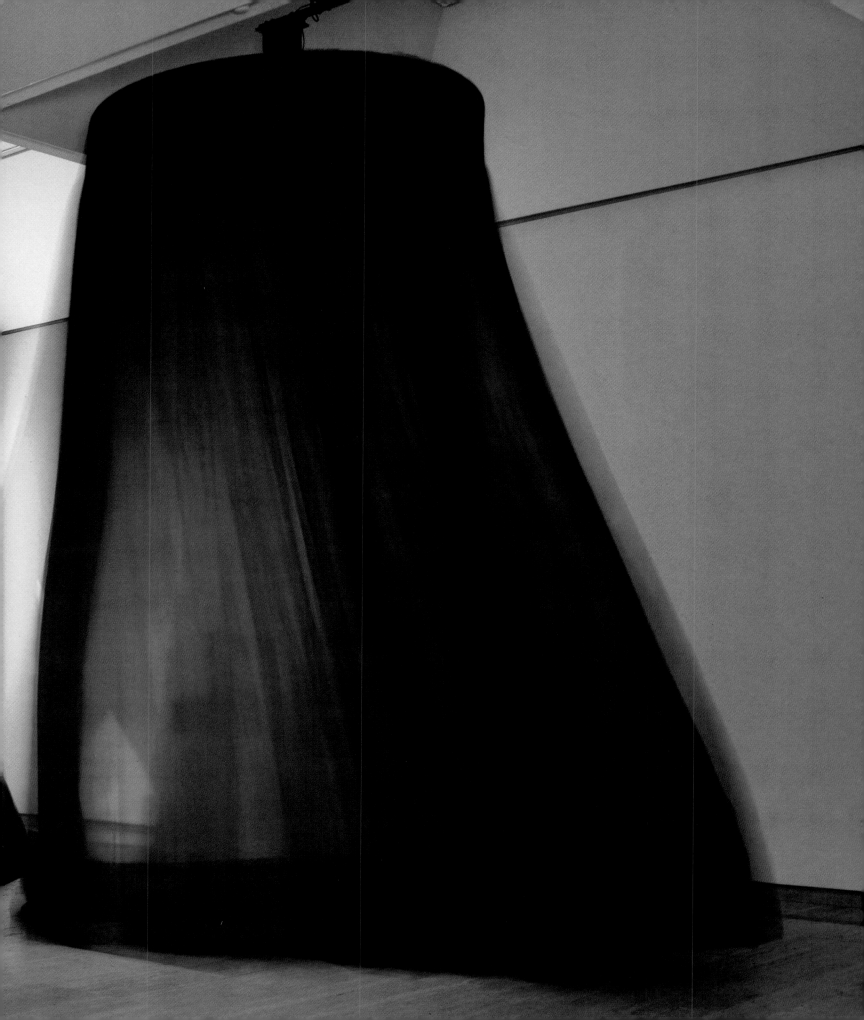

JIM HODGES

31. (left) Jim Hodges making *No Betweens* (1996), Spokane, Washington, 1996

32–33. Jim Hodges with The Fabric Workshop and Museum, Philadelphia
You, 1997
Silk flowers and thread
16 x 14 feet
Collection The Fabric Workshop and Museum, Philadelphia

You
1997

Jim Hodges is unabashedly dedicated to connecting with viewers on an instinctual, emotional, and even sentimental level, and his earnest sincerity has been responsible in part for broadening the arena for personal expression and so shifting the aesthetic "rules" of the 1990's. Trained as a painter but disillusioned with that medium, Hodges makes objects and installations from pedestrian, ephemeral, and unassuming materials, including tar paper and duct tape, paper napkins, jewelry chain, mirrors, colored pencils, light bulbs, and silk flowers. Many small, intimate gestures are collected, then amplified into larger statements to bring issues of beauty, high and low culture, the use of non-art materials, and attention to craftsmanship out into the open.

It is with his dissected petals and blossoms of factory-fabricated decorative flowers that Hodges has made his largest and most memorable statements to date. The first works took the form of wall installations, with petals pinned up like butterflies to form delicate splashes of color. For more dramatic works, including *You*, 1997, thousands of blossoms were sewn together to create curtains that drop from the ceiling to the floor. With both series, the starting point was a fragment of an artificial flower, which Hodges mines for rich metaphors. In life and art, flowers can celebrate spring, the senses, love, hope, and achievement, as well as transience, vulnerability, and death. But the fabric facsimiles that Hodges chooses to use provide much that a natural blossom cannot, including stems that won't wilt, color that won't fade, and softness that dries up and hardens, thus successfully evading—or purposefully denying—the underside of a flower's metaphorical range: pre-

carious perfection and short-lived beauty. And yet the very permanence of these flowers seems to call attention to loss and absence, especially that following the AIDS pandemic.

The conceptual roots of Hodges' flower curtains lie in his *A Diary of Flowers*, 1993–96, a set of 565 diversely styled ballpoint pen doodles on coffee shop napkins pinned casually to the gallery wall, and in *A Possible Cloud*, 1993, a sculptural sweep of gauze into which small flowers have been sewn. That first work with fabric, produced in collaboration with his mother, led to an invitation from The Fabric Workshop and Museum, an innovative organization in Philadelphia dedicated to helping artists use fabric as a material and metaphor in new ways for new works. There Hodges worked with a technician and various craftspeople to establish a process and produce the first curtain work, *Every Touch*, 1995, which quickly entered the collection of the Philadelphia Museum of Art. Ten curtains form the series to which *You* belongs; the first are randomly colored fields of flowers; in the middle was *You* (created expressly for the collection of The Fabric Workshop on a return visit), which is primarily white with splashes of color; then there are other monochromes in yellow, pink, and black. There is certainly a painterly aspect to these works, which recall moments from Modernism's most important abstract paintings, from Claude Monet's monumental Impressionist waterlilies to Jackson Pollock's drip paintings. We are invited to both *see* and *see through* these works; as discrete objects, they have further art historical connections to Eva Hesse's hanging nets, although their installation approach links them more perhaps to Robert Irwin's scrims. In this one series, Hodges succeeds in pushing for-

ward formal issues from several threads of art history at once.

In discussing these works, however, Hodges stresses the viewer's physical and emotional experience. "For any viewer, these pieces function architecturally. They act like *real* curtains; they create a 'here' and a 'there.'"[1] This is confirmed by titles in the series addressing issues of space or place or time, such as *Already Here, Already There*, 1995; *From Our Side*, 1995; *No Betweens*, 1996; or *The End From Where You Are*, 1999. But with these veils of flowers, "hard" architecture is neither created nor sought, but instead *relations* are predominant—the expression of physical, visual, and metaphorical situations or points of view. In his already metaphorically charged materials, Hodges finds inherent physical characteristics that extend the relational content further: the work's flexibility provides subtle and unpredictable movement in space, and the lack of a clear front or back defies hierarchy. Stitched together from bits and pieces of petals and stems, the curtains' loose construction makes them even more ephemeral, spectral, and evasive—or as the artist confesses about their beauty, "half of it is air, merely blank space."[2]

Hodges has always been interested in that which divides and that which connects—and how we perceive and respond to these in-between spaces. "This title, *You*, points a finger at the viewer and is the only title in the series which brings the emphasis back to the viewer."[3] Something so beautiful, so quietly sublime, should not be left to separate us, so it must have been made to bring us together.

—*Dana Friis-Hansen*

1. Jim Hodges, telephone conversation with the author, December 27, 1999.
2. Ibid.
3. Ibid.

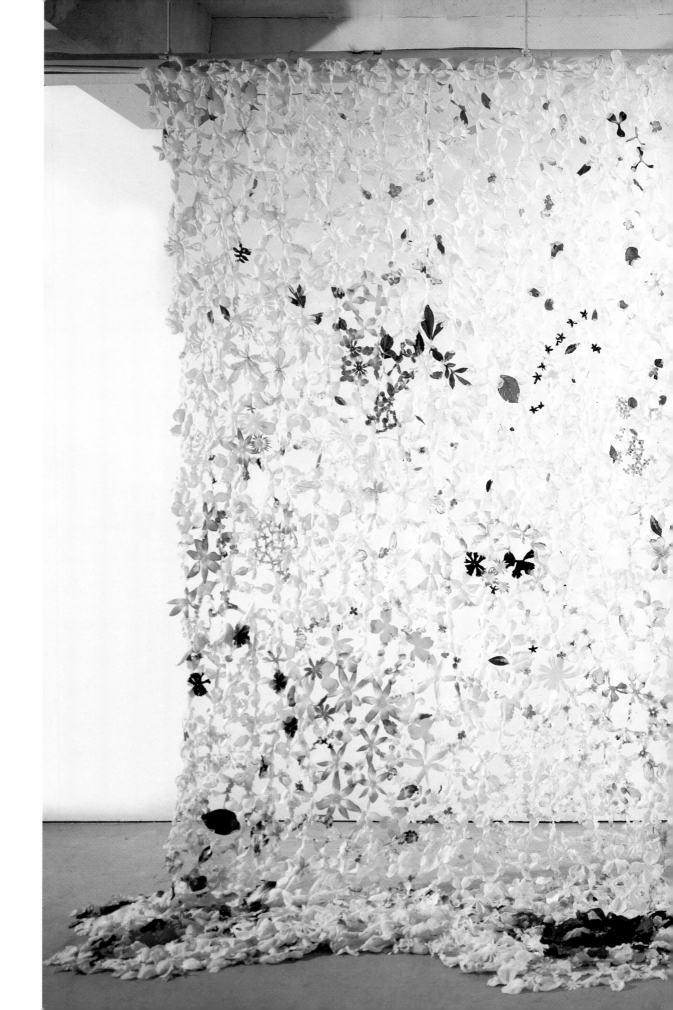

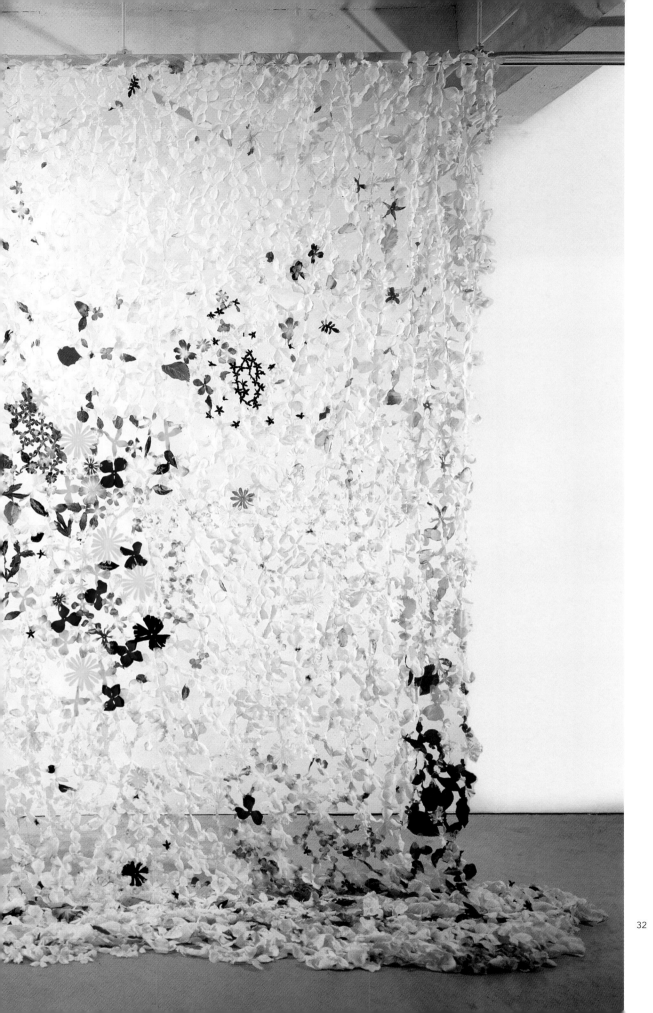

32 33 (pp. 50–51)

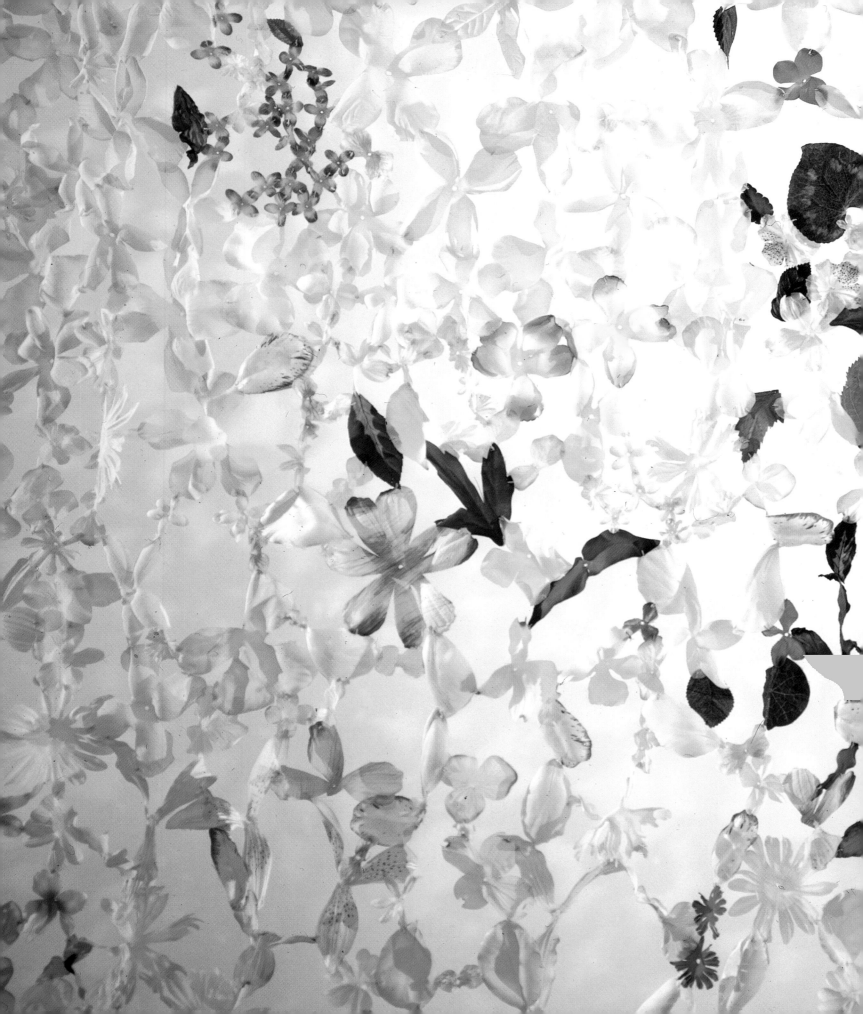

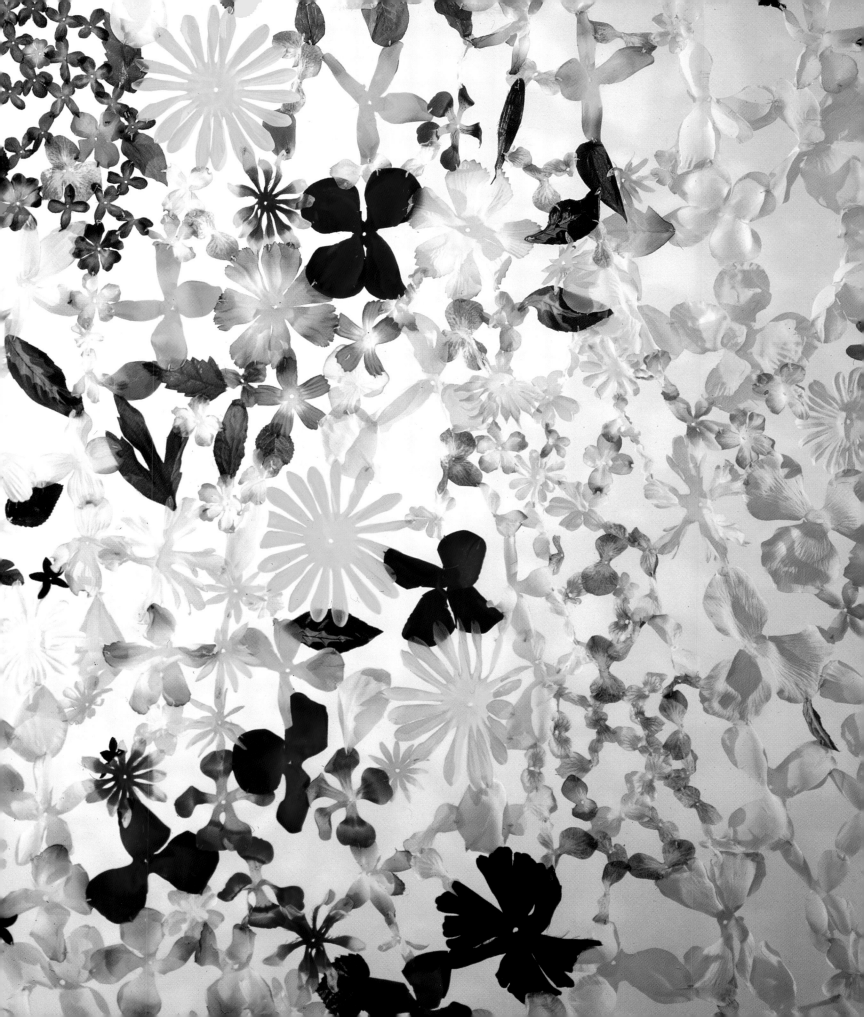

WILLIAM KENTRIDGE

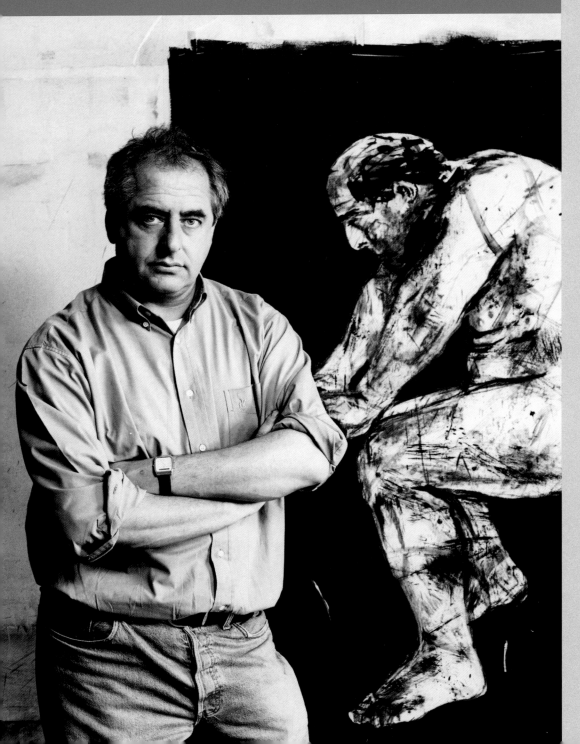

34. (left) William Kentridge in his studio, Johannesburg, 1997

35, 37, 38, 46. Drawings from *History of the Main Complaint*, 1996
Charcoal and pastel on paper
35. *Title Page*, 23⅝ x 48 inches
37. *X-ray, Typewriter*, 41¾ x 29½ inches
38. *Consultation*, 48 x 63 inches
46. *Private Ward*, 39⅜ x 48 inches
Courtesy the artist and The Goodman Gallery, Johannesburg

36, 39–45. Stills from *History of the Main Complaint*, 1996
Video and sound installation
Courtesy the artist and Marian Goodman Gallery, New York

History of the Main Complaint
1996

When *History of the Main Complaint* was presented in 1997 at *Documenta X*, a large-scale international exhibition for contemporary art, it stood out as an intensely original, personal, and engaging work. It also introduced William Kentridge, an artist from South Africa, to a much larger audience. With hundreds of other works demanding their attention, viewers still jammed into the small viewing room, watched Kentridge's short animated film, and then lingered on, finding it hard to tear themselves away. Approaching his subject with great pathos, Kentridge explores in his work what it is to live in a compromised society, with particular focus on the legacy of apartheid.

History, memory, guilt, and accountability are themes that weave through Kentridge's work, but as the artist has said, the starting point for him has always been "the desire to draw."[1] Kentridge's unique drawing style is a contemporary extension of an older European humanist tradition. He has found inspiration in the work of such artists as George Grosz, Otto Dix, and Max Beckmann, who depicted the horrors and excesses of early twentieth-century German life; Francisco de Goya and William Hogarth, who created serials that examined the follies and cruelties of their times, have also been influential.[2] *History of the Main Complaint* is the sixth film in Kentridge's own ongoing serial about Soho Eckstein, a voracious South African industrialist with a heavily burdened conscience, and his alter-ego, Felix Teitlebaum, a more sympathetic, anxious soul. Kentridge's making of the film coincided with the painful national catharsis of South Africa's public hearings held by its Truth and Reconciliation Commission into human rights abuses during apartheid. During those hearings, perpetrators as well as victims were called upon to publicly relive their stories.

In *History of the Main Complaint*, we find Soho in the hospital in a coma, wrestling with his own personal story. His medical team, a collective composed of Soho look-alikes in pinstripe suits, is searching for the root of Soho's ailment, or "complaint." Through assorted diagnostic equipment, we look "inside" Soho and take inventory. X-rays reveal an array of business accoutrements such as a typewriter and hole puncher as integral to Soho's being. And through a sonogram screen-cum-car windshield, we relive two events that occurred while Soho was driving in the countryside. In one reenactment, Soho witnesses a man being brutally beaten in the middle of the road. In another, a man suddenly runs in front of Soho's car and is killed. The rear-view mirror doesn't reflect Soho's cold eyes, but rather Felix's more empathetic ones.

There is an entrancing immediacy to Kentridge's expressionistic style: his use of large pieces of charcoal gives his drawings a distinctively open and gestural look. The artist's presence is further felt by the smudges and erasures that allude to his alterations of these drawings for successive filming. This film was made from approximately twenty drawings that Kentridge repeatedly altered and then filmed using frame-based animation techniques including dissolves, pans, and zooms. Kentridge's fluid, lyrical style also lends itself to the many surrealistic metamorphoses that occur throughout the film, leading from one idea to the next: the typewriter clacking inside Soho generates red "X's" that come to mark points of impact on Soho, on the various victims of assault, and even on the abused South African landscape.

It is the revelation that he has inadvertently killed someone in a car accident that finally awakens Soho from his coma. The collective guilt generated by witnessing a beating firsthand, albeit through the filter of a windshield, is not enough to rouse him. It is the car accident that brings him to the hospital and that has aroused his conscience. Does this witness *and* perpetrator display remorse or accept accountability? The curtains surrounding Soho's hospital bed open, and we discover that he is already back in his office running his empire.

The air of nostalgic authenticity in this short charcoal animation, full of dated equipment and human frailties, is further heightened by its evocative musical score: Claudio Monteverdi's seventeenth-century madrigal *Ardo*. Translated from Italian, *ardo* means "I burn" or "I am consumed," and the music opens the door to a sympathetic, tender reading of Soho and his moral struggle, reminding us that he is human, imperfect, and compromised. Soho and Felix are both created in the likeness of the artist, and in them we also find elements of ourselves. A melancholia pervades Kentridge's work, one befitting his examination of the darker side of humanity. And yet the works always seem to move forward, to forge ahead in spite of everything. After viewing *History of the Main Complaint*, we find ourselves committed to following Soho's path, hoping for his atonement as well as our own.

—*Lynn M. Herbert*

1. William Kentridge, "Interview: Carolyn Christov-Bakargiev in Conversation with William Kentridge," *William Kentridge* (London: Phaidon, 1999), p. 8.
2. Francisco de Goya's *Los caprichos* (1796–98) examined the follies of Spanish court life and his *Disasters of War* (1810–14) chronicled the horrors of the Napoleonic occupation. William Hogarth's moral narratives about contemporary life in England include *The Rake's Progress* (1735) and *Industry and Idleness* (1747).

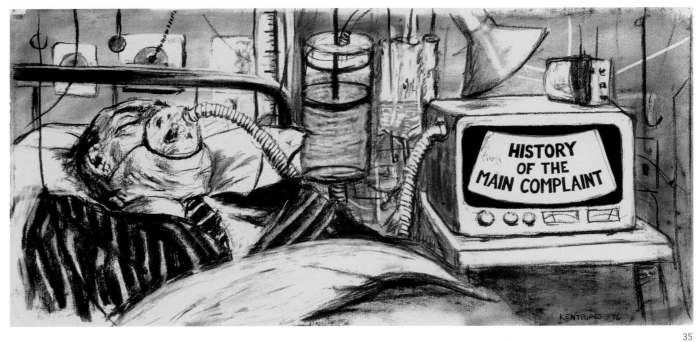

35

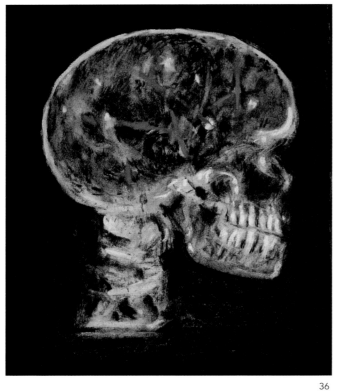

36

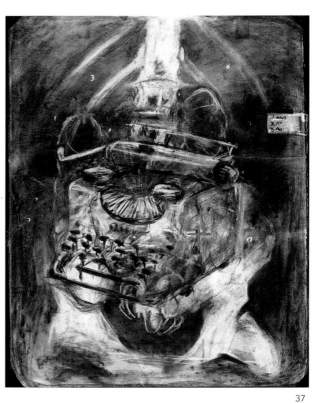

37

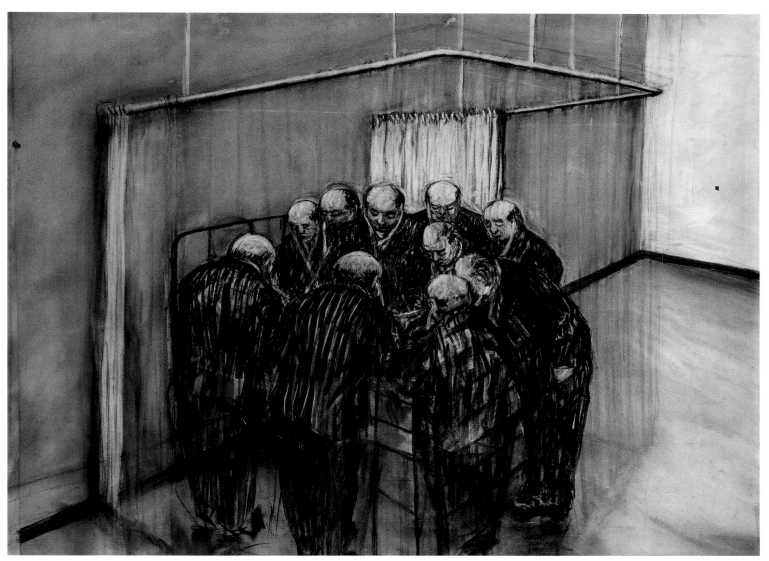

38

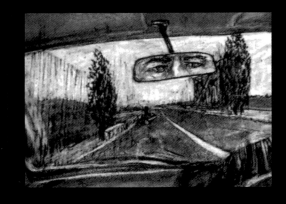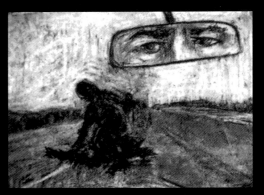

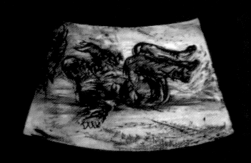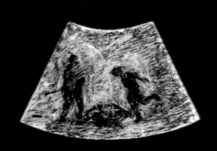

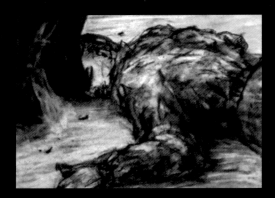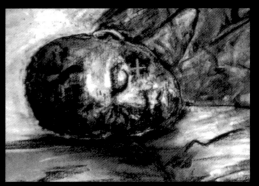

39–44

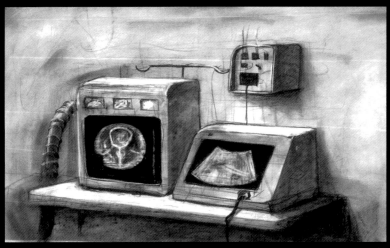

45

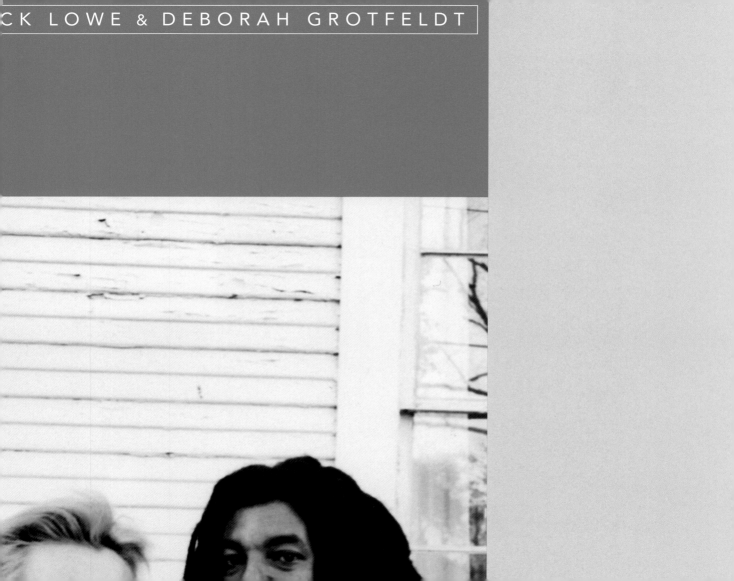

Sharing the Wealth
1999–2000

Art's civic influence has played a fundamental role in the Western world, reflecting the dialogue that artists, to different degrees, entertain with the natural, urban, and social environment in which they live. Artist Rick Lowe has made this dialogue the focus of his work and has directed his innovative and engaged creativity toward the city of Houston and one of its poorest African-American neighborhoods, called the Third Ward. Here, in 1992, Lowe founded *Project Row Houses* (*PRH*), a truly successful convergence of public art and community commitment (p. 11). Deborah Grotfeldt has collaborated with Lowe since the project's inception as *PRH*'s executive director. She now directs the Project Row Houses Foundation.

Relying on funds and resources gathered from private and public donors, and the enthusiastic support of many artists, community residents, and volunteers from all backgrounds, Lowe and Grotfeldt restored an abandoned stretch of twenty-two shotgun houses—modest yet historically significant dwellings in a southern vernacular architectural style. The buildings are now the center of a full schedule of activities that include exhibitions introducing national and international artists to the neighborhood and the city; interdisciplinary art and multi media programs for elementary and middle-school students; and housing and counseling for young single mothers.

Lowe describes *PRH* as a community development project with broader implications than the conventional, primarily economic ones: it is at once public art, historic preservation, and a conduit for community services.[1] With this unique convergence of practices, *PRH* aims to redress poverty and restore empowerment among the local residents by stressing the importance of both family and creativity, unifying the two drives through a unique vision of community revitalization. *PRH* has confronted the issue of the rehabilitation of inner-city neighborhoods directly by starting with the symbolic function of the local architecture, imbued with the memories and lives of the Third Ward's residents. In *PRH*, Lowe and Grotfeldt have cultivated latent meanings coded within the neighborhood itself, particularly the sense of group identity and subjective feelings of belonging.

This singular vision has proved to be a winning one. *PRH* keeps expanding within the Third Ward with the donation of more historical buildings to be devoted to additional activities—such as the 1940's "Eldorado Ballroom" to be used for jazz, blues, and hip hop performances. *PRH* has received national and international recognition, and it provokes daily interest, debate, and involvement from Houstonians. As visitors to its art spaces, we find ourselves moving between a public space (the neighborhood, the street) and a private one (an artist's exhibition inside one of the houses) in a way that makes both experiences become interchangeable and mutually enlightening.

Sharing the Wealth, a work Lowe and Grotfeldt developed especially for *Outbound*, emphasizes the need for a closer relationship between a museum and its city. The work takes place both in the Contemporary Arts Museum's gallery and in Third Ward dwellings. Stationed at the museum throughout the time of the exhibition, the artists are using their part of the gallery as temporary office to answer questions from the public about *PRH* and to encourage volunteer activities related to *Sharing the Wealth*. A real-time website link connects this office to the Third Ward, portions of which are illustrated on collaged photographs and blown-up wall maps highlighting the locations of *PRH* buildings.[2] The website documents the ongoing developments at one of *PRH*'s sites where, with the help of volunteers and using a design developed by architecture students from the University of Virginia, six newly acquired buildings are being restored by high school students from various parts of Houston. The students will then name the new facilities and devise an artistic mission that will guide their organization and implementation of an exhibition program there.

While introducing the viewer to *PRH*'s vigorous educational focus, *Sharing the Wealth* also makes a connection between two neighborhoods that are socially but not geographically far apart: the Third Ward and the wealthy residential neighborhood that forms Houston's museum district. Even as the high school students look to the museum as an accepted cultural model to be observed, emulated, and questioned, viewers are being introduced to and invited to take part in the ideas and creative energies developed outside of it in another part of the city. At the museum, *Sharing the Wealth* also includes photographic portraits of and statements from the Third Ward's residents and others who have been active in shaping *PRH* (pl. 49). One meaning of the "wealth" to which the work's title refers derives from these same individuals, those whom Lowe and Grotfeldt define as their audience. *Sharing the Wealth* also acknowledges the museum's viewers' contribution, but asks us to question how effective this and other museums have been in linking their own contributions to the wider cultural and social fabric of the entire city in which they operate.

PRH has redefined the very meaning of being an artist today: Lowe and Grotfeldt believe that artistic discipline helps people find their place—as opposed to urban developers who displace people. *Sharing the Wealth* takes this view to an established institution. It points out how an exhibition begins with the artists themselves, whose work springs from the place in which they live. Challenging the accepted methods of artistic practice, *PRH* invites museums to fuel their own operation with this direct exposure to life.

—*Paola Morsiani*

1. Rick Lowe, unpublished notes on *Project Row Houses* and in conversation with the author, October 25, 1999.
2. The website can be found on *PRH*'s web page at <http://www.NeoSoft.com/~prh/>.

I think education is key. I would like to see art used as an educational tool to bridge the gap between the elders and young children. We can come up with projects that involve both young and old that promote unity that also educates.

—Joseph Dixon

I hope for the best for our neighborhood. I want it to get better than what it is. I'd like to see it built up, more people, and see people helping clean the neighborhood up.

—Mr. Lee Hooper

Togetherness! I'd just like to see us all come together.

—Mrs. Hooper

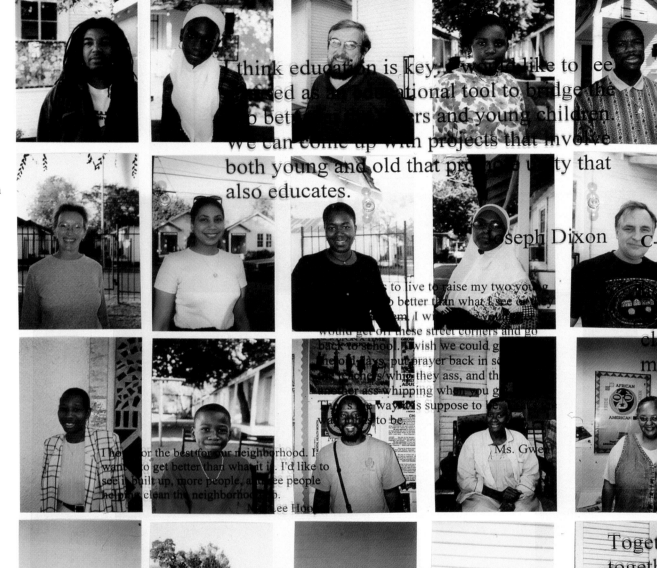

My dream is to live to raise my two young children to do better than what I see or they see around them. I wish these youngsters would get off these street corners and go back to school. I wish we could go back to the old days, put prayer back in schools, let the teachers whip their ass, and then you get another ass whipping when you get home. That's the way it is supposed to be. That's the way it has to be.

—Ms. Gwen

c-o-m-m-u-n-i-t-y c-o-m-m-u-n-i-t-y
My hope is to better myself to be better able to help the community. My dream is that each community center would come together to clean up a block in the neighborhoods each month. It will pull us closer together.

—Kenya Shabazz

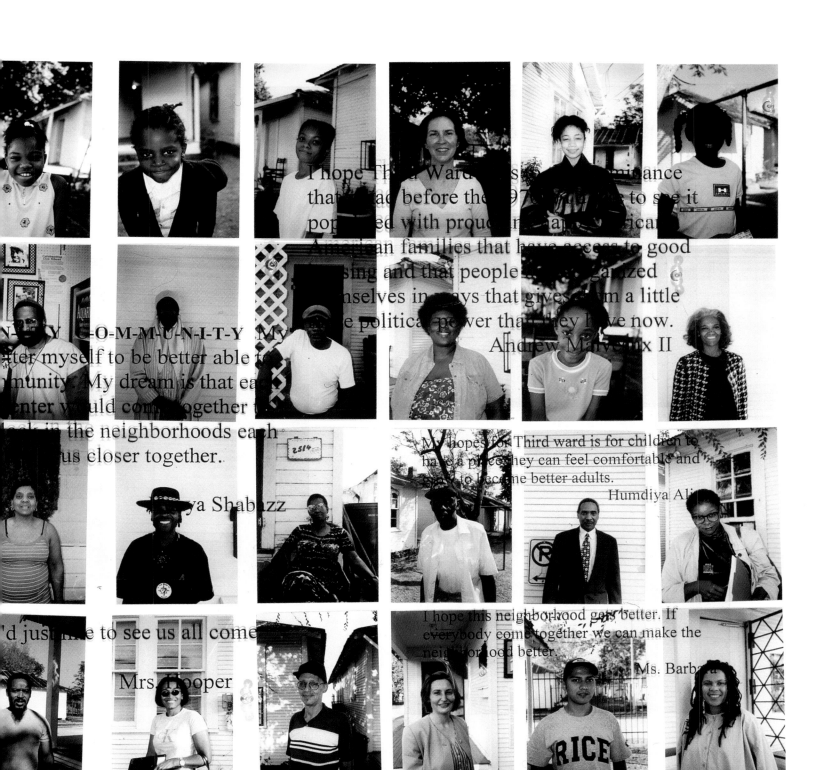

My hopes for Third Ward are for children to have a place where they can feel comfortable and grow to become better adults.
—Humdiya Ali

I hope this neighborhood gets better. If everybody comes together we can make the neighborhood better.
—Ms. Barbara

I hope Third Ward rises to the prominence that it had before the 1970's. I'd like to see it populated with proud and happy African-American families that have access to good housing and for people to organize themselves in ways that give them a little more political power than they have now.
—Andrew Malveaux II

SHIRIN NESHAT

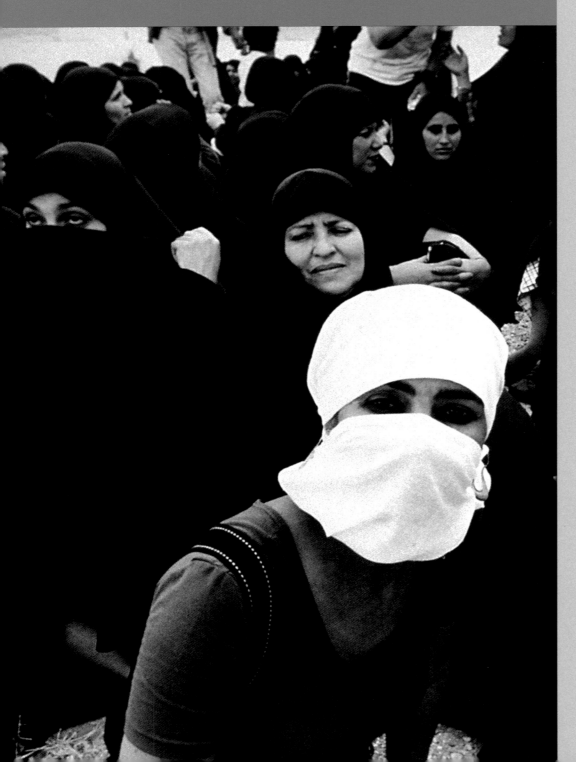

50. (left, foreground) Shirin Neshat during the
production of *Rapture*, Morocco, 1998

51–56. Stills from *Rapture*, 1999
Video and sound installation
Courtesy the artist and Barbara Gladstone Gallery,
New York

Rapture
1999

Shirin Neshat's *Rapture* draws viewers into a transcendent realm brimming with metaphor. The work emanates from an artist in exile coming to terms with the social, political, and spiritual upheavals that have engulfed her homeland. Its roots are in keeping with much of the sociopolitically motivated art made during the 1990's, but *Rapture* goes beyond that specificity. With its epic grandeur, it carries away all who come upon it, whether they know anything about the Islamic revolution in Iran and its ramifications or not. Poetic, universal, and open-ended, it is a meditation that addresses our essential human nature.

Upon entering the installation's darkened room, the viewer immediately becomes a player in *Rapture*, poised between two black-and-white videos projected on opposite walls. To one side, 125 men in black pants and white shirts wind their way through an ancient seaside fortress, taking part in assorted group rituals along the way. Across the room, an equal number of women in black chadors approach the viewer from a distance, making their way through a vast and windy desert wilderness. Sussan Deyhim's charged score of clacking percussion reaches a climax when the women gather in the foreground and begin to ullulate, stopping the men dead in their tracks. Frozen, the two groups gaze at one another across the room. The women then turn and determinedly continue across the harsh terrain toward a nearby shoreline as Deyhim's score of primal emotive utterances follows their movements. The men go back to their rituals and eventually make their way to the ramparts of the fortress where they begin to take note of the women, who have reached the shore and are engaged in dragging an unwieldy wooden vessel across the sand to the water. Six of the women climb into the boat and drift out to sea with the men watching and ultimately waving from the ramparts. This majestic and mysterious fable comes to a close without a word having been spoken.

When Neshat first returned to Iran in 1990 after the revolution of 1978, she found herself both frightened and excited by the ideology that had gripped her country.[1] The visit led her to embark on a series of photographs and films addressing what it is to be a woman in Islam: "I found them [women] to be the most potent subject, in terms of how the social and political changes caused by the revolution affected their lives, how they embodied this new ideology, and how they were managing to survive the changes."[2] From the outset, Neshat made a conscious decision to examine the situation from different points of view, embracing its full complexity.

Neshat carefully choreographed and directed *Rapture* so as to encompass this complexity. Sussan Deyhim shares Neshat's interest in the ancient and traditional, as well as her desire to contemporize and universalize her subjects and the powerful and mesmerizing blend of old and new in her score for *Rapture* becomes an integral part of the work. Neshat's choice of black-and-white film ascribes a certain fundamentality to the work, eliminating real-world distractions that come with color. And there are no individuals in *Rapture*, only two gender groupings, each uniformly dressed. Using long shots and aerial views to look down over her collective "man" and "woman," Neshat allows us to draw larger truths. Yet as viewers observing this dynamic from a pseudo "middle ground" between the two projections, looking back and forth from left to right, we come to realize that each time we view this work, we will literally and figuratively be seeing it in a different way—exposing a complex ambiguity behind the collective truth.

Pared down to its essentials, Neshat's realm is one that both perpetuates and challenges our myriad assumptions and associations. The men move in an ordered authoritarian environment, the fortress, a seemingly indomitable architectural element imposed upon the landscape. The veiled women, on the other hand, inhabit the unforgiving wilds of nature, subject to its whims and hardships. And yet the fortress is a ruin, outdated and irrelevant, while the veils, often viewed by Westerners as repressive, seem to protect and empower the women. They move about resolutely, as if guided by a mission, while the men go around in circles, trapped within their fortress walls. Walls and veils, two commanding symbolic barriers in Islamic culture, come up against one another in *Rapture*, and then seem miraculously to dissolve away. Ironically, the women adrift at sea appear to know exactly where they are going while the men, safely ensconced in their fortress, seem lost. In this epic allegory, we are the raptured ones, carried away by Neshat's cinematic poem of tradition, evolution, epiphany, and ultimately destiny.

—*Lynn M. Herbert*

1. Lina Bertucci, "Shirin Neshat: Eastern Values," *Flash Art* (November–December 1997), p. 86.
2. Shirin Neshat quoted in Octavio Zaya, "Shirin Neshat," *Interview* (September 1999), p. 165.

51, 52 (pp. 66–67)

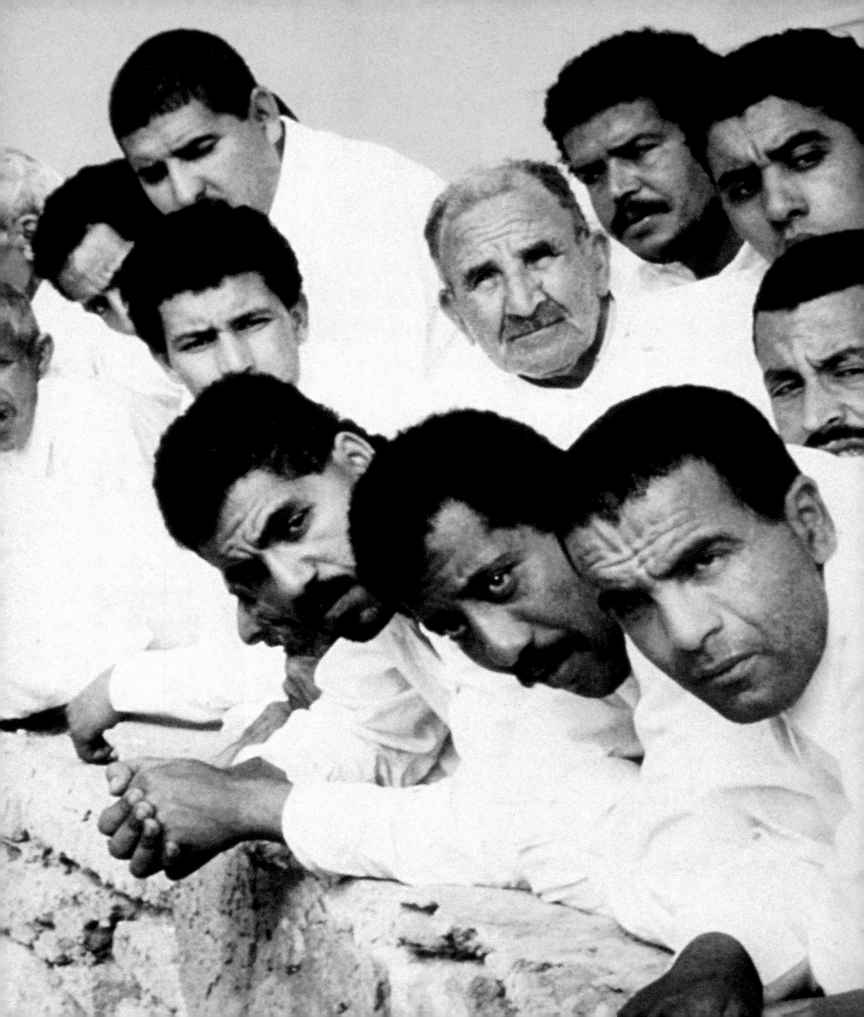

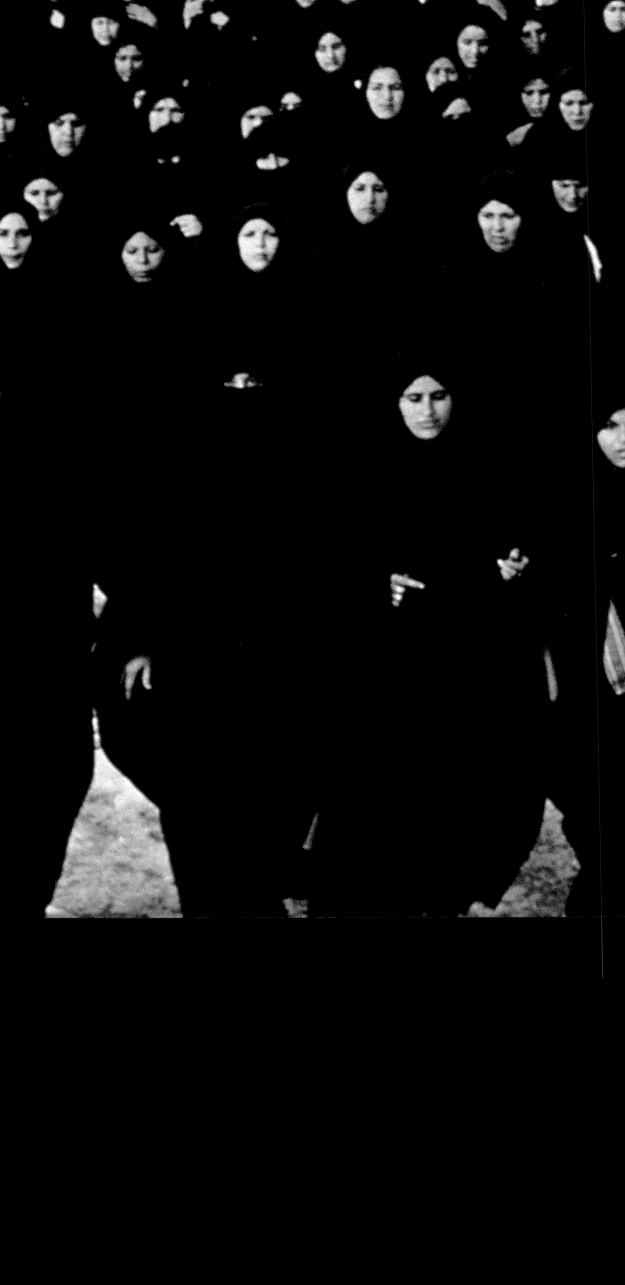

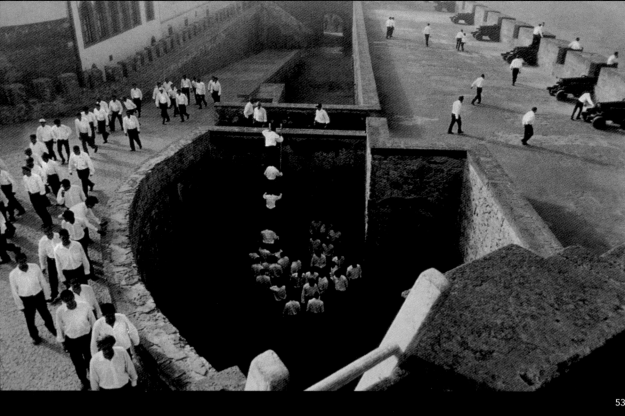

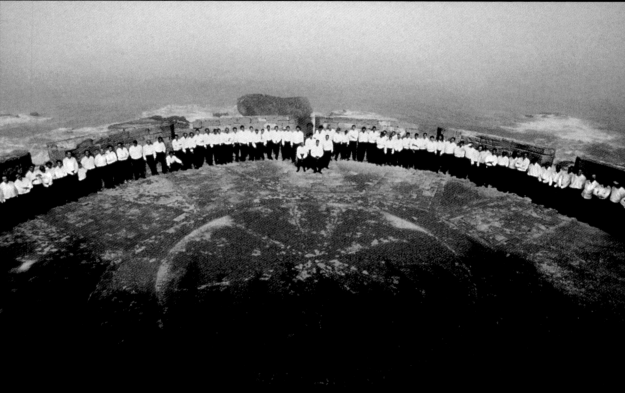

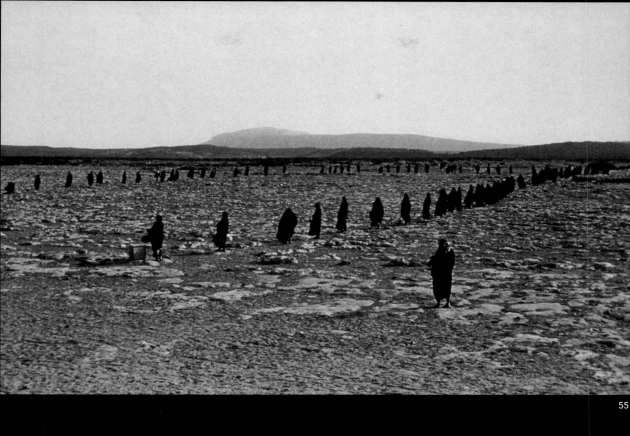

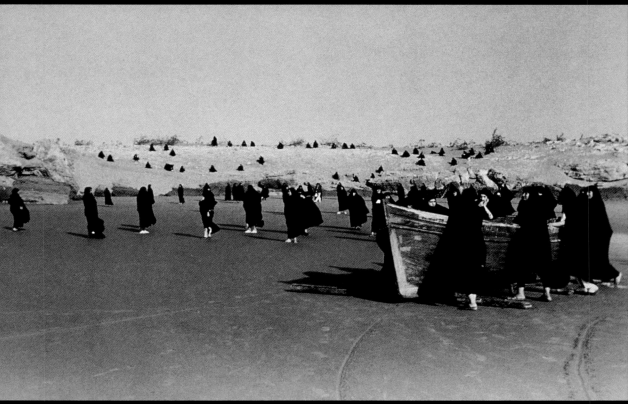

57. (left) Fred Wilson giving the gallery talk *My Life as a Dog* at the Whitney Museum of American Art, New York, on December 8, 1991

58. *Guarded View*, 1991
Installation view, *Primitivism: High and Low*,
Metro Pictures, New York, 1991
Wood, paint, steel, and fabric
6¼ x 4 x 13⅞ feet
Whitney Museum of American Art, New York;
Gift of the Peter Norton Family Foundation

59–62. *Guarded View*, 1991 (details)

63. *Guarded View*, 1991 (detail, without pedestal)

Guarded View
1991

On December 8, 1991, Fred Wilson gave a gallery talk at the Whitney Museum of American Art in New York.[1] He greeted his audience in the lobby and had lunch with them in the museum's restaurant. He then excused himself, saying that he needed to change into a costume and that they should meet him upstairs at the entrance to the exhibition for his gallery talk. Wilson changed into a Whitney guard's uniform and stood in the gallery where he was to meet his group, waiting next to a sign with his name on it that marked the point where the tour was to begin. Though they looked for him, no one "saw" Wilson. The artist's worst suspicions were confirmed—as a museum guard, he had become invisible. Wilson eventually revealed himself to his audience and proceeded to give his gallery talk (pl. 57).

Earlier that same year, in the spring of 1991, Wilson had presented a two-part exhibition at Metro Pictures and Gracie Mansion galleries in New York. For these exhibitions, Wilson created a series of faux museum installations that addressed cultural exploitation and the underlying racism in museums. Utilizing such tools of the trade as pedestals, vitrines, and wall labels, Wilson demonstrated how ethnographic art, when removed from its proper context, wrenched away from everything that shaped its origins, is essentially neutralized. For example, in *Friendly Natives*, skeletons are laid out for view in Victorian-style mahogany vitrines with such labels as "Someone's Mother," and "Someone's Sister."

With *Guarded View*, Wilson came at museum racism from a different angle. Four mannequins are lined up in a row, displayed together on a pedestal, each wearing, as the labels indicate, the uniform of a different New York museum. From left to right they are: The Jewish Museum, The Metropolitan Museum of Art, the Whitney Museum of American Art, and The Museum of Modern Art.[2] Wilson, who is himself of African-American and Caribbean-Indian descent and grew up in and around New York, is an avid museum-goer and also worked briefly as a museum guard at the Neuberger Museum of Art while he attended the State University of New York. He carried away from the experience a dichotomous sense of both being on display and yet being invisible. Years later, speaking to other artists who had held similar jobs, he heard stories of guards and other museum staff working together for decades without exchanging so much as a hello. Wilson therefore set out to create a work that would make viewers aware of this institutional racism.

The work's classic frontal presentation (similar to what one finds in costume exhibition displays) is the initial hook. Viewers might then dutifully note the different uniform styles and reflect on the different messages each museum has chosen to convey, from the regimental stamp of The Metropolitan to The Modern's more casual blue-blazer look. But this automatic activity is shortlived once we realize that all of the mannequins are dark skinned and headless. Beyond serving simply as commentary on the traditional hierarchies within museum staffs, the work reflects upon us, the museum-goers, and the attitudes that we bring into a museum, especially toward the men and women who protect the works of art we have come to see.

In 1992, one year after he created *Guarded View*, Wilson shook the art world with his landmark exhibition, *Mining the Museum* at the Maryland Historical Society (MHS) in Baltimore. The MHS gave Wilson carte blanche, allowing him to research the Society's collection, its history and its place within the community. Wilson proceeded to reinstall the third floor galleries in a way that revealed the latent racism that existed there. One section entitled *Cabinet Making 1820–1960* had a whipping post installed alongside assorted Victorian chairs. *Metalwork 1723–1880* grouped silver urns and goblets with slave shackles.

Thousands of museum professionals saw the exhibition, and its run was extended by popular demand.[3] With this installation, Wilson brought a fresh eye to the MHS, reconstructed its presentation of Maryland's past in a new, more encompassing manner, and exposed how a seemingly neutral institution might unwittingly reinforce racist attitudes. Since then, Wilson has been invited into museums all around the world to explore their collections and practices and to offer a startling reappraisal through his own reinstallations of their holdings.

As an artist, Wilson has opened our eyes to the wide range of inherent biases within museums, enabling us to see these institutions, their culture, and their many choices in a new light. His delivery is not that of a pedagogue, but more that of a nurturing educator—a role for which he is uniquely qualified having worked as a museum educator at such New York institutions as The Metropolitan Museum of Art, the American Museum of Natural History, and the American Crafts Museum. Although Wilson continues to work today within specific museums and their collections, *Guarded View* remains a seminal work from the days when he pioneered the practice of presenting museums of his own making. In 1997, the Whitney Museum of American Art acquired *Guarded View* for its permanent collection, and it now stands as a sentry there reminding us of the many biases found within museums as well as within ourselves.

—*Lynn M. Herbert*

1. Wilson's gallery talk was entitled *My Life as a Dog* in reference to a childhood experience. At a time when he was the only African-American in his school, Wilson was cast as "the dog" in a school play, a role for which he would be completely covered by a costume and so rendered, in a sense, invisible.
2. The Jewish Museum is the only museum that allowed Wilson to use one of its actual uniforms. The other three uniforms are approximations.
3. The American Association of Museums held its annual conference in Baltimore that year, and Wilson's exhibition was featured during the conference.

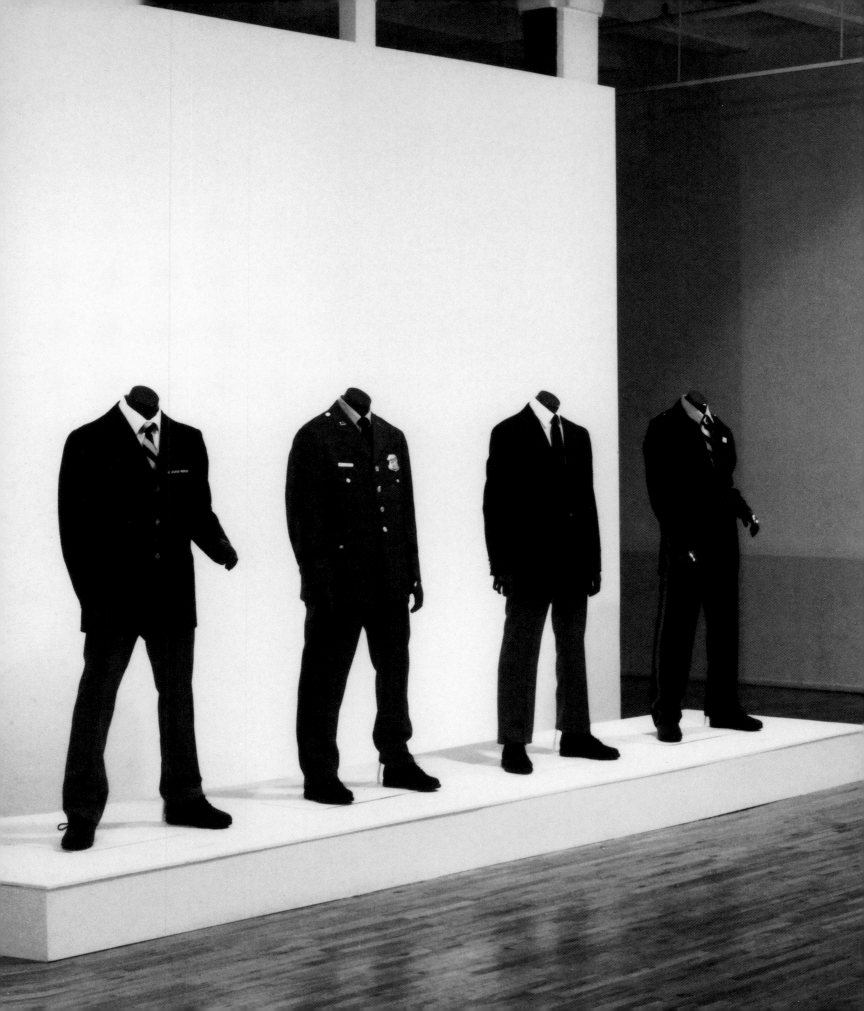

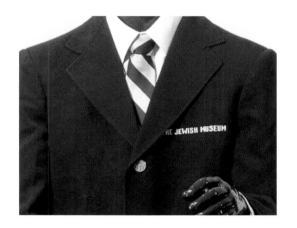

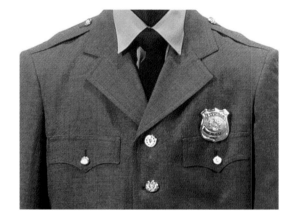

59–62

63 (pp. 74–75)

Selected Events from the 90's

Compiled by

WILLIAM R. THOMPSON

MILES

TONES

ROBERT
MAPPLETHORPE
THE PERFECT MOMENT

1

page 76: Guggenheim Bilbao Museoa, Spain, south view; Frank Gehry, architect

page 77: Dolly, the first cloned sheep, Roslin Institute, Edinburgh, Scotland, 1997

fig. 1. Cover from exhibition catalogue *Robert Mapplethorpe: The Perfect Moment*, Philadelphia: Institute of Contemporary Art, University of Pennsylvania, 1988

fig. 2. Wexner Center for the Arts, Columbus, Ohio, south view; Peter Eisenman, architect

fig. 3. Members of the "NEA Four" fighting artistic censorship (left to right): Holly Hughes, artist; Roberto Bedoya, National Association of Artists' Organizations; Karen Finley, artist; David Cole, attorney; and Tim Miller, artist

The historic fall of the Berlin Wall in 1989 marks the end of the decades-long Cold War and the beginning of dramatic political changes throughout Eastern Europe and the Soviet Union. In the United States, economic recession and increasing cultural conservatism produce heated debates over public funding of the arts, referred to as the "Culture Wars."

JANUARY
January 10: *The New York Times* announces the appointment of Michael Kimmelman as the paper's new chief art critic, succeeding John Russell.

January 27: The Witte de With Center for Contemporary Art in Rotterdam, opens its first exhibition in a former school building renovated by Herman Postma.

FEBRUARY
February 1: Christina Orr-Cahall's resignation as director of the beleaguered Corcoran Gallery of Art in Washington, D.C., officially becomes effective. She had announced her plans to leave the museum in December and quietly departed in January as a result of continuing controversy over the museum's cancellation of the 1989 exhibition *Robert Mapplethorpe: The Perfect Moment*. The exhibition was curated by Janet Kardon for the Institute of Contemporary Art in Philadelphia and received support from the National Endowment for the Arts (NEA). Numerous other members of the Corcoran staff also depart, including curator Jane Livingston, and the museum experiences artist boycotts and a decline in donations. Orr-Cahall becomes director of the Norton Gallery in Palm Beach, Florida, and in November 1990, David C. Levy, chancellor of the New School for Social Research in New York, will be appointed the new director of the

Corcoran. Artists, galleries, and museums continue to experience censorship controversies throughout the 1990s. *(fig. 1)*

February 11: After twenty-seven years in prison, Nelson Mandela is freed by South African president F. W. de Klerk. In 1991, the country's assembly votes to abolish the last of the apartheid laws. Mandela and de Klerk are awarded the Nobel Peace Prize in 1993.

February 15: In a bold move to expand its holdings of postwar American art, the Solomon R. Guggenheim Museum in New York announces that it will acquire through purchase and gift from Italian collector Giuseppe Panza di Biumo more than 300 Minimalist works from the 1960s and 1970s. The museum later makes the controversial decision to sell three major twentieth-century works from its permanent collection in order to fund the acquisition.

February 16: Artist Keith Haring dies from AIDS at age 31 in New York.

February 16: The newly opened Wexner Center for the Visual Arts at Ohio State University in Columbus, designed by Peter Eisenman and devoted to the presentation of multidisciplinary contemporary art, opens its first exhibition, *Art in Europe and America: The 1950s and 1960s. (fig. 2)*

February 20: Representative Dana Rohrabacher, R-Calif., a leading opponent of federal funding for the arts, sends a letter to members of Congress criticizing NEA support of the exhibition *David Wojnarowicz: Tongues of Flame* at the University Galleries of Illinois State University at Normal (January 23–March 4). Rohrabacher continues sending such letters to Congress throughout the year. In March, at the

2

request of Senator Jesse Helms, R-N.C., another staunch opponent of federal funding for the arts, the General Accounting Office (GAO) begins to investigate the NEA for misuse of taxpayer money. The GAO determines that the NEA has not broken any federal laws.

February 22: As a result of the recession and financial difficulties plaguing the banking industry, First Bank System Inc. of Minneapolis, a leading corporate collector of contemporary art, announces that it plans to sell hundreds of its most controversial works and to discontinue related programming.

February 29: In response to strong protests from the architectural community, the Kimbell Art Museum in Fort Worth announces that it has abandoned plans to construct a controversial addition designed by Romaldo Giurgola for its original Louis Kahn building, long considered one of the finest examples of museum architecture in the United States.

MARCH
March 5: More than two dozen demonstrators are arrested when the Coalition for Freedom of Expression and ACT UP (AIDS Coalition to Unleash Power) stage a daylong protest against government censorship at the Congressional hearings on NEA reauthorization held at the J. Paul Getty Museum in Malibu, California.

March 11: Lithuania declares its independence from the Soviet Union. In a violent crackdown in January 1991, Soviet troops will attempt to end the independence movement in the Baltic republics.

March 18: The largest art theft in U.S. history takes place when thieves steal twelve works of art valued at $200 million from the Isabella Stewart Gardner Museum in Boston.

March 21: The J. Paul Getty Museum announces that it has purchased Vincent Van Gogh's *Irises* (1889) for an undisclosed amount from Australian businessman Alan Bond, who paid $53.9 million for the work at an auction in 1987.

APRIL
April 7: The Contemporary Arts Center in Cincinnati opens *Robert Mapplethorpe: The Perfect Moment* and the museum and its director, Dennis Barrie, are indicted on obscenity charges for presenting the controversial exhibition. Following a costly court battle, the museum and Barrie will be acquitted of the charges in October.

April 11–June 3: Organized by René Block, *The Readymade Boomerang: Certain Relations in Contemporary Art*, the Eighth Biennale of Sydney, is presented in Sydney, Australia. The exhibition reveals the enduring influence of the readymade (found object) on artists throughout the world.

Mid-April: Reverend Donald Wildmon, executive director of the American Family Association

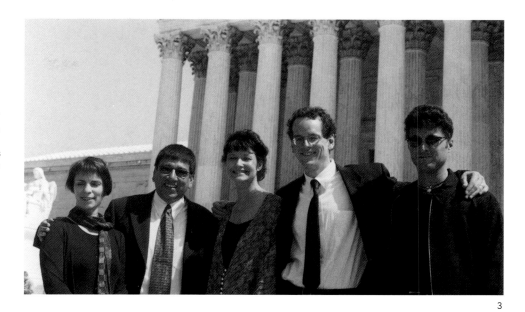

3

(AFA), mails thousands of letters and pamphlets denouncing the work of David Wojnarowicz and the NEA's support of one of his exhibitions. Wojnarowicz in turn sues Wildmon and the AFA for $5 million in damages. The AFA is ordered to stop distributing the pamphlets and Wojnarowicz is awarded a symbolic $1 in damages.

April 22: Italian architect Aldo Rossi is awarded the 1990 Pritzker Architecture Prize. The $100,000 award was established by the Hyatt Foundation in 1979 and modeled after the Nobel Prize.

April 25: Investigating allegations of child pornography, the FBI seizes thousands of negatives and prints from San Francisco photographer Jock Sturges. A federal grand jury later refuses to indict the artist, who files suit against the government for damages.

MAY
May 12–August 19: Curated by Julia Herzberg, Laura Trippi, Gary Sangster, and Sharon Patton, *The Decade Show: Frameworks of Identity in the 1980s* is presented in New York at the Museum of Contemporary Hispanic Art, The New Museum of Contemporary Art, and The Studio Museum in Harlem. The exhibition features 200 works by ninety artists, with a strong emphasis on women, racial minorities, and other marginalized social groups.

May 15: Christie's sells Vincent Van Gogh's *Portrait of Dr. Gachet* (1890) for $82.5 million, the highest price ever paid for a work of art, to a Japanese dealer acting on behalf of an anonymous Japanese corporation.

May 23: After receiving a $45,000 grant from the NEA in March to redesign its sculpture courtyard, the New School for Social Research in New York files suit against the NEA and its

chairman, John Frohnmayer. The suit seeks to overthrow the rule, established in 1989, that requires grant recipients to sign a pledge not to create obscene art. Nearly a year later, the NEA will decide to allow the New School to receive its grant without signing the pledge. The controversial pledge rule will expire on September 30 and not be renewed.

May 27–October 1: Organized by Giovanni Carandente, the *XLIV Esposizione Internazionale d'Arte, La Biennale di Venezia* opens in Venice. Jenny Holzer becomes the first woman to represent the United States at the Biennale. Golden Lions are awarded to Giovanni Anselmo, and Bernd and Hilla Becher.

May 29: Boris Yeltsin is elected president of the Russian Republic, defeating Aleksandr Vlasov, the candidate favored by Soviet leader Mikhail Gorbachev.

JUNE
June 4: Protesters in Beijing mark the one-year anniversary of the Tienanmen Square massacre, when the Chinese government violently suppressed a pro-democracy demonstration.

June 10: The Civic Forum, led by former dissident Vaclav Havel, wins Czechoslovakia's first free elections since 1946.

June 22: Checkpoint Charlie, the official point of entry between East and West Berlin, is dismantled.

June 29: NEA chairman John Frohnmayer overrides the recommendation of a peer review panel and vetoes grants awarded to four performance artists—Karen Finley, Holly Hughes, John Fleck, and Tim Miller—all of whose work addresses issues of sexuality. The artists, henceforth known as the "NEA Four," will file suit

against the NEA on September 27, charging that the organization denied their grants for political reasons. In 1993, the NEA will agree to pay $252,000 to settle part of the lawsuit. Dozens of other grants to artists and organizations continue to be vetoed by the National Council on the Arts, the NEA's oversight body, or by the NEA chairman throughout the decade. *(fig. 3)*

JULY
July 10: The Lannan Foundation, founded by financier J. Patrick Lannan and devoted to the promotion of contemporary art and literature, opens its new Los Angeles headquarters to the public with exhibitions in Marina del Rey of work by Gerhard Richter and Tom Otterness.

AUGUST
August 2: Iraqi troops invade neighboring Kuwait, leading the United Nations (U.N.) to impose sanctions and to mobilize troops to the Persian Gulf.

August 27: Kathy Halbreich, founding director of the department of contemporary art at the Museum of Fine Arts, Boston, and a former director at the MIT List Visual Arts Center in Cambridge, Massachusetts, is appointed director of the Walker Art Center in Minneapolis, one of the leading museums of contemporary art in the United States. She succeeds Martin Friedman, who becomes director emeritus.

SEPTEMBER
September 27: Businessman Seymour Knox, a major patron of contemporary art and the Albright-Knox Art Gallery, dies at age 92 in Buffalo, New York.

OCTOBER
October: Based in London and edited by Anna Somers Cocks, *The Art Newspaper*, an English-language version of the Italian periodical *Giornale dell'Arte*, publishes its first issue.

October 1: Congress allocates the NEA $174 million for the 1991 fiscal year, a slight increase from its 1990 budget of $171.2 million. In contrast, the 1990 culture budget for the city of Paris is 1.026 billion francs ($171 million).

October 2: Artist Judy Chicago withdraws an offer to donate her controversial installation *The Dinner Party* (1979) to the University of the District of Colombia following a series of student protests and Congressional opposition to the use of federal funds to house the work.

October 3: Less than one year after the fall of the Berlin Wall, East Germany merges with West Germany to form the unified Federal Republic of Germany, led by chancellor Helmut Kohl. In 1991, the German government will decide to move the country's capital from Bonn to Berlin.

October 7–January 15: Organized by Kirk Varnedoe and Adam Gopnik, *High and Low: Modern Art and Popular Culture* is presented at The Museum of Modern Art, New York. It is an encompassing history of the century-long dialogue between art and popular culture, from the Cubists to the Neo-Expressionists. The exhibition will travel to the Art Institute of Chicago and the Museum of Contemporary Art, Los Angeles.

October 11: The U.S. House of Representatives reauthorizes the NEA for three more years and drops a proposed ban on obscene art. Future grant decisions, however, must consider "general standards of decency and respect for the diverse beliefs and values of the American people." In 1996, a U.S. Court of Appeals will declare this requirement unconstitutional. On October 24, the U.S. Senate also will vote to reauthorize the NEA but passes an amendment that denies funding for works of art that denigrate religion. The Senate's bill also requires grant recipients to return funds if a court decides the funded work is obscene.

October 15: Mikhail Gorbachev is awarded the Nobel Peace Prize for his role in helping to end the Cold War. *(fig. 4)*

NOVEMBER
November 15–January 13: Curated by John Caldwell, *Sigmar Polke* is presented at the San Francisco Museum of Modern Art. It is the first large-scale American museum survey of this influential artist's work. The exhibition will travel to the Hirshhorn Museum and Sculpture Garden in Washington, D.C.; Museum of Contemporary Art, Chicago; and the Brooklyn Museum of Art.

November 16: NEA chairman John Frohnmayer informs the Citizens Environmental Coalition in Houston that he has vetoed a $10,000 grant to artist Mel Chin to support an earthwork project called *Revival Field*, which uses plants to cleanse contaminated soil. After meeting with the artist to discuss the grant proposal, Frohnmayer will reverse his decision in February 1991.

November 27: John Major becomes prime minister of Great Britain, succeeding Margaret Thatcher.

November 28: Designed by Edward Larrabee Barnes, the Armand Hammer Museum of Art and Cultural Center—housing a collection of Old and Modern Masters, works by Honoré Daumier, and Leonardo da Vinci's *Codex Hammer* —opens in Los Angeles. The museum's founder, Occidental Petroleum chairman Armand Hammer, will die at age 92 on December 10.

DECEMBER
December 1: The second annual Day Without Art is observed. Some 1,200 institutions throughout the United States participate in an effort to raise awareness of the impact of the AIDS epidemic on the art world.

December 1: President George Bush signs into law the Visual Artists Rights Act of 1990, which protects a work of art from being altered or destroyed during the artist's lifetime.

December 9: Lech Walesa, founder of the Solidarity union, is elected president of Poland. He succeeds Wojciech Jaruzelski, who led the crackdown against Solidarity in 1981.

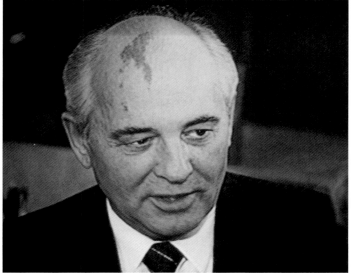

4

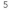

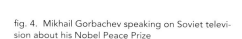

5

fig. 4. Mikhail Gorbachev speaking on Soviet television about his Nobel Peace Prize

fig. 5. *Robert Wilson's Vision* (installation view), Contemporary Arts Museum, Houston, 1991

Global recession and anxiety over the Gulf War take their toll on the economy and the art world. A number of Japanese corporations, frequent bidders on multimillion-dollar works of art during the booming 1980s, are investigated for speculative purchasing of art and pull out of the market. Christie's and Sotheby's announce major declines in their 1990–91 sales, and state arts agencies and museums throughout the United States experience drastic budget cuts. The Detroit Institute of Arts is forced to lay off more than 100 employees and to shorten visiting hours, and the Brooklyn Museum of Art and the Museum of Fine Arts, Boston also experience severe budget cuts.

JANUARY

January: After closing its offices in Italy and New York, the Italian magazine *Contemporanea*, edited by Thomas McEvilley, publishes its last issue.

January 9: David A. Ross, director of the Institute of Contemporary Art, Boston is appointed director of the Whitney Museum of American Art in New York. He succeeds Thomas N. Armstrong III, who left the post in March 1990.

January 16: U.N. forces begin air strikes against Iraq. Kuwait will be liberated on February 23, and a cease-fire will be signed between Iraq and the U.N. on February 28. As they retreat, Iraqi troops will set fire to hundreds of Kuwaiti oil wells, while Kurdish rebels are forced to flee to northern Iraq. Saddam Hussein, Iraq's leader, will remain in power following the war.

FEBRUARY

February 6–April 21: Curated by Trevor Fairbrother, *Robert Wilson's Vision* is presented at the Museum of Fine Arts, Boston. The exhibition will travel to the Contemporary Arts Museum, Houston and the San Francisco Museum of Modern Art. *(fig. 5)*

February 17–May 12: Organized by Stephanie Barron, *Degenerate Art: The Fate of the Avant-Garde in Nazi Germany* is presented at Los Angeles County Museum of Art. Based on the infamous *Entartete Kunst* exhibition in Munich in 1937, the exhibition features 175 works by German Expressionists and other modern artists condemned by the Nazis. It will travel to the Art Institute of Chicago, the Smithsonian Institution, and the Altes Museum in Berlin.

February 19: Painter Carlos Alfonzo dies at age 41 from AIDS in Miami.

February 25: The six countries comprising the Warsaw Pact vote to disband the alliance.

MARCH

March 2: Painter Elmer Bischoff dies at age 74 in Berkeley, California.

March 3: A witness videotapes the beating of black motorist Rodney King by four white police officers in Los Angeles. The tape of the incident will be broadcast around the world and spark national debate on the subject of race and police brutality. On April 29, 1992, a jury will acquit

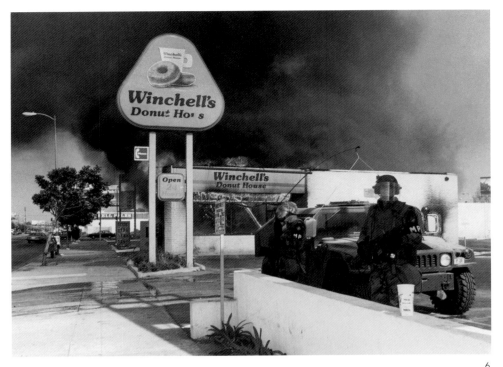

6

the four policemen charged in King's beating, and riots will break out for several days throughout Los Angeles. More than 50 people will be killed and thousands injured. *(fig. 6)*

March 6: The National Museum of the American Indian in Washington, D.C. agrees to return religious artifacts and human remains to Native American tribes who claim them. Cultural repatriation became an issue in the 1970s and 1980s, and affected public and private collections worldwide, culminating in laws relating to cultural artifacts from many countries. The issue expanded to include debates over the return of the Elgin Marbles in the British Museum to Greece and lawsuits regarding the ownership of Nazi-looted art in museums and private collections in the late 1990s.

March 11: Former ambassador Walter Annenberg announces that he is giving his collection of Impressionist and Post-Impressionist art, estimated to be worth $1 billion, to the Metropolitan Museum of Art in New York following his death.

APRIL
April 2–June 16: Curated by Richard Armstrong, John G. Hanhardt, Richard Marshall, and Lisa Phillips, the *1991 Biennial Exhibition* is presented at the Whitney Museum of American Art.

April 8: American architect Robert Venturi is awarded the 1991 Pritzker Architecture Prize of $100,000.

April 9: The Soviet republic of Georgia declares its independence.

April 20–July 21: Organized by Christo M. Joachimides and Norman Rosenthal, *Metropolis* is presented at the Martin-Gropius Bau in Berlin. A symbol of the city's rich artistic heritage and new cultural aspirations, the exhibition showcases the work of seventy contemporary artists from twenty countries.

April 30: Despite the weak economy, Robert Rauschenberg's *Rebus* (1955) sells for a record $7.26 million at Sotheby's.

MAY
May: Edited by Matthew Slotower and Tom Gidley, *Frieze*, a bimonthly magazine focusing on London's art scene, publishes its first issue.

May 2: Focusing on the art of the twentieth century, the Irish Museum of Modern Art opens in Dublin in a renovated seventeenth-century building.

May 3: Ned Rifkin, chief curator of the Hirshhorn Museum and Sculpture Garden, is appointed director of the High Museum of Art in Atlanta. He succeeds Gudmund Vigtel, who retires.

May 7: The Smithsonian Institution's board of regents votes to establish the National African-American Museum on the Mall in Washington, D.C. In 1994, Senator Jesse Helms will stop a bill founding the museum from reaching the Senate.

May 20: The Zimmerli Museum at Rutgers University in New Brunswick, New Jersey, announces that it has been given two major gifts of Russian art, including the Norton T. and Nancy Dodge Collection of Soviet Non-Conformist Art.

May 21: A suicide bomber kills India's Premier Rajiv Ghandi.

JUNE
June: Civil war breaks out in Yugoslavia as Slovenia and Croatia declare their independence and Serbia attempts to keep the country intact. Thousands will die in the fighting that ensues, and artistic monuments throughout the region will be devastated.

June 1–September 2: Organized by William Rubin and Richard Koshalek, *Ad Reinhardt* is presented at The Museum of Modern Art. The artist's first retrospective will travel to the Museum of Contemporary Art, Los Angeles.

June 5: Designed by Hans Hollein and housing a collection of Abstract Expressionist, Pop, and Minimalist art, the new Museum für Moderne Kunst opens in Frankfurt, Germany. *(fig. 7)*

June 20: Formerly an exhibition hall for Impressionist and Post-Impressionist painting, the Galerie Nationale du Jeu de Paume in Paris reopens as a gallery for exhibitions of contemporary art.

June 24: Artist Rufino Tamayo dies at age 91 in Mexico City.

JULY
July 16: Artist Robert Motherwell dies at age 76 in Provincetown, Massachusetts.

July 29: President George Bush travels to Moscow to sign the Strategic Arms Reduction Treaty, which calls for the reduction of long-range nuclear weapons in the arsenals of the United States and the Soviet Union.

AUGUST
August 19–21: Hardline Communists attempt to overthrow Soviet president Mikhail Gorbachev. He survives the coup, thanks to the support and intervention of Russian president Boris Yeltsin, and the Communist Party crumbles. The Soviet Union will be officially dissolved on September 5, and Gorbachev will resign on December 25.

August 30: Artist Jean Tinguely dies at age 66 in Bern, Switzerland.

SEPTEMBER
September 3–October 13: Organized by Thierry Raspail and Thierry Prat, *L'Amour de l'art*, the first Lyon Biennale, is presented at the Halle Tony Garnier in Lyon, France. The survey features sixty-nine individual installations and exhibitions by artists working in France.

September 12: The Dia Center for the Arts in New York opens Dan Graham's *Rooftop Urban Park Project*, a glass pavilion installed on the roof of its 548 West 22nd Street building for performances, readings, and other events.

September 19: The U.S. Senate approves a bill sponsored by Senator Jesse Helms that bans the NEA from awarding grants for sexually explicit work. Congress will later block the legislation.

September 21–December 10: Directed by Joao Candido Galvao and featuring 300 artists from fifty countries, the *XXI Bienal Internacional de São Paulo* is presented in São Paulo. It is the oldest biannual art survey after the Venice Biennale. Ann Hamilton represents the United States, and the first Grand Prize of $150,000 is awarded to Horst Antes.

September 26–December 31: Curated by Peter Galassi, *Pleasure and Terrors of Domestic Comfort* is presented at The Museum of Modern Art, New York. The exhibition features 150 photographs by seventy artists, and explores the subject of people and where they live.

OCTOBER

October 1: Congress allocates the NEA $176 million for the 1992 fiscal year, the largest amount it will receive this decade.

October 9: More than 1,800 workers begin to open 3,100 gigantic umbrellas installed in Ibaraki, Japan, and California as part of Christo and Jeanne-Claude's latest project, *The Umbrellas, Japan–U.S.A.* (1984–91). The installation will be closed prematurely after a woman is killed in California by an uprooted umbrella. Later, a crane operator will be electrocuted while deinstalling the Japanese section of the project.

October 15: The U.S. Senate votes to confirm Clarence Thomas to the Supreme Court following several days of hearings to investigate allegations by law professor Anita Hill that Thomas sexually harassed her when she worked for him. The hearings will spark a national debate on the topic of sexual harassment.

October 19–February 16: Curated by Lynne Cooke and Mark Francis and featuring site-specific installations, the *Carnegie International 1991*, the oldest periodical survey of contemporary art in North America, is presented at the Carnegie Museum of Art in Pittsburgh. The Carnegie Prize of $10,000 is awarded to On Kawara.

October 20–January 7: Curated by Robert Storr, *Dislocations* is presented at The Museum of Modern Art, New York. It is Storr's first exhibition at the museum as a curator and marks the museum's entry into the exhibition of large-scale contemporary art.

October 23: Independent curator Milena Kalinovska is appointed director of the Institute of Contemporary Art, Boston. She succeeds David A. Ross.

NOVEMBER

November 2–January 5: Curated by Neal Benezra, *Martin Puryear* is presented at the Art Institute of Chicago. Featuring sculptures from 1976 to 1990, the exhibition is the most ambitious museum presentation of Puryear's work to date. It will travel to the Hirshhorn Museum and Sculpture Garden; the Museum of Contemporary Art, Los Angeles; and the Philadelphia Museum of Art.

November 5–6: In spite of objections from the American Association of Art Museum Directors and the American Association of Museums, the Rose Art Museum of Brandeis University in Waltham, Massachusetts, sells eleven Impressionist and Post-Impressionist works deaccessioned from its collection in order to fund an endowment for acquisitions, education, and conservation. The controversial sale at Christie's adds to the debate over the ethics of museums selling works from their collections for the purpose of covering operating expenses.

November 11: Located in a renovated Art Deco building near the Sydney Opera House, the Museum of Contemporary Art, Sydney, opens in Australia. It is the country's first major contemporary art museum and features a collection of 4,500 works of art.

November 17: Violence breaks out in Mogadishu, Somalia, between supporters of acting president Ali Mahdi Muhammad and General Farah Aidid. Tens of thousands will be killed in the fighting, and thousands more will face starvation because of severe food shortages. In December 1992, U.S. Marines will be sent to the country to secure the region and to allow food and medicine to be distributed.

November 26: Sculptor Anish Kapoor wins the 1991 Turner Prize of £20,000, sponsored by the Tate Gallery in London and presented each year to a British artist under the age of 50. The prize was not awarded in 1990 due to lack of funds.

DECEMBER

December: Edited by Barbara Rose, the *Journal of Art* publishes its last issue. Citing the bad economy, Rizzoli dismissed the staff and suspended publication in November.

December 15: The Irish Republican Army detonates a fire bomb in the bookstore of the National Gallery's newest wing in London.

fig. 6. Two National Guardsmen stand outside a burning donut shop in Los Angeles, on April 30, 1992, during the riots following the acquittal of four policemen charged in the beating of Rodney King on March 3, 1991

fig. 7. Hans Hollein, elevation drawing, Museum für Moderne Kunst, Frankfurt, Germany

7

8

fig. 8. *Helter Skelter: L.A. Art in the 1990s* (installation view), The Temporary Contemporary of the Museum of Contemporary Art, Los Angeles, 1992. Charles Ray, *Yes*, 1990, (detail), framed color photograph on convex wall

fig. 9. *Henri Matisse: A Retrospective* (installation view), The Museum of Modern Art, New York, 1992–93

figs. 10–11. (left) Women's Action Coalition (WAC) and the Guerrilla Girls protest at the opening of the Guggenheim Museum SoHo, New York, 1992; (right) WAC's pro-choice demonstration in front of Planned Parenthood, Houston, National Republican Convention, 1992

The collapse of Communism in Eastern Europe brings optimism for the future, tempered by political instability, longstanding ethnic tensions, and outbreaks of violence. Philanthropist George Soros begins to establish the network of Soros Centers for Contemporary Art in countries throughout Eastern Europe and the former Soviet Union. The world is shocked by stories of "ethnic cleansing" and images from Serbian concentration camps in Bosnia. The U.S. economic recession leads to more budget cuts for arts organizations—in 1992, overall state art funding falls 21.6 percent—while controversies over censorship and government funding of the arts continue.

JANUARY
January 26–April 26: Curated by Paul Schimmel, *Helter Skelter: L.A. Art in the 1990s* is presented at the Temporary Contemporary of The Museum of Contemporary Art, Los Angeles.

(fig. 8)

FEBRUARY
February: The London art magazine *Artscribe*, edited by Marjorie Allthorpe-Guyton, publishes its final issue due to financial troubles and a lack of subscribers.

February 22: At the request of President George Bush, who is under pressure from conservative critics, NEA chairman John Frohnmayer announces his resignation. He is replaced by Anne-Imelda Radice, the NEA's senior deputy chairman. The change in leadership, however,

does not solve the problems of the beleaguered agency. On May 12, Radice will veto two $10,000 grants, one for the exhibition *Corporal Politics* at the MIT List Visual Arts Center in Cambridge and the other for the exhibition *Anonymity and Identity* at the Anderson Gallery at Virginia Commonwealth University in Richmond. In November, she will veto grants totaling $17,500 to three separate gay and lesbian film festivals—the National Council on the Arts, will restore the grants in October 1993.

MARCH
March: Edited by Barry Schwabsky, *Arts Magazine* publishes its last issue as a result of falling ad revenues.

March 10: Painter James Brooks dies at age 85 on Long Island, New York.

March 11: Theater director Peter Brook is awarded the first Wexner Prize of $50,000 at a ceremony in Columbus, Ohio.

March 20: China's prime minister Li Peng, who was closely involved in the crackdown on pro-democracy demonstrators at Tienanmen Square in 1989, calls for sweeping economic reforms and the introduction of a Western-style market system while retaining the country's Communist philosophy.

APRIL
April 3: The Museum of Fine Arts, Houston announces that it has selected José Rafael Moneo to design a major expansion. Later named the Audrey Jones Beck Building, the new addition is scheduled to open in March 2000.

April 3–4: Bard College opens the Richard and Marieluise Black Center for Curatorial Studies and Art in Contemporary Culture. In 1994, Bard will establish a graduate program to train curators of contemporary art.

April 4–February 28, 1993: Curated by Lisa G. Corrin, *Mining the Museum*, an installation by artist Fred Wilson, is presented at the Maryland Historical Society in conjunction with The Contemporary. Wilson's re-installation of the Society's collection addresses racial biases found within the institution. The exhibition receives widespread acclaim and draws record crowds.

April 15–July 31: Curated by Helen A. Cooper, *Eva Hesse: A Retrospective* is presented at the Yale University Art Gallery in New Haven, Connecticut. The exhibition is an important showing of work by the artist, whose career was cut short by her untimely death in 1970. It will travel to the Hirshhorn Museum and Sculpture Garden.

April 27: Portuguese architect Alvaro Siza is awarded the 1992 Pritzker Architecture Prize of $100,000.

92

April 28: Painter Francis Bacon dies at age 82 in Madrid.

April 28: Earl A. "Rusty" Powell III, director of the Los Angeles County Museum of Art, is appointed director of the National Gallery of Art in Washington, D.C. He succeeds retiring director J. Carter Brown.

MAY
May 30: Designed by Gabriel Charbonneau, the Musée d'Art Contemporain de Montréal opens a new facility with a survey of contemporary Canadian art.

JUNE
June 2: *The New York Times* announces the appointment of Herbert Muschamp, architecture critic for *The New Republic* and *Artforum*, as the paper's new architecture critic.

June 3–14: The U.N. Conference on Environment and Development, the largest gathering of world leaders ever, convenes in Rio de Janeiro to address issues of global development and environmental protection.

June 13–September 20: Organized by Jan Hoet, *Documenta IX* is presented in Kassel, Germany. The exhibition explores the theme of the artist as outsider and includes more than 180 artists.

June 16: Attorney Edward Hayes files a court petition contending that he is owed millions of dollars more in legal fees from the estate of Andy Warhol. Hayes challenges Christie's 1991 appraisal of the estate at $220 million, claiming its value is much greater and that he is entitled to fees of $14 million instead of the $4.85 million he was paid. In 1995, a judge will award Hayes $7.2 million in legal fees, but in 1996, the New York State Supreme Court will rule that The Andy Warhol Foundation for the Visual Arts should pay Hayes only $3.5 million. Hayes will ultimately be allowed to keep $1.5 million in legal fees already paid by the Warhol Foundation. The

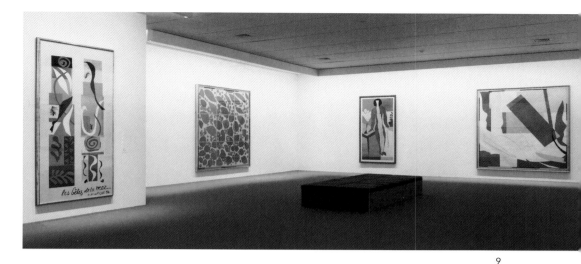

9

Hayes dispute is one of several precedent-setting legal battles that the Warhol Foundation faces in the 1990s. In 1993, Frederick Hughes, the executor of the Andy Warhol estate, will settle a long-standing disagreement with the Warhol Foundation and receive $5.2 million in executor's fees.

June 19: The city of Bonn, Germany, inaugurates two new museums of contemporary art. Designed by Gustav Peichel, the Kunst-und Ausstellungshalle der Bundesrepublik Deutschland opens with the exhibition *Territorium Artis*, curated by Pontus Hulten and featuring 150 works of modern and contemporary art that trace the development of the century's avant-garde movements (through September 20). Designed by Axel Schutes, the Municipal Art Museum of Bonn opens as an exhibition space for German artists.

June 25: As part of director Thomas Krens' ambitious program of expansion, the Solomon R. Guggenheim Museum reopens its renovated Frank Lloyd Wright building and a new ten-story annex designed by Gwathmey Siegel & Associates. The museum also opens a new satellite branch, the Guggenheim SoHo, in a building

renovated by Arata Isozaki. The Guerrilla Girls and the recently formed activist group Women's Action Coalition (WAC) stage a demonstration at the museum to protest the lack of women artists on view. Later in the summer, WAC will stage a pro-choice demonstration at the Republican National Convention in Houston. *(figs. 10, 11)*

JULY
July 2: U.N. forces take control of the airport outside of the besieged city of Sarajevo in Bosnia in order to begin airlifting relief supplies to the civilian population.

July 22: Artist David Wojnarowicz dies from AIDS at age 37 in New York.

July 25–August 9: The 1992 Summer Olympic Games open in Barcelona. In preparation for hosting the event, the historic city embarked upon a massive revitalization effort and constructed new buildings, public parks, and streets. A number of major public sculptures were commissioned, including works by Frank O. Gehry, Roy Lichtenstein, and Claes Oldenburg and Coosje van Bruggen.

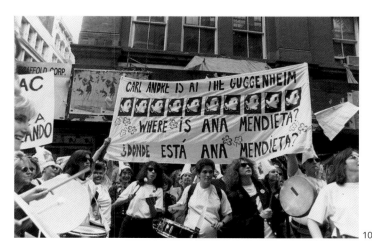

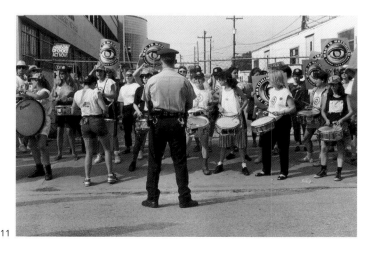

10 11

July 26: Pablo Picasso's famed mural *Guernica* (1937), which previously had been on view at the Prado, is transferred to the Museo Nacional Centro de Arte Reina Sofía in Madrid, where it becomes the centerpiece of the newly renovated museum's holdings of modern art. Madrid's status as a major art center will be further enhanced in September when the Thyssen-Bornemisza Museum opens to house the $3 billion collection of American and European art assembled by Baron Thyssen-Bornemisza.

AUGUST

August: The Whitney Museum of American Art vacates its satellite branch at Equitable Center. The Whitney's downtown branch at Federal Reserve Plaza will close in September.

August 12: Artist and composer John Cage dies at age 79 in New York.

August 26: Michael Shapiro, chief curator of the St. Louis Art Museum, is appointed director of the Los Angeles County Museum of Art. He resigns after nine months and Graham W. J. Beal, director of the Joslyn Art Museum in Omaha, Nebraska is appointed his successor.

SEPTEMBER

September 24–January 12: Curated by John Elderfield, *Henri Matisse: A Retrospective* is presented at The Museum of Modern Art in New York. The exhibition is the largest gathering of the artist's work ever and will attract a record 945,000 visitors. *(fig. 9)*

OCTOBER

October 1: Congress allocates the NEA $174.5 million for the 1993 fiscal year. In July, the U.S. House of Representatives voted down a measure supported by conservatives to end the agency's funding. In contrast, the 1993 budget for culture in France reaches 13.7 billion francs (nearly $2.5 billion).

October 16: *The Los Angeles Times* reports that the Walt Disney Company has demanded that Dennis Oppenheim's sculpture *Virus* (1988), which includes copyrighted images of Mickey Mouse and Donald Duck, be dismantled. In 1993, following several years of litigation, artist Jeff Koons will settle four lawsuits brought against him as a result of his appropriation of copyrighted imagery in his work. Numerous artists face similar challenges throughout the decade.

October 23–February 14: Curated by Richard Marshall, *Jean-Michel Basquiat* is presented at the Whitney Museum of American Art. The late artist's first museum survey will travel to The Menil Collection in Houston, the Des Moines Art Center in Iowa, and the Montgomery Museum of Fine Arts in Alabama.

October 30: Painter Joan Mitchell dies at age 66 in Paris.

October 31: Designed by Rem Koolhaas, the Kunsthal Rotterdam opens in The Netherlands. *(fig. 12)*

NOVEMBER

November 2: Sculptor Robert Arneson dies at age 62 in Benicia, California.

November 4: William Jefferson Clinton, former Democratic governor of Arkansas, is elected president of the United States, defeating Republican incumbent George H. W. Bush.

November 6–January 31: Curated by Barbara Haskell, *Agnes Martin* is presented at the Whitney Museum of American Art. It will travel to the Milwaukee Art Center; the Center for the Fine Arts, Miami; the Contemporary Arts Museum, Houston; and the Museo Nacional Centre de Arte Reina Sofía.

November 11: Christie's sells Henri Matisse's *Harmony in Yellow* (1927–28), featured in the Matisse retrospective, for $14.5 million, a new record for the artist's work. On November 17, Sotheby's will sell Bruce Nauman's *One Hundred Live and Die* (1984) for a record $1,925,000.

November 20: A fire destroys much of historic Windsor Castle outside London.

November 24: Sculptor Grenville Davey is awarded the 1992 Turner Prize of £20,000.

DECEMBER

December 3: The Solomon R. Guggenheim Museum announces that the Robert Mapplethorpe Foundation is donating $2 million and 200 photographs to the museum to establish a photography program.

December 15–March 15: Directed by Tony Bond, *The Boundary Rider*, the Ninth Biennale of Sydney, is presented at the Art Gallery of New South Wales and Bond Store 3/4. The survey features 400 works by 100 artists and explores the theme of conceptual and cultural boundaries.

December 17: The United States, Canada, and Mexico sign the North American Free Trade Agreement (NAFTA), which creates a free-trade zone among the three countries.

December 31: Czechoslovakia is peacefully dissolved into two separate nations—the Czech Republic and Slovakia.

12

13

fig. 12. Kunsthal Rotterdam, Rotterdam, front view; Rem Koolhaas, architect

fig. 13. The Hall of Witness, United States Holocaust Memorial Museum, Washington, D.C.; James Ingo Freed, architect

fig. 14. A worker removes window frames inside the Uffizi Gallery in Florence, Italy, damaged by a car bombing on May 27, 1993

93

Russia experiences severe economic and political turmoil, while in the United States, President Bill Clinton—the first Democrat to occupy the White House in twelve years—introduces more inclusive policies toward women, people of color, and gays and lesbians. After several years of recession, the economy begins to improve, thanks in part to lower interest rates.

JANUARY
January 17: The United States launches cruise missiles against a suspected nuclear weapons plant in Iraq as punishment for the country's refusal to respect U.N. Security Council resolutions enacted following the Gulf War.

January 20: Anne-Imelda Radice, acting chairman of the NEA, resigns as expected on the day of Bill Clinton's inauguration as president.

January 28: Artist Hannah Wilke dies at age 52 in Houston.

FEBRUARY
February 2: The Museum of Contemporary Art, San Diego opens a permanent downtown exhibition space with an exterior designed by Helmut Jahn and interiors by Robert Irwin, Richard Fleischner, and David Raphael Singer.

February 17–April 25: Curated by Robert Storr, *Robert Ryman* is presented at the Tate Gallery. The exhibition will travel to the Museo Nacional Centro de Arte Reina Sofía, Madrid, and The Museum of Modern Art, New York.

February 19: The financially troubled New York Historical Society closes its doors to the public and considers selling parts of its collection to raise much-needed funds. In 1995, the institution will sell a large number of Old Master paintings and decorative arts to increase its operating endowment.

February 24–June 20: Curated by Elisabeth Sussman, the *1993 Biennial Exhibition* is presented at the Whitney Museum of American Art. The exhibition explores issues of sexual identity, race, and class, and includes works by more than eighty artists.

February 26: Photography historian Beaumont Newhall, founding curator of The Museum of Modern Art's photography department, dies at age 84 in Santa Fe.

February 26: A car bomb explodes, killing six people and injuring more than 1,000 others, in New York's World Trade Center.

MARCH
March 8: Dancer Merce Cunningham and the late artist and composer John Cage are awarded the 1993 Wexner Prize of $50,000.

March 12–May 15: Curated by William A. Camfield, Walter Hopps, and Susan Davidson,

Max Ernst: Dada and the Dawn of Surrealism is presented at The Museum of Modern Art, New York. The exhibition explores Ernst's early career from 1912 through the 1920s. It will travel to The Menil Collection, Houston, and the Art Institute of Chicago.

March 30: Painter Richard Diebenkorn dies at age 70 in Berkeley, California.

March 30: The Clinton administration appeals a 1992 federal court ruling that declared unconstitutional the 1990 Congressional mandate that all NEA grants uphold standards of decency.

APRIL
April 19: A fifty-one-day standoff between federal agents and members of the Branch Davidian cult in Waco, Texas, ends in a fire that claims seventy-five lives.

April 22: Designed by James Ingo Freed, the United States Holocaust Memorial Museum is dedicated in Washington, D.C. In addition to housing permanent and temporary exhibitions, archives, and a library and auditorium, the museum features works commissioned from artists Ellsworth Kelly, Sol LeWitt, Richard Serra, and Joel Shapiro. *(fig. 13)*

April 25: An estimated 300,000 demonstrators convene in Washington, D.C., for the "March on Washington for Lesbian, Gay, and Bi Equal Rights and Liberation."

April 26: Japanese architect Fumihiko Maki is awarded the 1993 Pritzker Architecture Prize of $100,000.

14

15

MAY

May 2–August 15: *From Cézanne to Matisse: Great French Paintings from the Barnes Foundation* is presented at the National Gallery of Art in Washington, D.C. It is the first public showing of works from the celebrated holdings of the Barnes Foundation in Merion, Pennsylvania, which went to court to allow the works to travel and be reproduced in color—both of which had been forbidden by the founder's will. The highly successful exhibition will travel to the Musée d'Orsay in Paris, the National Museum of Western Art in Tokyo, and the Philadelphia Museum of Art. The Barnes Foundation will then return to court to allow other venues to present the exhibition, raising much-needed funds for the renovation of its physical plant.

May 27: A powerful car bomb explodes outside the Uffizi Gallery in Florence, Italy, killing six people and severely damaging the building and numerous works of art. *(fig. 14)*

JUNE

June 5–September 26: Directed by Valerie D. F. Smith, *Sonsbeek 93*, an international art survey, is presented in Arnhem, The Netherlands.

June 13–October 10: Curated by Achille Bonito Oliva and focusing on themes of nomadism and multiculturalism, the *XLV Esposizione Internazionale d'Arte, La Biennale di Venezia* is presented. Sculptor Louise Bourgeois represents the United States. Golden Lions are awarded to Richard Hamilton, Antoni Tàpies, Robert Wilson, and David Sylvester.

June 22: Sherri Geldin, associate director of the Museum of Contemporary Art, Los Angeles, is appointed director of the Wexner Center for the Visual Arts.

AUGUST

August 4: François Barré, director of the Centre National des Arts Plastiques, is appointed president of the Centre Georges Pompidou in Paris. He succeeds Dominique Bozo, who died in April.

August 7: The Clinton administration announces that actress Jane Alexander has been nominated to serve as chairwoman of the NEA. She will be unanimously approved by the U.S. Senate on September 29. *(fig. 15)*

SEPTEMBER

September 13: In a symbolic gesture of hope for peace in the Middle East, PLO leader Yasir Arafat and Israeli prime minister Yitzhak Rabin shake hands at a White House ceremony.

September 18–December 5: Directed by Doug Hall, the first *Asia-Pacific Triennial of Contemporary Art* is presented at the Queensland Art Gallery in South Brisbane, Queensland, Australia. The survey features 200 works by seventy-six artists from Australia, Asia, and the Pacific.

September 19: The CBS news program "60 Minutes" airs a feature by correspondent Morley Safer mocking both contemporary art and the high prices collectors and museums pay to acquire it. In 1998, The Museum of Modern Art director Glenn Lowry will decline Safer access to MoMA to do another CBS news program for "Sunday Morning" on the museum's Jackson Pollock retrospective, presumably in retaliation for his infamous "60 Minutes" piece.

OCTOBER

October 1: The NEA, after surviving a Congressional vote in July to eliminate the agency, is allocated $170.2 million for the 1994 fiscal year. The new federal budget also restores tax deductions for gifts of appreciated property allowing individuals (other than the artist) to deduct the full market value of artwork donated to museums—thousands of valuable works will be given to American museums as a result.

October 4: A coup attempt against Russian president Boris Yeltsin fails after the Russian army shells the country's parliament building, where leaders of the rebellion had barricaded themselves.

October 8–January 16: Curated by Diane Waldman, *Roy Lichtenstein* is presented at the Solomon R. Guggenheim Museum. The retrospective will travel to the Museum of Contemporary Art, Los Angeles and the Montreal Museum of Fine Arts.

NOVEMBER

November 1: The European Union, an alliance of Western European nations working toward economic and political integration, is established.

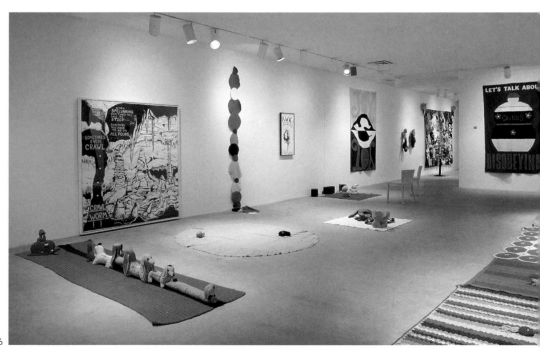

16

November 5–February 20: Curated by Elisabeth Sussman, *Mike Kelley: Catholic Tastes* is presented at the Whitney Museum of American Art. The artist's first large-scale survey will travel to the Los Angeles County Museum of Art and the Moderna Museet in Stockholm. *(fig. 16)*

November 6–December 18: Curated by Ingrid Schaffner, *The Return of the Cadavre Exquis* is presented at The Drawing Center in New York. Exploring chance and the subconscious, the exhibition features 100 drawings made using the Surrealists' "Exquisite Corpse" method, whereby two or more artists create a drawing collaboratively but without knowing what his or her predecessor has done to it.

November 21: Designed by Frank O. Gehry, the Frederick R. Weisman Art Museum at the University of Minnesota in Minneapolis opens to the public.

November 23: Sculptor Rachel Whiteread wins the 1993 Turner Prize of £20,000.

November 30–February 21: Organized by Kathy Halbreich and Neal Benezra, *Bruce Nauman* is presented at the Museo Nacional Centro de Arte Reina Sofía. The sixty-work retrospective will travel to the Walker Art Center; the Museum of Contemporary Art, Los Angeles; the Hirshhorn Museum and Sculpture Garden; and The Museum of Modern Art.

DECEMBER
December 15: In London, British prime minister John Major and Irish prime minister Albert Reynolds sign a declaration for peace in Ireland.

fig. 15. Jane Alexander, National Endowment for the Arts Chairwoman from 1993 to 1997

fig. 16. *Mike Kelley: Catholic Tastes* (installation view), Whitney Museum of American Art, New York, 1994

fig. 17. Donald Judd, *100 untitled works in mill aluminum*, 1982–86, The Chinati Foundation, Marfa, Texas

The media broadcasts shocking images of genocide in Africa throughout the world. Technology continues to advance at a rapid pace, particularly in such fields as communication and medicine. A new class of drugs known as "protease inhibitors," which improves the life expectancies of those infected with HIV, is introduced. The Internet company Netscape launches a new web browser that makes it possible for millions to navigate the World Wide Web—artists, museums, and galleries are among the many who make use of it. Museums lure more corporate money in response to the decline in public funding—according to a 1995 report by the Business Committee for the Arts in New York, corporate support of the arts reached a record $875 million in 1994, up from $518 million in 1991.

JANUARY
January 10: Katherine Kuh, the Art Institute of Chicago's first curator of modern art, dies at age 89 in New York.

January 22: The Lannan Foundation announces that it is discontinuing its art collecting program. In 1996, the organization will decide to end its exhibition program and to disperse its 1,500-piece collection, diverting funds to programs to support rural Native American communities. In 1997, some 300 works of art will be donated to the Museum of Contemporary Art, Los Angeles; the Art Institute of Chicago; and the Museum of Contemporary Art, Chicago.

FEBRUARY
February 2: Citing budget shortfalls, the Solomon R. Guggenheim Museum dismisses 10 percent of its staff, shortly after announcing that it had raised half of its $100 million capital campaign goal.

94

February 3: Artist Jorge Zontal, one of the three members of the Canadian conceptual art collaborative General Idea, dies at age 50 of AIDS. Another member of the group, Felix Partz, will die at age 49 of AIDS on June 5.

February 5–March 30: Organized by Alexandra Munroe, *Japanese Art After 1945: Scream Against the Sky* is presented at the Yokohama Museum of Art in Japan. The exhibition will travel to the Guggenheim SoHo, the San Francisco Museum of Modern Art and the Center for the Arts at Yerba Buena Gardens.

February 12: Sculptor Donald Judd dies at age 65 in New York. Later that year, Marianne Stockebrand, director of the Cologne Kunstverein, will become director of the Chinati Foundation, the organization that Judd established in Marfa, Texas, for the purpose of exhibiting permanent large-scale installations of his work and that of other artists. In 1996, the Judd Foundation will be established to oversee the estate's holdings of works by Judd and other artists, as well as several properties in Marfa, including Judd's home and studio. *(fig. 17)*

February 12: Edvard Munch's *The Scream* (1893) is stolen from the National Art Museum in Oslo on the opening day of the Winter Olympics. The painting will be recovered when two thieves are arrested trying to ransom it three months later.

MARCH
March 5: Los Angeles artist Ron Athey presents a performance, sponsored by the Walker Art Center and partially funded by the NEA, in a Minneapolis nightclub, where he cuts a design on the back of an HIV-positive man and wipes the blood with paper towels, which he then hangs on a clothesline above the audience. The Walker will endure media criticism for presenting Athey's performance as opponents of public funding for the arts in Congress continue their campaign to cut support for the NEA. Senator Jesse Helms will sponsor an amendment, defeated by a 49–42 vote, forbidding the NEA from funding projects or works of art involving bodily mutilation or the drawing of blood.

March 18: Artist Bruce Nauman is awarded the Wexner Prize of $50,000.

APRIL
April 6: Rwanda's president dies in a plane crash. In the weeks that follow, a bitter tribal disagreement erupts between Hutus and Tutsis, resulting in the eventual slaughter of hundreds of thousands of people throughout the African nation.

April 8: After a lengthy and controversial restoration, Michelangelo's frescoes painted on the ceiling of the Sistine Chapel are unveiled at the Vatican.

18

April 19–August 8: Organized by Gary Tinterow and Henri Loyrette, *Origins of Impressionism* is presented at the Galeries Nationales du Grand Palais in Paris. The exhibition explores the early years of the Impressionist movement. It will travel to the Metropolitan Museum of Art.

April 24: Conceptual artist Alighiero Boetti dies at age 53 in Rome.

April 29–May 2: The first annual Gramercy International Contemporary Art Exhibition is held at the Gramercy Hotel in New York. Unlike more traditional art fairs, European and American dealers exhibit works in their hotel rooms.

MAY
May 2: French architect Christian de Portzamparc is awarded the 1994 Pritzker Architecture Prize of $100,000.

May 6: The "Chunnel," a subterranean tunnel under the English Channel connecting France and Great Britain, officially opens.

May 7: Art critic Clement Greenberg dies at age 85 in New York.

May 8–September 5: Curated by Marla Prather, David Sylvester, and Nicholas Serota, *Willem de Kooning: Paintings* is presented at the National Gallery of Art in Washington, D.C. The exhibition will travel to the Metropolitan Museum of Art and the Tate Gallery.

May 9: Artist Anni Albers, the last living teacher from the original Bauhaus, dies at age 94 in Orange, Connecticut.

May 9: Marti Mayo, director of the Blaffer Gallery, University of Houston, is appointed director of the Contemporary Arts Museum, Houston. She replaces Suzanne Delehanty who resigned in May, 1993.

May 10: Nelson Mandela is inaugurated as the first black president of South Africa. *(fig. 18)*

May 11: Michael Govan, a deputy director of the Solomon R. Guggenheim Museum, is appointed director of the Dia Center for the Arts. He succeeds Charles Wright, who previously resigned.

May 12: The Andy Warhol Museum, the largest museum in the United States devoted to a single artist, opens in Pittsburgh in a former warehouse building renovated by Richard Gluckman. In 1993, Thomas N. Armstrong III, former director of the Whitney, was named the museum's director. *(fig. 19)*

JUNE
June 8: Designed by Frank O. Gehry, the new American Center in Paris, which laid off much of its staff in 1992 due to budget cuts, opens with the exhibition *Pure Beauty*, featuring work by contemporary California artists. Lacking operating funds, the Center will lay off its remaining staff and put the facility up for sale in 1996. The French government will announce plans to purchase it in 1998.

June 10: Assemblage artist Edward Kienholz dies at age 66 in Sandpoint, Idaho.

June 16–September 4: Curated by Richard Morphet, *R. B. Kitaj: A Retrospective* is presented at the Tate Gallery. The exhibition includes 100

19

works exploring the artist's 30-year career. It will travel to the Los Angeles County Museum of Art and the Metropolitan Museum of Art.

June 23: Malcolm Rogers, deputy director of the National Portrait Gallery in London, is appointed director of the Museum of Fine Arts, Boston. In 1995, facing a $4.5 million deficit, the museum will cut back on operations and exhibitions, and reduce its staff by 20 percent.

JULY
July 1: Yasir Arafat's exile from Palestine ends when he enters the Gaza Strip for the first time in 27 years.

July 9: In a continuing atmosphere of corporate downsizing, IBM closes the IBM Gallery of Science and Art in New York. The company also decides to sell its 4,800-piece art collection.

AUGUST
August: Peter de Jager, a Canadian computer scientist, publishes an article in *CA Magazine* warning that the majority of the world's computers will not be able to recognize dates after December 31, 1999. The problem becomes popularly known as "Y2K."

August 5: The National Council for the Arts, votes to overturn a peer-panel award of a $20,000 fellowship to photographer Andres Serrano, whose photograph *Piss Christ* (1987) showing a crucifix submerged in a jar of urine was the focus of major controversy over government funding of the arts in 1989.

August 16: Curator and art critic Henry Geldzahler dies at age 59 in Southampton, Long Island, New York.

August 31: The Irish Republican Army announces a cease-fire in Northern Ireland. It will last until February 1996.

SEPTEMBER
September 11: Art collector Frederick R. Weisman dies at age 82 in Holmby Hills, California.

September 19: U.S. troops move into Haiti to allow the return of the country's exiled elected president Jean-Bertrand Aristide.

September 25–October 30: Directed by Lynda Forsha, *inSITE94*, a bi-national exhibition of installation and site-specific art, is presented at thirty-seven venues on both sides of the Mexico/United States border around Tijuana and San Diego. *(fig. 20)*

OCTOBER
October 1: Congress allocates the NEA $162.3 million for the 1995 fiscal year.

October 2: Designed by Gunner Birkerts, the Kemper Museum of Contemporary Art and

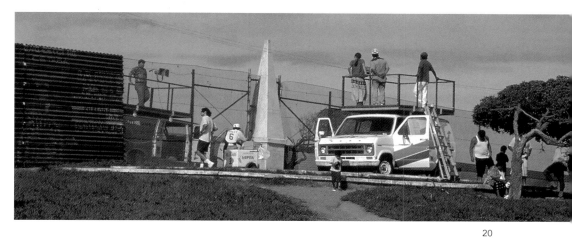

20

Design opens at the Kansas City Art Institute in Missouri. The Institute will later get into a dispute with its primary benefactor, R. Crosby Kemper, over matters of administration, and the museum and school separate.

October 7–January 22: Organized by Germano Celant, *The Italian Metamorphosis, 1943–1968* is presented at the Solomon R. Guggenheim Museum. The exhibition will travel to the Triennale di Milano and the Kunstmuseum Wolfsburg.

October 12–December 11: Organized by Nelson Aguilar, the *XXII Bienal Internacional de São Paulo* is presented. Betye Saar and John Outterbridge represent the United States.

NOVEMBER
November 4: Painter Sam Francis dies at age 71 in Santa Monica, California.

November 8: Led by Speaker of the House Newt Gingrich and running on a platform outlined in their "Contract with America," Republicans win a majority in Congress and a number of state assemblies. Many of those elected promised to shrink the federal government and bring an end to its support of the arts and such agencies as the NEA.

November 8–January 8: Curated by Sidra Stich, *Yves Klein* is presented at the Ludwig Museum in Cologne, Germany and Kunstsammlung Nordrhein-Westfalen in Düsseldorf, Germany. The retrospective will travel to the Hayward Gallery and the Museo Nacional Centro de Arte Reina Sofía.

November 10–March 5: Curated by Thelma Golden, *Black Male: Representations of Masculinity in Contemporary American Art*, is presented at the Whitney Museum of American Art. The exhibition includes 100 works in all media exploring changing perceptions of black masculinity.

November 11: After merging with the University of California at Los Angeles, the Armand Hammer Museum of Art and Cultural Center sells Leonardo da Vinci's seventy-two-page *Codex*

Hammer at Christie's for $30.8 million. The manuscript is purchased by Microsoft chairman Bill Gates, who restores its original name: the *Codex Leicester*.

November 12–January 15: Curated by Patrick T. Murphy, *Andres Serrano, Works 1983–1993* is presented at Institute of Contemporary Art in Philadelphia. It will travel to the New Museum of Contemporary Art, New York; the Center for the Fine Arts, Miami; the Contemporary Arts Museum, Houston; and the Museum of Contemporary Art, Chicago.

November 16: Glenn D. Lowry, director of the Art Gallery of Ontario, is appointed director of The Museum of Modern Art. He succeeds Richard E. Oldenburg, who retires from the job after twenty-one years and is later appointed director of American operations for Sotheby's.

November 22: Sculptor Antony Gormley is awarded the 1994 Turner Prize of £20,000.

DECEMBER
December 11: Following weeks of bombing, Russian tanks move into the breakaway republic of Chechnya. Fighting will continue through the end of the decade.

December 18–April 30: Organized by Angelica Zander Rudenstine and a team of curators, *Piet Mondrian: 1872–1944* is presented at the Haags Gemeentemuseum. The exhibition will travel to the National Gallery of Art in Washington, D.C. and The Museum of Modern Art.

fig. 18. President-elect Nelson Mandela, Cape Town, South Africa

fig. 19. The Andy Warhol Museum, Pittsburgh, entrance; Richard Gluckman, renovation architect

fig. 20. *inSITE94* (installation view), San Diego, California, and Tijuana, Mexico, 1994. Terry Allen, *cross the razor/cruzar la navaja*, 1994, two vans with wooden platforms, amplification system, microphones, translators, and ladders

Japan and the United States both experience unprecedented acts of domestic terrorism, and an assassin attempts to undermine the Middle East peace process. Biennial exhibitions are presented for the first time in Africa and Asia, symbolic of the increasing globalization of the art world—throughout the decade, international biennials and art surveys proliferate in cities such as Cairo, Dakar, Havana, Istanbul, and Lima.

JANUARY
January 11–April 9: Curated by Nayland Blake and Lawrence Rinder, *In a Different Light: Visual Culture, Sexual Identity, Queer Practice* is presented at the University Art Museum in Berkeley, California. The exhibition is the first to explore gay and lesbian sensibilities in twentieth-century American art. *(fig. 22)*

January 18–April 30: Designed by Mario Botta, the new San Francisco Museum of Modern Art opens to the public with the inaugural exhibition *Public Information: Desire, Disaster, Document*, curated by Gary Garrels. The largest museum in the United States devoted to modern and contemporary art after The Museum of Modern Art, the museum will embark on an ambitious program of exhibitions and acquisitions, bringing international attention to San Francisco and helping to revitalize the city's art scene. Among the museum's high-profile purchases are works by Eve Hesse, René Magritte, Robert Rauschenberg, and Mark Rothko. *(fig. 24)*

January 21–March 26: Organized by Helaine Posner and Andrew Perchuk, *The Masculine Masquerade* is presented at the MIT List Visual Arts Center. The exhibition examines social and cultural constructions of masculinity in the visual arts, literature, film, and the media.

January 24: The Tate Gallery announces that it has selected the Swiss architectural firm Herzog & de Meuron to design the museum's new annex for twentieth-century art, which will be housed in a renovated power station on the Thames River in Bankside.

FEBRUARY
February 6: The U.S. space shuttle Discovery docks with the Russian space station Mir. It is the first such orbital rendezvous since the 1970s.

February 12: Designed by architect Renzo Piano, the Cy Twombly Gallery, a joint project of The Menil Collection and the Dia Center for the Arts, opens at The Menil Collection in Houston concurrently with the exhibition *Cy Twombly: A Retrospective*, (through March 19) organized by Kirk Varnedoe and previously shown at The Museum of Modern Art. *(fig. 21)*

February 12–May 7: Organized by Germano Celant, *Claes Oldenburg: An Anthology* is presented at the National Gallery of Art in Washington, D.C. The retrospective will travel to the Museum of Contemporary Art, Los Angeles; the Solomon R. Guggenheim Museum; the Bonn Kunsthalle; and the Hayward Gallery.

February 28–April 30: Organized by Christopher Till and Lorna Ferguson, *Africus 95*, the first Johannesburg Biennale, is presented in Johannesburg. The survey, which features local and international artists in venues throughout the city, explores the influences of European and African culture.

MARCH
March 3–May 10: Curated by Nancy Spector, *Felix Gonzalez-Torres* is presented at the Solomon R. Guggenheim Museum. The exhibition will travel to the Centro Galego de Arte Contemporaneo, Santiago de Compostela, Spain, and the Musée d'art moderne de la Ville de Paris.

21

fig. 21. Cy Twombly Gallery, The Menil Collection, Houston, exterior view; Renzo Piano, architect

fig. 22. *In a Different Light* (installation view), University of California, Berkeley Art Museum, 1994–95

fig. 23. Christo and Jeanne-Claude, *Wrapped Reichstag*, Berlin, 1971–95

fig. 24. San Francisco Museum of Modern Art, San Francisco, California, aerial view; Mario Botta, architect

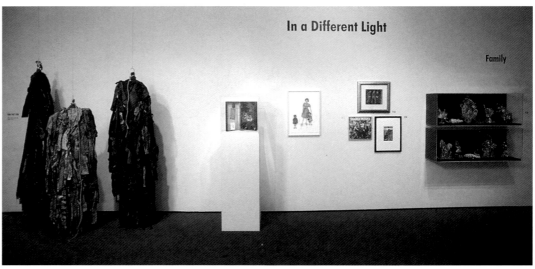

22

March 11–May 21: Curated by Madeleine Grynsztejn, *About Place: Recent Art of the Americas, The 76th American Exhibition* is presented at the Art Institute of Chicago. The exhibition introduces Latin American and Canadian influences to this long-running survey.

March 15–June 25: Curated by Klaus Kertess and exploring the theme of metaphor, the *1995 Biennial Exhibition* is presented at the Whitney Museum of American Art.

March 18: Designed by Takahiko Yanagisawa and the TAK Urban Architecture Office, the Museum of Contemporary Art opens in Tokyo. The museum is criticized for its extravagant recent acquisitions, which total some 6.4 billion yen ($70 million).

March 20: The Japanese cult Aum Shinrikyo releases nerve gas in five Tokyo subway trains, killing twelve people and injuring some 5,000 more.

March 24: Filmmaker Yvonne Rainer receives the 1995 Wexner Prize of $50,000.

March 30–March 1996: Organized by the Hermitage, *Hidden Treasures Revealed* is presented in St. Petersburg. Attended by 1.5 million visitors, the exhibition features seventy-four French paintings, including major Impressionist works believed lost, which were seized by Russian troops from Germany at the close of World War II and kept hidden. Throughout the decade, governments and museums in Europe and Russia will debate and attempt to resolve questions of restitution of art stolen and looted by the Nazis and subsequently acquired by other World War II powers and individuals.

APRIL
April 17: Japanese architect Tadao Ando wins the 1995 Pritzker Architecture Prize of $100,000.

April 19: The Alfred P. Murrah Federal Building in Oklahoma City is destroyed by a car bomb planted by anti-government extremist Timothy McVeigh. The blast kills 168 people, including dozens of young children in a day care center.

April 22: Tutsi-controlled government troops open fire on thousands of Hutu refugees in a camp in an effort to force 250,000 Hutus out of southwestern Rwanda.

MAY
May 7: Conservative Jacques Chirac is elected president of France, ending fourteen years of Socialist rule. He succeeds François Mitterand, who will die in 1996.

May 26–September 17: Curated by Diane Waldman, *Georg Baselitz* is presented at the Solomon R. Guggenheim Museum. The exhibition will travel to the Los Angeles County Museum of Art; Hirshhorn Museum and Sculpture Garden; and Nationalgalerie, Staatliche Museen zu Berlin, Preussischer Kulturbesitz.

JUNE
June 11–October 15: Directed by Jean Clair and exploring issues of otherness and identity, the *XLVI Esposizione Internazionale d'Arte, La Biennale di Venezia* is presented in Venice. Bill Viola represents the United States, and Golden Lions are awarded to R. B. Kitaj and Gary Hill. *Trans-Culture*, an exhibition curated by Fumio Nanjo and

25

Dana Friis-Hansen that explores communication across cultural boundaries, is presented at the Palazzo Giustinian Lolin (through September 4).

June 16–September 11: Curated by Lynn Zelevansky, *Sense and Sensibility: Women Artists and Minimalism in the Nineties* is presented at The Museum of Modern Art.

June 21: Art dealer Joe Fawbush dies at age 38 of AIDS in New York.

June 24: After twenty-four years of negotiations and preparations, artists Christo and Jeanne-Claude, working with ninety professional climbers and 120 installation workers, complete the wrapping of the Reichstag, Germany's historic parliament building, in silver polypropylene fabric. *(fig. 23)*

JULY

July 10: Bosnian Serbs take over Srebenica, a haven for Muslims under the protection of NATO. Intense fighting will take place in the former Yugoslavia throughout the summer.

July 14–October 8: Organized by Vincent J. Varga, *Longing and Belonging: From the Faraway Nearby*, is presented at SITE Santa Fe. The exhibition explores issues of identity within the context of global culture.

July 22–November 26: Organized by Charles Stuckey, *Claude Monet, 1840–1926* is presented at the Art Institute of Chicago. It is the largest Monet retrospective ever assembled.

AUGUST

August 6: Japan observes the fiftieth anniversary of the destruction of Hiroshima by an atomic bomb.

SEPTEMBER

September 20–November 20: Directed by Lee Yong-Woo, *Beyond the Borders*, the first Kwangju International Biennale, is presented in Kwangju, Republic of South Korea. The survey features ninety-four artists from fifty-one countries.

September 21–January 2: Curated by Terence Riley, *Light Construction* is presented at The Museum of Modern Art. The exhibition explores the use of light in modern architecture.

September 25–January 7: Curated by Françoise Cachin, Nicholas Serota, and Joseph Rishel, *Cézanne* is presented at the Galeries Nationales du Grand Palais in Paris. One of the largest presentations ever of the artist's work, the exhibition will draw enormous crowds of visitors before travelling to the Tate Gallery and the Philadelphia Museum of Art.

September 28: A historic agreement is signed at the White House between Israeli prime minister Yitzhak Rabin and PLO leader Yasir Arafat, giving Palestine control of the long disputed West Bank.

OCTOBER

October 1: Congress allocates the NEA $99.5 million for the 1996 fiscal year, and a ban on grants to individual visual artists goes into effect. The drastic budget cuts were approved in July by the U.S. House and Senate, which also voted to eliminate the agency altogether in 1997. The NEA lays off ninety staff members as a result.

October 3: After nine months of highly publicized court proceedings, a Los Angeles jury finds O.J. Simpson not guilty of the murder of his former wife, Nicole Brown Simpson, and her friend Ronald Goldman. In 1997, he will be found liable for their deaths in a civil suit filed by the victims' families.

October 15–February 4: Organized by Ann Goldstein and Anne Rorimer, *Reconsidering the Object of Art: 1965–1975* is presented at the newly reopened Temporary Contemporary of the Museum of Contemporary Art, Los Angeles. It is the first major survey of Conceptual Art presented in the United States.

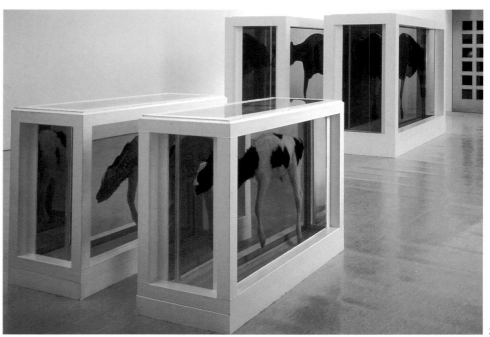

26

October 16: Muslim leader Louis Farakhan leads the "Million Man March," a gathering of approximately 400,000 African-American men in Washington, D.C.

October 21: Artist Nancy Graves dies at age 54 in New York.

NOVEMBER

November: Edited by Sandra Antelo-Suarez, *Trans>*, a multilingual journal focusing on art, culture, and media throughout the Americas, begins publishing in New York.

November 4: Israeli prime minister Yitzhak Rabin is killed by a Jewish extremist at a peace rally in Jerusalem. In 1996, Benjamin Netanyahu, a member of the conservative Likud Party, will be elected prime minister.

November 5–February 18: Curated by Richard Armstrong, the *1995 Carnegie International* is presented at the Carnegie Museum of Art in Pittsburgh. The 1995 Carnegie Prize of $10,000 is awarded to Richard Artschwager and Sigmar Polke.

November 14: As a result of partisan bickering between the White House and Congress over the budget, federal agencies close for six days, and again from December 16–January 5. The National Gallery of Art in Washington, D.C., obtains private funding to remain open for its popular Vermeer exhibition.

November 21: After three weeks of talks in Dayton, Ohio, the leaders of Serbia, Croatia, and Bosnia agree to a peace plan.

November 21–January 14: Curated by Maria Morris Hambourg, *Sugimoto* is presented at the Metropolitan Museum of Art.

November 24: Founded by Rebecca A. Hoffberger for the purpose of exhibiting the work of self-taught or visionary artists, the American Visionary Art Museum opens in a renovated building in Baltimore. *(fig. 25)*

November 28: Damien Hirst is awarded the 1995 Turner Prize of £20,000. *(fig. 26)*

November 29: Designed by Richard Meier, the Museo d'Art Contemporani de Barcelona opens in Spain.

27

fig. 25. *The Tree of Life* (installation view), American Visionary Art Museum, Baltimore, 1995–96

fig. 26. *Turner Prize 1995* (installation view), Tate Gallery, London, 1995. Damien Hirst, *Mother and Child Divided*, 1993, steel, GRP composites, glass, silicone sealants, cow, calf, and formaldehyde solution, Astrup Fearnley Collection, Oslo

fig. 27. Cindy Sherman, *Untitled Film Still #7*, 1978, gelatin-silver print, 9½ x 7¾ inches, The Museum of Modern Art, New York. Purchase

fig. 28. *Felix Gonzalez-Torres* (installation view), Kunstverein St. Gallen Kunstmuseum, St. Gallen, Switzerland, 1997. Felix Gonzalez-Torres, "Untitled," 1989–95, (detail), paint on wall

In the United States, the economy and the art market continue to strengthen, and a number of new contemporary art museums open to the public. Change comes to New York's gallery scene as retail stores move into the popular SoHo arts district, making the neighborhood increasingly crowded and expensive, and many gallery dealers relocate to the Chelsea neighborhood.

JANUARY

January 9: Artist Felix Gonzalez-Torres dies of AIDS at age 38 in Miami. *(fig. 28)*

January 22: The Museum of Modern Art announces that it has acquired the complete set of Cindy Sherman's *Untitled Film Stills*, a series of self-portraits of the artist posing in imagined female roles. The purchase price is estimated to be $1 million. *(fig. 27)*

January 31: Filmmaker Martin Scorsese is awarded the 1996 Wexner Prize of $50,000.

FEBRUARY

February 24: Designed by Charles Gwathmey, the new Museum of Contemporary Art, Miami opens with the exhibition *Defining the Nineties: Consensus-making in New York, Miami, and Los Angeles*, curated by Bonnie Clearwater (through April 6).

February 29–June 2: Curated by Walter Hopps, *Kienholz: A Retrospective* is presented at the Whitney Museum of American Art. The artist's first American retrospective, it will travel to the Museum of Contemporary Art, Los Angeles, and the Berlinsche Galerie.

MARCH

March 3: Legendary art historian and critic Meyer Schapiro dies at age 91 in New York.

96

28

March 10: The Museum of Contemporary Art, San Diego opens its renovated facility in La Jolla, California, designed by Robert Venturi and Denise Scott Brown. The inaugural exhibition, *Continuity and Contradiction*, features works from the museum's permanent collection (through August 28). *(fig. 30)*

March 10–July 14: *Too Jewish? Challenging Traditional Identities* is presented at The Jewish Museum in New York. The exhibition presents forty-five works by young Jewish artists that investigate the representation of Jewishness in contemporary art and culture. *(fig. 29)*

May 17–July 28: Organized by Kerry Brougher, *Hall of Mirrors: Art and Film Since 1945* is presented at the Museum of Contemporary Art, Los Angeles. The exhibition will travel to the Wexner Center for the Visual Arts, the Palazzo delle Esposizioni in Rome, and the Museum of Contemporary Art, Chicago.

March 27: Jean-Jacques Aillagon, director of cultural affairs in Paris, is appointed president of the Centre Georges Pompidou, succeeding François Barré. He will oversee an extensive renovation at the facility. In 1997, German art historian Werner Spies will be named director of the Centre Georges Pompidou's Musée National d'Art Moderne and the Centre de Création Industrielle, succeeding Germain Viatte.

APRIL

April 3: The FBI arrests Ted Kaczynski, known as the Unabomber, who is responsible for some sixteen bomb attacks throughout the United States over the past two decades.

April 16: The Museum of Modern Art receives a gift of seventy-five works of contemporary art from Elaine Dannheisser and the Dannheisser Foundation. Among the artists represented in the collection are Joseph Beuys, Bruce Nauman, Sigmar Polke, and Cindy Sherman.

29

April 29: Spanish architect José Rafael Moneo is awarded the 1996 Pritzker Architecture Prize of $100,000.

JUNE

June 20–September 15: Curated by Neal Benezra and Olga M. Viso, *Distemper: Dissonant Themes in the Art of the 1990s* is presented at the Hirshhorn Museum and Sculpture Garden. *(fig. 32)*

June 26: A truck bomb explodes outside a U.S. army barracks in Saudi Arabia, killing nineteen and injuring more than 100 soldiers.

JULY

July 1–September 9: Curated by Lynne Cooke, *Jurassic Technologies Revenant*, the Tenth Biennale of Sydney, is presented. The exhibition features the work of forty-eight artists and reappraises traditional reproductive technologies such as photography, video, and film.

July 2: Designed by Josef Paul Kleihues, the new Museum of Contemporary Art, Chicago opens with the exhibition *Negotiating Rapture: The Power of Art to Transform Lives*, curated by Richard Francis and exploring the concept of creativity as a form of religious ecstasy (through October 20).

July 22: German art collector and museum patron Peter Ludwig dies at age 71 in Aachen, Germany. Using the wealth from his chocolate manufacturing empire, Ludwig established the Ludwig Museum in Cologne in 1986 and later established annexes in Aachen and Coblenz, both in Germany, Budapest, Vienna, Moscow, St. Petersburg, and Havana.

July 27: A bomb explodes in Centennial Park during the Olympic Games in Atlanta, killing two and injuring more than 100 people.

30

AUGUST

August 12: Richard Armstrong, chief curator and curator of contemporary art at the Carnegie Museum of Art, is appointed its director.

SEPTEMBER

September: Designed by Oscar Niemeyer, the Museu de Arte Contemporânea de Niterói, a museum devoted to contemporary Brazilian art, opens near Rio de Janeiro.

OCTOBER

October 1: Congress allocates the NEA $99.5 million for 1997 fiscal year. The agency once again survives Republican attempts to end its funding, but Arts America, a bureau within the U.S. Information Agency that helps fund and organize U.S. participation in international art festivals, is eliminated.

October 3–January 5: Curated by Elisabeth Sussman, *Nan Goldin: I'll Be Your Mirror* is presented at the Whitney Museum of American Art. The photographer's first retrospective, it will travel to the Kunstmuseum Wolfsburg, the Stedelijk Museum of Modern Art in Amsterdam, and the Fotomuseum Winterthur.

October 5–December 8: The *XXIII Bienal Internacional de São Paulo* is presented. The survey explores the theme of dematerialization at the end of the millennium. Sol Lewitt represents the United States.

October 9: The Museum of Modern Art announces that it has acquired two major works from the Pop movement, Andy Warhol's *Campbell Soup Cans* (1962) and James Rosenquist's *F-111* (1965).

October 11: The AIDS Memorial Quilt, the world's largest ongoing community arts project, is displayed on the Mall in Washington, D.C. *(fig. 31)*

October 18–January 15: Curated by Diane Waldman, *Ellsworth Kelly: A Retrospective* is presented at the Solomon R. Guggenheim Museum. The exhibition travels to the Museum of Contemporary Art, Los Angeles; the Tate Gallery; and Haus der Kunst, Munich.

October 20–January 21: Curated by Kirk Varnedoe, *Jasper Johns: A Retrospective* is presented at The Museum of Modern Art. The exhibition will travel to the Ludwig Museum and the Museum of Contemporary Art, Tokyo.

October 23–January 5: Curated by Milena Kalinovska, *New Histories* is presented at Institute of Contemporary Art, Boston. The exhibition explores multiculturalism from a global perspective.

NOVEMBER

November 6: Bill Clinton is reelected president of the United States defeating Republican challenger Robert Dole.

November 20: Christie's sells Willem de Kooning's *Woman* (1949) for $15.6 million, the most paid for a work of art at auction in 1996. The fall auctions post the best results for contemporary art since 1990.

November 20–January 19: *The Hugo Boss Prize: 1996* exhibition is presented at the Solomon R. Guggenheim Museum. Matthew Barney is awarded the first annual Hugo Boss

31

Prize of $50,000. Administered by the Guggenheim and funded by Hugo Boss, the award is modeled after the Turner Prize and is presented to an international artist whose recent work represents a major achievement in contemporary art.

November 29: Douglas Gordon is awarded the 1996 Turner Prize of £20,000.

DECEMBER

December 4: Sculptor Dan Flavin dies at age 63 in Riverhead, Long Island, New York.

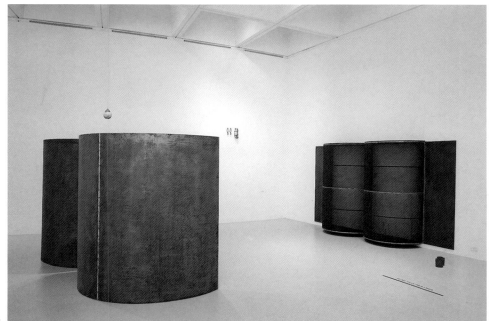

fig. 29. *Too Jewish? Challenging Traditional Identities* (installation view), The Jewish Museum, New York, 1996

fig. 30. Museum of Contemporary Art, San Diego, at La Jolla, entrance; Robert Venturi and Denise Scott Brown, architects

fig. 31. THE NAMES Project, *National AIDS Memorial Quilt*, displayed on The Mall, Washington, D.C., October 11, 1996

fig. 32. *Distemper: Dissonant Themes in the Arts of the 1990s* (installation view), Hirshhorn Museum, Washington, D.C., 1996. Miroslaw Balka, *Zeitnot*, steel, soap, and electric cord, Hirshhorn Museum and Sculpture Garden, Smithsonian Institution, Joseph H. Hirshhorn Bequest Fund, 1996

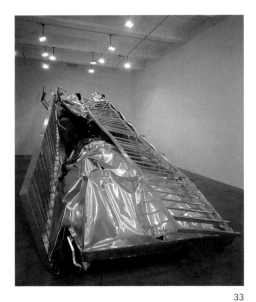

33

fig. 33. Martin Kippenberger, *Transportable Subway Entrance (Crushed)*, 1997, aluminum and stainless steel

fig. 34. Mourners, amidst a sea of flowers in memory of the late Princess Diana, at Kensington Palace, London, September 4, 1997

fig. 35. Guggenheim Bilbao Museoa, Spain, south view; Frank Gehry, architect

fig. 36. Fondation Beyeler, Riehen, Switzerland, The Monet Room; Renzo Piano, architect

A deepening financial crisis shakes markets throughout Asia but spares the U.S. economy, which continues to flourish. After years of preparation, the Guggenheim Bilbao Museoa and the Getty Center in Los Angeles—the two most ambitious museum projects of the 1990s—open to critical acclaim. Several other museums, including The Museum of Modern Art, select prominent architects for coveted building projects and two small museums, each with a unique focus, are successfully inaugurated in Santa Fe and Riehem, Switzerland.

JANUARY
January 17: Israel withdraws its troops from Hebron and turns control of the town over to the Palestinian Authority.

January 17–April 27: Curated by Jennifer Blessing, *Rrose is a Rrose is a Rrose: Gender Performance in Photography* is presented at the Solomon R. Guggenheim Museum. The exhibition includes eighty works by thirty artists and explores the representation of sexual identity in photography.

FEBRUARY
February 19: Deng Xiaoping, the leader of China since 1976, dies at age 92.

February 24: Scientists at Edinburgh's Roslin Institute announce that they have successfully cloned a sheep named "Dolly." It is the first successful cloning of an adult mammal and sparks fresh debate on the ethics of genetic engineering.
(page 77)

MARCH
March 7: Artist Martin Kippenberger dies at age 43 in Vienna, Austria. *(fig. 33)*

March 19: Artist Willem de Kooning dies at age 92 in East Hampton, Long Island, New York.

March 20–June 15: Organized by Lisa Phillips and Louise Neri, the *1997 Biennial Exhibition* is presented at the Whitney Museum of American Art. The exhibition features 200 works by seventy artists.

APRIL
April 14: Norwegian architect Sverre Fehhn is awarded the 1997 Pritzker Architecture Prize of $100,000.

April 18: Two Russian diplomatic cars block a road outside the Corcoran Gallery of Art to prevent the exhibition *Jewels of the Romanovs: Treasures of the Russian Imperial Court* from being shipped to its next venue at the Museum of Fine Arts, Houston, while the organizers squabble over the administration and profits from the show. The 200-piece exhibition will open as planned in Houston on May 11 and the resulting publicity will dramatically boost attendance.

MAY
May 1: Labour Party member Tony Blair is elected prime minister of Great Britain, succeeding John Major.

May 6: The Modern Art Museum of Fort Worth announces that Tadao Ando has been selected to design its new building, scheduled to open in 2004.

May 12: Samuel Sachs II, director of the Detroit Institute of Arts, is appointed director of the Frick Collection in New York. In July 1999, Graham W. J. Beal, director of the Los Angeles County Museum of Art, is appointed director of the Detroit Institute of Arts.

May 23: Performance and installation artist James Lee Byars dies at age 65 in Cairo, Egypt.

97

34

35

JUNE
June 4: Painter Gerhard Richter is awarded the 1997 Wexner Prize of $50,000

June 15–November 9: Organized by Germano Celant, the *XLVII Esposizione Internazionale d'Arte, La Biennale di Venezia* in Venice is presented. The survey features established and emerging artists from the last thirty years. Robert Colescott represents the United States. Golden Lions are awarded to Gerhard Richter, Marina Abramovic, Agnes Martin, and Emilio Vedova.

June 21–September 28: Curated by Catherine David, *Documenta X* is presented in Kassel, Germany. The survey features numerous artists, architects, and filmmakers from Europe and the United States and a vast international exchange of ideas involving "100 Days/100 Guests."

June 23: In Cambodia, Pol Pot, the former leader of the Khmer Rouge responsible for the deaths of millions during the 1970s, is captured. He will die in April 1998.

JULY
July 1: Great Britain turns over control of Hong Kong to the Chinese government.

July 17: The Georgia O'Keeffe Museum opens in Santa Fe in a historic building renovated by Richard Gluckman. It is the first major U.S. museum devoted exclusively to the work of a woman artist.

July 18–October 12: Organized by Francesco Bonami, *Truce: Echoes of Art in an Age of Endless Conclusions* is presented at SITE Santa Fe. The exhibition explores multiculturalism in the work of twenty-seven artists from twenty countries.

AUGUST
August 31: Princess Diana, her companion Dodi Fayad, and their driver are killed in a car crash in Paris while being pursued by photographers. Millions of people will mourn her death and watch her memorial service, which is televised around the world on September 6. *(fig. 34)*

SEPTEMBER
September 19–January 7: Curated by Walter Hopps and Susan Davidson and featuring some 400 works, *Robert Rauschenberg: A Retrospective* is presented at the Solomon R. Guggenheim Museum, the Guggenheim SoHo, and at Ace Gallery. The exhibition will travel to Houston, where it is presented by The Menil Collection, Contemporary Arts Museum, and the Museum of Fine Arts, Houston, before moving on to the Ludwig Museum and the Guggenheim's new museum in Bilbao.

36

September 25–June 14: Curated by Lynne Cooke, *Richard Serra: Torqued Ellipses* is presented at the Dia Center for the Arts.

September 26: Earthquakes in Italy's Umbrian region severely damage numerous monuments, including the Basilica of Saint Francis of Assisi and its important frescoes by Cimabue and Giotto.

September 29: Artist Roy Lichtenstein dies at the age of 73 in New York.

OCTOBER
October 1: Congress allocates the NEA $98 million for the 1998 fiscal year. The Clinton administration unsuccessfully proposed to raise the NEA's budget to $136 million. In July, the U.S. House of Representatives voted to eliminate all funding for the agency, but this largely symbolic decision was later reversed in a House/Senate conference committee.

October 9: NEA chairman Jane Alexander announces that she will resign from the agency. In 1998, the Clinton administration will nominate William Ivey, director of the Country Music Foundation in Nashville, Tennessee, who is unanimously confirmed for the position.

October 13: Timothy Potts, director of the National Gallery of Victoria in Melbourne, Australia, closes an exhibition of works by photographer Andres Serrano after the artist's *Piss Christ* (1987) is vandalized and the museum receives numerous bomb threats. In the spring, vandalism and a bomb threat had temporarily closed the Groninger Museum in The Netherlands during its presentation of the exhibition.

October 19: Designed by Frank Gehry, the Guggenheim Bilbao Museoa, the centerpiece of a $1.5 billion development plan designed to revitalize the Basque region, opens in Bilbao, Spain. The museum's dramatic facade and interiors,

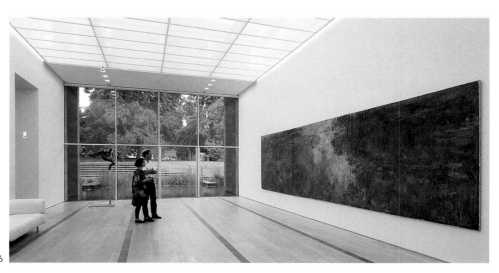

37

which challenge the staid, neutral look of many recent museum designs, are met with critical acclaim, and it will attract 1.36 million visitors in its first year of operation. Continuing to expand its presence on a global scale, the Solomon R. Guggenheim Museum will open the Deutsche Guggenheim Berlin in November. This more modest satellite branch is housed on the ground floor of its sponsor, the Deutsche Bank.

(p. 76; fig. 35)

October 21: Designed by Renzo Piano, the Foundation Beyeler opens in Riehem, Switzerland, housing the renowned collection of modern art assembled by its founder, art dealer Ernst Beyeler. In contrast to the drama and publicity surrounding the opening of the Guggenheim Museum Bilbao, the Beyeler is a modestly scaled facility, designed to foster a contemplative atmosphere. *(fig. 36)*

October 22: As a result of the financial crisis sweeping through Asia, the Hong Kong stock market plunges ten percent. The economies of Thailand, Malaysia, Indonesia, and South Korea are among the countries experiencing severe economic troubles.

October 24: Doreen Bolger, director of the Rhode Island School of Design's Museum of Art, is named director of the Baltimore Museum of Art. She succeeds Arnold Lehman, who becomes director of the Brooklyn Museum of Art. In January, Bolger will ask longtime assistant director and contemporary curator Brenda Richardson to resign.

October 29: P.S.1 Contemporary Art Center in Long Island City, Queens, New York, reopens after a major renovation and expansion designed by Frederick Fisher.

NOVEMBER

November 2–February 1: Organized by Elizabeth A. T. Smith and Amada Cruz, *Cindy Sherman: Retrospective* is presented at the Museum of Contemporary Art, Los Angeles. The exhibition will travel to the Museum of Contemporary Art, Chicago; Galerie Rudolfinum, Prague; Centro Cultural de Belem, Lisbon; CAPC Musée d'art contemporain, Bordeaux; the Museum of Contemporary Art, Sydney; and the Art Gallery of Ontario. In December, the artist will premiere her first film, a dark comedy called *Office Killer*.

November 10: Christie's sells the collection of modern art assembled by the late Victor and Sally Ganz for $206 million.

November 17: Islamic terrorists gun down seventy people, mostly tourists, at the Temple of Hatshepsut in Luxor, Egypt.

November 21: Gerard Jan van Bladeren, the vandal who slashed a major Barnett Newman painting in 1986 at the Stedelijk Museum of Modern Art, returns to the museum and slashes Newman's *Cathedra* (1951), worth an estimated $12 million.

DECEMBER

December 2: Gillian Wearing is awarded the 1997 Turner Prize of £20,000.

December 8: The Museum of Modern Art selects Japanese architect Yoshio Taniguchi to design its expansion.

December 16: Designed by Richard Meier and costing $1 billion, the Getty Center, a vast hilltop complex housing the J. Paul Getty Museum and other operations of the Getty Trust, opens in Los Angeles. The new facility, which includes a three-acre garden designed by artist Robert Irwin, will draw an international audience to the city. The complex will be overwhelmed by the public response, which far exceeds expectations. *(fig. 37)*

December 31: The Museum of Contemporary Art, Chicago, files suit against former trustee Paul Oliver-Hoffman and his wife, Camille, in order to collect an unpaid pledge of $5 million for the museum's capital campaign. In 1998, the museum will receive a painting by Anselm Kiefer and one by Chuck Close as a settlement.

December 31: Art patron Dominique de Menil, who with her husband, John, commissioned the Rothko Chapel and who later oversaw the design and construction of The Menil Collection to house her family's important holdings of antiquities, tribal works, and modern and contemporary art, dies at age 89 in Houston. *(fig. 38)*

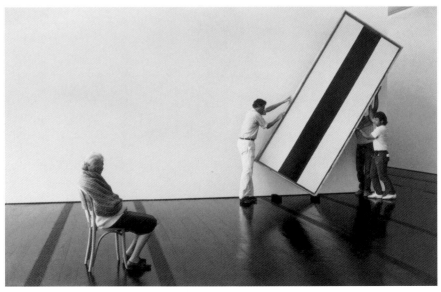

38

39

fig. 37. Getty Center, Los Angeles, aerial view facing south; Richard Meier, architect

fig. 38. Dominique de Menil supervising the installation of Barnett Newman, *Now II*, 1967, The Menil Collection, Houston, 1987

fig. 39. Nykytaiteen museo Kiasma, Helsinki, Finland, entrance hall; Steven Holl, architect

98

The story of President Bill Clinton's affair with White House intern Monica Lewinsky and his impeachment dominates headlines around the world for much of the year, often stifling the coverage of other important news. Slobadan Milosevic, president of the Federal Republic of Yugoslavia, wages a shocking campaign of "ethnic cleansing" against ethnic Albanians in Kosovo. The United States economy continues to flourish and initial public offerings for high tech companies abound. Chelsea replaces SoHo as the "hot" district for contemporary art galleries in New York.

JANUARY
January 7: The Manhattan district attorney issues a subpoena ordering The Museum of Modern Art to hold two Egon Schiele paintings loaned to the exhibition *Egon Schiele: The Leopold Collection*, Vienna while a grand jury investigates claims that the works were stolen from Jewish art collectors in Austria during the Nazi era. On May 13, the New York Supreme Court will rule that the museum may return the two works to the Austrian government, which purchased the Leopold Collection in 1994. The following year, on September 21, 1999, the New York State Court of Appeals will rule that one of the works must stay in New York while the question of its proper ownership is resolved in court. The case brings to light the complicated legal and ethical issues surrounding artwork stolen by the Nazis during the Holocaust and World War II. In February, the Association of Art Museum Directors will announce that it has formed a task force to develop guidelines for resolving such disputes; these will be adopted in June.

January 22: Pope John Paul II visits Cuba, where he meets with Fidel Castro and openly criticizes the dictator's oppressive Communist regime.

January 26: President Bill Clinton denies that he had an affair with White House intern Monica Lewinsky and that he encouraged her to lie about their relationship to Kenneth Starr, the independent counsel charged with investigating the president's role in the failed Arkansas land deal known as Whitewater and other potential wrongdoings. On June 30, Linda Tripp, a friend of Lewinsky's who secretly taped their conversations about the affair, will testify to a Washington grand jury that Lewinsky and Clinton intended to lie about their relationship in a pending sexual harassment lawsuit filed by Paula Jones.

FEBRUARY
February 8–May 10: Curated by Paul Schimmel, *Out of Actions: Between Performance and the Object, 1949–1979* is presented at The Geffen Contemporary of the Museum of Contemporary Art, Los Angeles. The exhibition explores the complex relationship between performance art and object-oriented art in the post-war era. It will travel to the Österreichisches Museum für Angewandte, Vienna; Museu d'Art Contemporani, Barcelona; and the Museum of Contemporary Art, Tokyo.

February 13: Harris County constables seize fifteen works from the Robert Rauschenberg retrospective on view at The Menil Collection in Houston as a result of a lawsuit filed against the artist by dealer Alfred Kren. The works will be returned on February 19 after Rauschenberg and Kren reach a settlement. In 1999, Texas will pass a law to prevent authorities from seizing works of art on loan to museums.

February 15: The Moderna Museet in Stockholm reopens following a renovation and expansion designed by José Rafael Moneo with the exhibition *Wounds: Between Democracy and Redemption in Contemporary Art*, which explores developments in contemporary art from the 1960s to the present (through April 19).

February 26–May 26: Curated by Robert Storr, *Chuck Close* is presented at The Museum of Modern Art. The retrospective travels to the Museum of Contemporary Art, Chicago; the Hirshhorn Museum and Sculpture Garden; and the Seattle Art Museum.

MARCH
March 8–June 8: Curated by Lynn Zelevansky and Laura Hoptman, *Love Forever: Yayoi Kusama, 1958–1968* is presented at the Los Angeles County Museum of Art. The exhibition travels to The Museum of Modern Art; the Walker Art Center; and Museum of Contemporary Art, Tokyo.

March 29: Art dealer Richard Bellamy dies at age 70 in New York.

March 29–July 12: Curated by Marla Prather, *Alexander Calder* is presented at the National Gallery of Art in Washington, D.C. The retrospective will travel to the San Francisco Museum of Modern Art.

APRIL
April 4: The Whitney Museum of American Art opens its newly renovated permanent collection galleries, designed by Richard Gluckman, with an installation of 100 works from the museum's holdings. The understated renovation is the first major alteration to the Whitney's Marcel Breuer building.

April 10: Historic peace talks are concluded between the British and Irish governments and the Ulster political parties.

April 19: Poet and art critic Octavio Paz dies at age 84 in Mexico City.

April 20: Italian architect Renzo Piano is awarded the 1998 Pritzker Architecture Prize of $100,000.

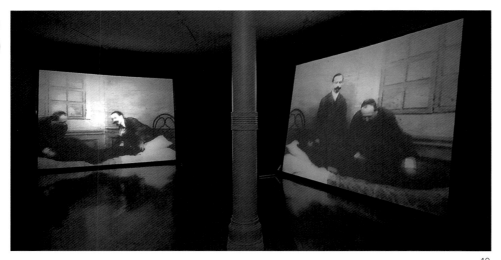

40

April 23: Citing the economic benefit of the city's museums, New York mayor Rudolph Giuliani pledges $65 million in city funds toward The Museum of Modern Art's $650 million capital campaign. Throughout the decade, an unprecedented number of museums and cultural organizations embark on capital campaigns. Among the largest are those of the Metropolitan Museum of Art ($300 million) and the Museum of Fine Arts, Houston ($115 million).

MAY
May 3–August 16: Curated by Jeffrey Weiss, *Mark Rothko* is presented at the National Gallery of Art in Washington, D.C. The retrospective will travel to the Whitney Museum of American Art and the Musée d'Art Moderne de la Ville de Paris.

May 5: *The New York Times* reports that Bill Gates has purchased Winslow Homer's *Lost on the Grand Banks* (1885), the last seascape by the artist in private hands, for $30 million, the highest sum ever spent on an American work of art.

May 12: India conducts its first nuclear test in twenty-four years. On May 28, Pakistan will test several nuclear devices, adding to the tension between the two rival countries.

May 14: Sotheby's sells Andy Warhol's painting *Orange Marilyn* (1964) for $17.3 million, a new record for the artist.

May 20: Indonesia's president Suharto, who ruled the economically troubled country for more than thirty years, resigns following weeks of rioting in Jakarta that claimed the lives of thousands.

May 29: Designed by Steven Holl, Nykytaiteen museo Kiasma, a dramatic new museum devoted to contemporary art, opens in Helsinki. *(fig. 39)*

May 29: Robert Fitzpatrick, former CEO of Euro Disney and dean of Columbia University's School of the Arts, is named director of the Museum of Contemporary Art, Chicago. He succeeds Kevin E. Consey who resigned in 1997.

JUNE
June 3: The Sara Lee Corporation announces that it will donate many of the finest works in its art collection, valued at $100 million, to twenty museums throughout the United States. It is one of the largest corporate gifts in history.

June 4–August 30: Organized by Paul Schimmel, *Charles Ray* is presented at the Whitney Museum of American Art. The exhibition documents Ray's psychologically charged, body-oriented work from 1973 to 1998 and will travel to the Museum of Contemporary Art, Los Angeles and the Museum of Contemporary Art, Chicago.

June 5: Artist Dieter Roth dies at age 68 in Basel, Switzerland.

June 24–September 20: Featuring works by William Kentridge, Pipilotti Rist, Lorna Simpson, Huang Yong Ping, and other artists, the *Hugo Boss Prize: 1998* exhibition is presented at the Guggenheim SoHo. Scottish artist Douglas Gordon is awarded the 1998 Hugo Boss Prize of $50,000. *(fig. 40)*

June 26–September 20: Curated by motorcycle enthusiast and museum director Thomas Krens, *The Art of the Motorcycle* is presented at the Solomon R. Guggenheim Museum. The exhibition, part of the museum's attempt to broaden its cultural reach and audience, will attract record crowds before moving to the Field Museum in Chicago and the Guggenheim Bilbao Museoa. *(fig. 41)*

41

42

43

JULY

July 29: Maxwell Anderson, director of the Art Gallery of Ontario, is appointed director of the Whitney Museum of American Art. He succeeds David A. Ross, who resigned in March to become director of the San Francisco Museum of Modern Art. Anderson will implement major administrative changes, and a number of the museum's top curators will soon depart, including Lisa Phillips who is appointed director of The New Museum of Contemporary Art in December. She succeeds Marcia Tucker, the museum's founding director, who announced her retirement earlier in the year.

AUGUST

August 7: Terrorist bombs destroy two U.S. embassies, one in Nairobi, Kenya, and the other in Dar Es Salaam, Tanzania, killing twelve Americans and more than 200 Africans. The United States retaliates on August 20 by launching missile attacks on suspected terrorist sites in Afghanistan and Sudan.

SEPTEMBER

September 18–November 8: Directed by Jonathan Watkins, *Every Day*, the Eleventh Sydney Biennale, is presented. Exploring numerous themes, the survey presents the work of 101 artists at ten separate venues.

September 20–December 27: Curated by Paul Hayes Tucker with George T. M. Schackelford and Mary Anne Stevens, *Monet in the 20th Century* is presented at the Museum of Fine Arts, Boston. It will be the best attended art exhibition of the year, with 537,502 visitors, before traveling to the Royal Academy of Arts, London.

September 20–January 3: Curated by Elizabeth Armstrong, *David Reed Paintings: Motion Pictures* is presented at the Museum of Contemporary Art, San Diego. The exhibition is the artist's first retrospective in the United States and will travel to the Wexner Center for the Visual Arts and P.S.1 Contemporary Art Center, Long Island City, New York.

September 29–January 3: Curated by Klaus Biesenbach, Hans Ulrich Obrist, and Nancy Spector, *Berlin/Berlin*, the first Berlin Biennale, is presented. The survey explores the relationships between art, architecture, performance, and design.

OCTOBER

October 1: Congress allocates the NEA $98 million for the 1999 fiscal year. The Clinton administration had proposed a budget of $168 million, but the U.S. House of Representatives voted in July to keep the NEA's 1999 budget at the previous year's level.

October 3–December 13: Curated by Paulo Herkenhoff, the *XXIV Bienal Internacional de São Paulo* is presented. The Bienal does not have an overall theme but is instead divided into segments that explore historical works, the subject of "routes," and national representations. Judy Pfaff represents the United States.

October 15: Bellagio, a luxury resort and casino with a fine art theme, opens in Las Vegas. The centerpiece of the $1.9 billion resort is the Bellagio Gallery of Fine Art, which houses a $285 million collection of Old and Modern Masters, including works by Claude Monet, Vincent Van Gogh, Pablo Picasso, Willem de Kooning, Robert Rauschenberg, and other major artists acquired for the gallery by entrepreneur Stephen A. Wynn. *(figs. 42–43)*

October 26: *The New York Times* reports that The Museum of Modern Art has turned over two prized Vincent Van Gogh drawings from its collection to the Metropolitan Museum of Art and two Georges Seurat drawings to the Art Institute of Chicago. The works were bequeathed to the museum by Abby Aldrich Rockefeller, who stipulated that the drawings must be given to other museums after 50 years when they are no longer considered "modern."

NOVEMBER

November 1–February 2: Curated by Kirk Varnedoe with Pepe Karmel, *Jackson Pollock* is presented at The Museum of Modern Art. The acclaimed retrospective will travel to the Tate Gallery.

November 16–17: In order to boost its low profits, the Reader's Digest Association, Inc., sells off a number of major works at Sotheby's, including paintings by Paul Cézanne, Amedeo Modigliani, and Claude Monet, from its 8,000-piece art collection. The sale raises $90.5 million.

November 19: In a sign that the art market has completely recovered from the recession of the early 1990s, a self portrait by Vincent Van Gogh sells for $71.5 million at Christie's. The fall auctions establish new records for contemporary works as well: on November 12, Christie's sold Jean Michel Basquiat's *Self Portrait* (1982) for $3.3 million and Robert Gober's *Untitled (Man in Drain)* (1993–94) for $522,000. Sotheby's sold Jeff Koons's sculpture *String of Puppies* (1988) for $288,500 on November 17.

November 19: *The New York Times* reports that the Solomon R. Guggenheim Museum is considering building a new branch on a fifteen-acre pier on the Hudson River near Greenwich Village and SoHo. The plan would call for closing the museum's existing SoHo branch. Hoping to repeat the success of its Bilbao museum, the Guggenheim will propose in 1999 to build a forty-five-story, $850 million building designed by Frank O. Gehry on New York's East River near Wall Street.

fig. 40. *Hugo Boss Prize 1998* (installation view), Guggenheim Museum SoHo, New York, 1998. Douglas Gordon, *Hysterical*, 1995, two-channel video installation, transferred from archival film (dir. Roberto Omegna, Turin, 1908), continuous loop, Musée départemental d'art contemporain, Rochechouart (Haute-Vienne), France

fig. 41. *The Art of the Motorcycle*™ (installation view), Solomon R. Guggenheim Museum, New York, 1998

figs. 42–43. The Gallery of Fine Art and the Fountains at the Bellagio, Las Vegas

44

November 20: The Menil Collection opens a long-term light installation by the late Dan Flavin in its exhibition annex Richmond Hall. It is the penultimate project completed by the artist before his death and the last work commissioned by the late Dominique de Menil. The installation opens in conjunction with the exhibition *Dan Flavin/ Donald Judd: Aspects of Color* curated by Marianne Stockebrand (through January 24, 1999).

DECEMBER
December 1: Painter Chris Ofili is awarded the 1998 Turner Prize of £20,000.

December 8: British advertising magnate and art collector Charles Saatchi sells a substantial number of works from his collection of contemporary art at Christie's, London, bringing record prices for work by artists Chris Ofili, Jenny Saville, Thomas Schütte, Cindy Sherman, and Rachel Whiteread. Throughout the decade, as the focus of his collection shifted, Saatchi sold older works from the 1980s and bought works by young British artists ("YBA's") from the 1990s, often in large quantities.

December 16–18: The United States once again launches missile strikes against Iraq for refusing to cooperate with U.N. weapons inspectors.

December 17: The U.S. House of Representatives votes to impeach President Bill Clinton for lying to a grand jury about his relationship with Monica Lewinsky and for obstruction of justice. He will be acquitted by the U.S. Senate on February 12, 1999.

December 18: John R. Lane, who resigned as director of the San Francisco Museum of Modern Art in 1997, is appointed director of the Dallas Museum of Art. He succeeds Jay Gates, who became director of the Phillips Collection in Washington, D.C., in 1997.

fig. 44. MASS MoCA, view of Building 5 Gallery with Robert Rauschenberg, *The 1/4 Mile or 2 Furlong Piece*, 1981–present

fig. 45. *Global Conceptualism: Points of Origin, 1950s–1980s* (installation view), Queens Museum of Art, New York, 1999

fig. 46. Leo Castelli at the opening of *Roy Lichtenstein*, Musée des Beaux-Arts de Montréal, 1994

As ethnic tensions persist in Eastern Europe and fighting intensifies in the Russian republic of Chechnya, the world prepares for the year 2000, which brings a mixture of optimism and apprehension over the coming millennium. By the end of the year, more than $300 billion has been spent fixing Y2K computer problems. The strongest American economy in a generation, driven in part by low interest rates, low unemployment, and a dramatic rise in technology-related stocks, continues to fuel the art market and museum expansions. A national controversy over censorship and government funding of the arts emerges in Brooklyn.

JANUARY
January 14: The Fine Arts Museums of San Francisco select Herzog & de Meuron to design the new M.H. de Young Memorial Museum in Golden Gate Park.

January 21–April 4: Curated by Dan Cameron, *Fever: The Art of David Wojnarowicz* is presented at The New Museum of Contemporary Art.

January 23: Businessman and philanthropist Jay Pritzker, founder of the Pritzker Architecture Prize, dies at age 76 in Chicago.

FEBRUARY
February 1: Art collector and philanthropist Paul Mellon, a major patron of the National Gallery of Art in Washington, D.C., and the Yale Center for British Art, dies at age 91 in Upperville, Virginia.

February 2: The Museum of Modern Art and P.S.1 Contemporary Art Center announce that they have signed a letter of intent to merge the two organizations.

February 12: Catherine de Zegher, co-founder of the Kanaal Art Foundation in Kortrijk, Belgium, is appointed director of The Drawing Center in New York. She succeeds Ann Philbin, who

becomes director of the University of California, Los Angeles at the Armand Hammer Museum of Art and Cultural Center upon the retirement of Henry Hopkins.

February 22: Sculptor Louise Bourgeois is awarded the 1999 Wexner Prize of $50,000.

February 26–June 1: Curated by Gao Minglu, *Inside Out: New Chinese Art* is presented at the San Francisco Museum of Modern Art and the Asian Art Museum of San Francisco. It opened at the Asia Society Galleries, New York, and P.S.1 Contemporary Art Center, Long Island City, New York. It will travel to the Museo de Arte Contemporáneo, Monterrey, Mexico; and the Tacoma Art Museum and the Henry Art Gallery, Seattle.

MARCH

March 6: *The New York Times* reports that China has been able to develop a new generation of smaller, more advanced nuclear weapons using information stolen from Los Alamos National Laboratory in New Mexico. Scientist Wen Ho Lee is investigated and later indicted for spying for China, and the lab is harshly criticized for its lax security.

March 8: Jeremy Strick, curator of twentieth-century painting and sculpture at the Art Institute of Chicago, is named director of the Museum of Contemporary Art, Los Angeles. He succeeds Richard Koshalek, who retired in February.

March 8: The Dia Center for the Arts announces that it will open a new exhibition space in a renovated factory on the Hudson River in Beacon, New York. The facility will enable Dia to exhibit more of its holdings of large-scale contemporary works.

March 14–June 1: Curated by Kynaston

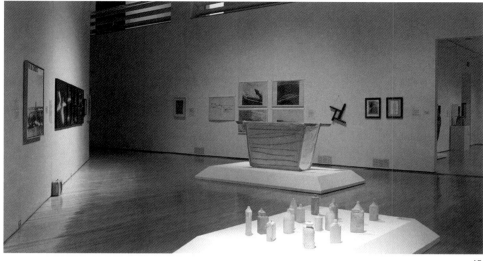

McShine, *The Museum as Muse: Artists Reflect* is presented at The Museum of Modern Art. The exhibition features works of art that reflect the complex relationships between artists and museums over the last 200 years. It will travel to the Museum of Contemporary Art, San Diego.

March 23: NATO commences air strikes against Serbian troops who are killing vast numbers of ethnic Albanians in Kosovo in an effort to drive them out of the region. More than 500,000 ethnic Albanians will be forced to flee to refugee camps in neighboring Macedonia, Montenegro, and Albania, and numerous mass graves will be discovered. On May 7, the Chinese embassy in Belgrade will be accidentally destroyed in the bombing, adding to the strained relationship between the United States and China.

March 29: The Dow Jones industrial average breaks the 10,000 barrier for the first time.

APRIL

April 11: British architect Sir Norman Foster is awarded the 1999 Pritzker Architecture Prize of $100,000.

April 17: The Nagoya/Boston Museum of Fine Arts opens in Nagoya, Japan. A month later, the Museum of Fine Arts, Boston announces that Sir Norman Foster has been selected to design the museum's renovation and expansion project in Boston. On June 25, director Malcolm Rogers, will announce a dramatic restructuring of the curatorial departments and eliminate eighteen positions, including those of several longtime curators. The museum's actions will make headlines around the world.

April 21: Two teenagers armed with automatic weapons and pipe bombs enter Columbine High School in Littleton, Colorado, and kill thirteen students and teachers. It is the worst in a rash of recent school shootings in the United States, which leads to an intensified national debate on teen violence and gun control.

April 23–August 22: Curated by Barbara Haskell and focusing on American art from 1900–1950, Part I of *The American Century: Art and Culture, 1900–2000* is presented at the Whitney Museum of American Art. Part II of the sweeping survey, curated by Lisa Phillips and featuring work from 1950–2000, will be presented September 26–February 13, 2000.

April 28–August 29: Curated by Jane Farver, Luis Camnitzer, and Rachel Weiss, *Global Conceptualism: Points of Origin, 1950s–1980s* is presented at the Queens Museum of Art in New York. The exhibition, which includes 240 works by more than 135 artists, explores the history and politics of Conceptual Art from an international perspective. *(fig. 45)*

MAY

May 3: *The New York Times* reports that two

47

dozen foundations and philanthropists have established the Creative Capital Foundation to offset the NEA's elimination of grants to individual artists. The organization plans to distribute $1 million a year in grants.

May 9: The Stedelijk Museum voor Actuele Kunst opens a new facility in a renovated ballroom in Ghent, Belgium, with an exhibition of contemporary art from its permanent collection, curated by the museum's director, Jan Hoet.

May 19: In a sign of the strong market for contemporary art, Christie's sells Robert Gober's *Untitled, (Leg with Candle)* (1991) for $794,500, a new record for the artist. The auction also establishes new records for works by Richard Serra, Christopher Wool, Matthew Barney, and Cindy Sherman.

May 28: Claudia Gould, director of Artists Space in New York, is appointed director of the Institute of Contemporary Art in Philadelphia.

May 30: After thirteen years of planning, the Massachusetts Museum of Contemporary Art, a thirteen-acre complex of renovated nineteenth-century factory buildings devoted to exhibitions, site-specific installations, dance, music, and theater performances, as well as commercial use, opens in North Adams, Massachusetts. *(fig. 44)*

JUNE
June 13–November 7: Directed by Harald Szeemann, the *XLVII Esposizione Internazionale d'Arte, La Biennale di Venezia* is presented in Venice. Global in its focus, the survey does not explore a specific topic. A major renovation at the Arsenale offers expanded exhibition space, while the *Aperto* exhibition, renamed *dAPERTutto* or "over all," features a mixture of young and established artists. Ann Hamilton represents the United States. Golden Lions are awarded to

Louise Bourgeois and Bruce Nauman, and Venice Biennial International Awards are given to Cai Guo-Qiang, Doug Aitken, and Shirin Neshat.

June 14: The trustees of the Seattle Art Museum vote to return a painting by Henri Matisse to the heirs of art dealer Paul Rosenberg, from whom the work was stolen by the Nazis during World War II.

June 15: Corbis, the digital imaging company established by Bill Gates, acquires Sygma, a leading news photography agency. With the acquisition, Corbis' archive exceeds 65 million images, which include digitized works from numerous museums and photographic archives.

JULY
July 1: After a sixth-month renovation, the Guggenheim SoHo reopens with the exhibition *Andy Warhol: The Last Supper*, a long-term installation of Warhol's last major series.

July 10–December 31: Curated by Rosa Martínez, *Looking for a Place*, is presented at SITE Santa Fe. The exhibition explores the different meanings of place in the work of thirty contemporary artists.

July 16: John F. Kennedy Jr., Carolyn Bessette Kennedy, and Lauren Bessette are killed when the small plane he is flying plunges into the Atlantic Ocean.

AUGUST
August 4: The Pew Charitable Trust announces the establishment of a $50 million, five-year initiative entitled "Optimizing America's Cultural Resources" to foster political and financial support for the arts and to help develop a national cultural policy.

August 6: Raymond D. Nasher announces that Renzo Piano has been selected to design the Nasher Sculpture Center in Dallas, scheduled to open in 2001 at a site next to the Dallas Museum of Art.

August 21: Art dealer Leo Castelli, whose gallery represented the work of Jasper Johns, Roy Lichtenstein, Bruce Nauman, Robert Rauschenberg, and other leading contemporary artists, dies at age 91 in New York. *(fig. 46)*

August 23: German chancellor Gerhard Schroder moves his office from Bonn to Berlin's Reichstag, the new home of Germany's government. Major works by Christian Boltanski, Jenny Holzer, Sigmar Polke, Gerhard Richter, and dozens of other contemporary artists are commissioned for the newly renovated building, the symbolic centerpiece of a massive rebuilding effort under way in unified Berlin.

SEPTEMBER
September 17: *The New York Times* reports that the Dia Center for the Arts has acquired Robert Smithson's *Spiral Jetty* (1970) in Utah's Great Salt Lake, one of the most celebrated examples of 1970s Earth Art.

48

September 22: A national controversy erupts in New York when Mayor Rudolph Giuliani threatens to cut $7.2 million in funding for the Brooklyn Museum of Art, to remove its trustees, and to revoke its lease as sanctions against the exhibition *Sensation: Young British Artists from the Saatchi Collection*. Curated by Norman Rosenthal and Charles Saatchi, the exhibition had opened at the Royal Academy of Arts, London, two years earlier. Giuliani, who is expected to run against First Lady Hillary Clinton for the U.S. Senate, found some of the included work "offensive." The museum will file suit against the city on September 28. The exhibition will open as planned on October 2, and the accompanying headlines will attract record numbers of visitors. On November 1, the U.S. District Court in Brooklyn will rule that Giuliani violated the First Amendment in cutting operating funds to the museum. *(fig. 47)*

September 30: A nuclear fuel-processing plant in Tokaimura, Japan, releases radiation that contaminates more than eighty people. It is the country's worst nuclear accident.

OCTOBER

October 1: Congress allocates the NEA $97.6 million for the 2000 fiscal year. The Clinton administration had proposed a $150 million budget for the agency.

October 7–January 17: Curated by Neal Benezra and Olga M. Viso, *Regarding Beauty: A View of the Late Twentieth Century* is presented at the Hirshhorn Museum and Sculpture Garden. The exhibition features the work of artists responding to the question of beauty. It will travel to Haus der Kunst, Munich.

October 7–March 14: Organized by John Elderfield, Peter Reed, Mary Chan, and Maria del Carmen González, *Modern Starts* is presented at The Museum of Modern Art. Showcasing work from 1880–1920, the exhibition is part of *MoMA 2000*, an experimental reinstallation of the museum's permanent collection in preparation for the opening of its new expansion in the next century.

October 17–February 13: Organized by Ann Goldstein, *Barbara Kruger* is presented at the Museum of Contemporary Art, Los Angeles. The artist's first retrospective, it will travel to the Whitney Museum of American Art.

October 29: Lowery Stokes Sims, curator of twentieth-century art at the Metropolitan Museum of Art, is appointed director of The Studio Museum in Harlem. She succeeds Kinshasha Holman Conwill, who becomes director emeritus.

NOVEMBER

November 6–March 26: Curated by Madeleine Grynsztejn, the *Carnegie International 1999/2000* is presented at the Carnegie Museum of Art. The survey includes forty international artists, with sections devoted to site-specific installations

49

and video and film works. William Kentridge is awarded the 1999 Carnegie Prize of $10,000. *(fig. 48)*

November 9: Germany observes the tenth anniversary of the fall of the Berlin Wall.

November 16: Christie's sale of contemporary art sets records for eighteen artists, including Jeff Koons and Damien Hirst. On November 17, Sotheby's will sell Mark Rothko's *No. 15* (1952) for $11 million, a new record for the artist. Hoping to match the success of other online retailers, Sotheby's will launch an online auction site on November 19 in collaboration with Amazon.com. They join a growing list of Internet companies offering art and collectibles online, including eBay, Artnet.com, eHammer.com, and Yahoo!.

November 18: Ned Rifkin, director of the High Museum of Art in Atlanta, is appointed director of The Menil Collection in Houston. He succeeds Paul Winkler, who resigned in February.

November 29: Protestants and Catholics establish a co-government in Ireland, renewing hopes for peace.

November 30: Riots break out in Seattle, Washington during the meeting of the World Trade Organization, which attracts 50,000 demonstrators.

DECEMBER

December: The Tate Modern nears completion in Bankside. Scheduled to open in 2000, it will be one of the world's largest museums devoted to modern and contemporary art. In 1997, Stephen Deuchar,

former head of the Neptune Court Project at the National Maritime Museum in Greenwich, was appointed director of the new facility. *(fig. 49)*

December 1: Steve McQueen is awarded the 1999 Turner Prize of £20,000.

December 31: The United States officially turns over control of the Panama Canal to Panama.

December 31: Designed by Richard Rogers, the Millennium Dome, billed as the world's largest indoor space, opens in Greenwich, England. A number of major sculptures are commissioned for the facility, including work by Tony Cragg, Antony Gormley, Anish Kapoor, and James Turrell.

December 31: Citing his poor health and a need for new leadership, Russian president Boris Yeltsin resigns and turns over control of the country to Prime Minister Vladimir Putin.

fig. 47. Protesters carrying images of the Virgin Mary outside the Brooklyn Museum of Art, New York, on the opening day of the exhibition *Sensation: Young British Artists from the Saatchi Collection*, October 2, 1999

fig. 48. *Carnegie International 1999/2000* (installation view), Carnegie Museum of Art, Pittsburgh, 1999–2000, with works by Bodys Isek Kingelez (foreground) and Franz Ackermann (background)

fig. 49. Tate Modern, London, under construction; Herzog & de Meuron, architects

SELECTED BIOGRAPHIES AND BIBLIOGRAPHIES

JANINE ANTONI

born 1964, Freeport, Bahamas
lives and works in New York

Janine Antoni earned a B.A. from Sarah Lawrence College in 1986 and an M.F.A. in sculpture in 1989 from the Rhode Island School of Design. She presented the work *Gnaw* in 1992 as her first one-person exhibition at the Sandra Gering Gallery, New York. Later exhibited as part of the *1993 Biennial Exhibition* at the Whitney Museum of American Art, *Gnaw* comprised two 600-pound cubes—one composed of solid chocolate, the other of lard—which the artist sculpted with her teeth. She then molded the nibbled chocolate and lard remnants into heart-shaped candy packaging and tubes of lipstick. In 1992, Antoni performed *Loving Care* at Anthony d'Offay Gallery in London by mopping the floor with her dye-soaked hair, creating an expansive, gestural "painting." She performed *Eureka* the following year at the Sandra Gering Gallery where she lowered herself into a tub of lard, displacing enough of the substance to leave behind an imprint of her body. Also in 1993, she presented *Lick and Lather* at the *Aperto* component of the 45th Venice Biennale. In this installation, comprising fourteen self-portrait busts (seven cast in chocolate and seven in soap), all mounted on classical pedestals, the artist used repetitive licking and washing to erode specific features on each bust, such as the eyes, ears, or mouth. In *Slumber* (1994), performed at the Anthony d'Offay Gallery, Antoni slept in the gallery while her R.E.M. cycles were recorded by a machine, then in the daytime, she wove the pattern of her eye movements into the design of a blanket, which would cover her while she slept. Antoni presented her first major video installation, *Swoon* (1997), at the Capp Street Project in San Francisco in the summer of 1997 and at the Whitney Museum of Ameri-

can Art in 1998. In addition to sculpture and performance art, Antoni has created a number of photographic works. In *Mom and Dad* (1994), she dressed her parents in similar outfits to make them resemble one another. The self-portrait *Ingrown* (1998) depicts the artist's fingernails fused together with bright red nail polish. In *Coddle* (1999), another self-portrait, Antoni cradles her leg as though it were a child.

Antoni has been featured in more than ten solo exhibitions in the United States and Europe, including *Slip of the Tongue* (1995) at the Centre for Contemporary Arts, Glasgow, and the Irish Museum of Modern Art, Dublin; *Janine Antoni/Matrix 129* (1996) at the Wadsworth Atheneum, Hartford, Connecticut; and *Imbed* (1999) at Luhring Augustine, New York. She has also exhibited in numerous national and international group exhibitions, including *The Big Nothing* (1992) at The New Museum of Contemporary Art, New York; *Self/Made Self/Conscious, Bruce Nauman and Janine Antoni* (1994) at the School of the Museum of Fine Arts, Boston; *Cocido y crudo* (1995) at the Museo Nacional Centro de Arte Reina Sofía, Madrid; *Young Americans I* (1996) at the Saatchi Gallery, London; *The Hugo Boss Prize 1996* at the Guggenheim Museum SoHo, New York; *On Life, Beauty, Translations and other Difficulties* (1997) at the 5th International Istanbul Biennial; and *Looking for a Place* (1999) at SITE Santa Fe. Antoni was awarded the Irish Museum of Modern Art's Glen Dimplex Artists Award in 1996, a MacArthur Fellowship and a grant from the Joan Mitchell Foundation in 1998, and a New Media Award from the Institute of Contemporary Art in Boston and the Larry Aldrich Foundation Award in 1999.

SELECTED REFERENCES

Antoni, Janine, and Dan Cameron. *Slip of the Tongue*. Glasgow: Center for Contemporary Art, and Dublin: Irish Museum of Modern Art, 1995.

Cameron, Dan, Amy Cappellazzo, Ewa Lajer-Burcharth, Rosa Martinez, Nancy Spector, and Maria Warner. *Janine Antoni*. Stuttgart: Cantz, 2000 (forthcoming).

Horodner, Stuart. "Janine Antoni." *Bomb* (Winter 1998), pp. 48–54.

Miller-Keller, Andrea. *Janine Antoni/Matrix 129*. Hartford, Conn.: Wadsworth Atheneum, 1996.

Sussman, Elisabeth. *Janine Antoni: Swoon*. New York: Whitney Museum of American Art, 1998.

MATTHEW BARNEY

born 1967, San Francisco, California
lives and works in New York

Matthew Barney earned a B.A. in 1989 from Yale University, where he took pre-med courses before switching to fine art. During college, he created sculptures and video performances. In one of his earliest works, *Field Dressing (Orifill)* (1989), shown in 1990 at Althea Viafora Gallery in New York, the athletic Barney videotaped himself climbing naked on a pole and various ropes while applying Vaseline to his body's orifices. The artist quickly became a prominent figure in the New York art world and had his first one-person exhibition in 1991 at Barbara Gladstone Gallery, where he presented *Blind Perineum* (1991), a video of himself climbing naked across the gallery's ceiling. Also on view were various props from the video, including a weight lifting bench made from petroleum jelly. In the installation *Drawing Restraint 7* (1993), shown at the *1993 Biennial Exhibition* at the Whitney Museum of American Art, New York, Barney presented a video depicting himself as a genderless horned creature trying desperately to catch his own tail while two other actors dressed as satyrs wrestled in the back seat of a limousine. In 1995, Barney presented *Cremaster 4* (1994–95), the first video in an extravagant five-part series that has occupied him for much of the decade. (The title of the series refers to the muscle that raises and lowers the testicles). Filmed on the Isle of Man in the Irish Sea, *Cremaster 4* again featured Barney and others made up as androgynous, mythological creatures in a narrative characteristically dense with ritualistic actions. Other works in the out-of-sequence series followed, including *Cremaster 1* (1995), filmed in a football stadium in Boise, Idaho, a city where the artist had lived as a child and played football;

Cremaster 5 (1997), filmed in Budapest, Hungary with Ursula Andress in the role of the Queen of Chains and Barney as three different suitors (the Diva, Magician, and Giant); and *Cremaster 2* (1999), filmed in Utah and Canada and focusing on the life of convicted murderer Gary Gilmore, played by Barney. In conjunction with his films and video work, Barney has produced sculptures, installations, drawings, and photographs, which have been shown widely.

Barney has had one-person exhibitions at Barbara Gladstone Gallery (1991, 1995, and 1997); the San Francisco Museum of Modern Art (1991 and 1996); The Tate Gallery, London (1995); Museum Boymans-van Beuningen, Rotterdam (1995); Kunsthalle Wien in Vienna, Austria (1997); and the Walker Art Center, Minneapolis (1999). He was featured in *Documenta IX* (1992) in Kassel, Germany; *Aperto* at the 45th Venice Biennale (1993); *DASAMERICAS II* (1995) at the Museu de Arte de São Paulo; the *1995 Biennial Exhibition* at the Whitney Museum of American Art, New York; *The Masculine Masquerade* (1995) at the MIT List Visual Arts Center, Cambridge, Massachusetts; *Jurassic Technologies Revenant* (1996), the 10th Biennale of Sydney; the Lyon Biennale, Lyon, France (1997); *Rrose is a Rrose is a Rrose: Gender Performance in Photography* (1997) at the Solomon R. Guggenheim Museum, New York; and the Andy Warhol Museum, Pittsburgh; *Wounds: Between Democracy and Redemption in Contemporary Art* (1998) at the Moderna Museet, Stockholm; *Regarding Beauty: A View of the Late Twentieth Century* (1999) at the Hirshhorn Museum and Sculpture Garden, Washington, D.C.; and the *Carnegie International*

1999/2000 (1999) at the Carnegie Museum of Art, Pittsburgh. In 1993, Barney was awarded the Europa 2000 prize at the 45th Venice Biennale, and in 1996, he received the first Hugo Boss Award from the Guggenheim Museum.

SELECTED REFERENCES

Barney, Matthew. *Cremaster 5*. Frankfurt am Main: Portikus, 1997.

Barney, Matthew. *Cremaster 2*. Minneapolis: Walker Art Center, 1999.

Goodeve, Thyrza Nichols. "Travels in Hypertrophia: Thyrza Nichols Goodeve Talks with Matthew Barney." *Artforum* (May 1995), pp. 66–71.

Sans, Jérôme. "Matthew Barney: héros modernes/Modern Heroes." *Art Press* (July–August 1995), pp. 25–32.

Siegrist, Hansmartin, and Theodora Vischer. *Matthew Barney: Cremaster 1*. Basel: Museum für Gegenwartskunst, 1998. This publication is a supplement to Barney, Matthew. *Cremaster 1*. Vienna: Kunsthalle Wien, and Basel: Museum für Gegenwartskunst, 1997.

CAI GUO-QIANG

born 1957, Quanzhou City, Fujian Province, China
lives and works in New York

Cai Guo-Qiang studied stage design in 1981–85 at the Shanghai Drama Institute. In 1986, he left China to study in Tokyo, where he remained until relocating to New York in 1995. Deeply interested in the customs and history of both East and West, Cai began to create elaborate indoor and outdoor projects rooted in the past and present nature of specific locations. In 1989, he introduced *Projects for Extraterrestrials*, a series of choreographed outdoor explosions which he executed in collaboration with a host of technicians and experts. The light from these works would theoretically be visible to other worlds once it left the earth. In *Project for Extraterrestrials No. 9: Fetus Movement II, Encounter the others* (1992), the artist sat on an island created by an artificial stream while a nine-second explosion expanded outward from the center, and then contracted, echoing the beginning and end of the universe. In 1994, Cai created *Add 10,000 Meters to the Great Wall of China*, which extended the length of the famous monument with a trail of fire. In *Bringing to Venice what Marco Polo Forgot* (1995), presented in *TransCulture* during the 46th Venice Biennale, the artist symbolically retraced the return home, 700 years earlier, of explorer Marco Polo from the artist's hometown of Quanzhou City to the explorer's hometown of Venice. Traveling the canals in a traditional Chinese fishing boat, Cai delivered to the exhibition site a collection of Chinese herbs underscoring the East's approach to the relationship between man and nature. Herbal tonics that promoted physical and spiritual well-being could also be purchased from a modern vending machine. Cai later included a vending machine of Chinese herbal medicines in *A cure when ill, a sup-*

plement when healthy (1997) for the exhibition *Performance Anxiety* at the Museum of Contemporary Art, Chicago, which featured a gallery of stones that visitors were invited to walk across barefoot to stimulate the acupuncture pressure points on the soles of their feet. More recent work has addressed contemporary political issues, especially among Europe, America, and China, against the backdrop of centuries of cultural history.

Cai has been featured in numerous group exhibitions, particularly in Asia and Europe, including *Art in Japan Today 1985–1995* (1995) at the Museum of Contemporary Art, Tokyo; *Silent Energy* (1995) at the Museum of Modern Art, Oxford, England; *TransCulture*, (1995) at the Venice Biennale; *Africus* (1995) at the first Johannesburg Biennale; *The Hugo Boss Prize 1996* at the Solomon R. Guggenheim Museum, New York; *Asia-Pacific Triennial of Contemporary Art* (1996, 1999) in Brisbane, Australia; *Cities on the Move* (1997) at the Vienna Secession; *Future, Past, Present 1965– 1997* at the 47th Venice Biennale; *Inside Out: New Chinese Art* (1998) presented by the Asia Society and P.S.1 Contemporary Art Center, New York; *Global Vision* (1998) at The Deste Foundation, Athens, Greece; and *dAPERTutto* (1999) at the 48th Venice Biennale. He has had one-person exhibitions at the Osaka Contemporary Art Center (1990) in Osaka, Japan; P3 art and environment (1991, 1993) in Tokyo; the IBM Kawasaki City Gallery (1992) in Kawasaki, Japan; the Iwaki City Museum of Art (1994) in Japan; Louisiana Museum of Modern Art (1997) in Humlebaek, Denmark; the Queens Museum of Art (1997) in New York; the Taiwan Museum of Art (1998) in Taichung, Taiwan; and the

Kunsthalle Wien (1999) in Vienna. Cai was awarded the International Award of the 48th Venice Biennale (1999), the Oribe Award (1997) in Japan, the Benesse Prize (1995) from *TransCulture* at the 46th Venice Biennale, and the Japan Cultural Design Prize (1995).

SELECTED REFERENCES

Cruz, Amada. "Cai Guo-Qiang." In *Performance Anxiety*. pp. 38–41. Chicago: Museum of Contemporary Art, 1997.

Farver, Jane and Reiko Tomii. *Cai Guo-Qiang, Cultural Melting Bath: Projects for the 20th Century*. New York: Queens Museum of Art, 1997.

Friis-Hansen, Dana. "Cai Guo-Qiang at the Iwaki City Art Museum." *Art in America*, (November 1994), p. 144.

Fuchs, Annali, et al. *Cai Guo-Qiang: Flying Dragons in the Heavens*. Humlebaek, Denmark: Louisiana Museum of Modern Art, 1997.

Akihiko Hirano. *Cai Guo-Qiang: From the Pan-Pacific*. Iwaki City, Japan: Iwaki City Museum of Art, 1994.

ROBERT GOBER

born 1954, Wallingford, Connecticut
lives and works in New York

Robert Gober attended the Tyler School of Art in Rome in 1973–74 and earned a B.A. in art in 1976 from Middlebury College in Middlebury, Vermont. After college, he moved to New York and worked for a time as a carpenter, making dollhouses and building stretcher bars for other painters. Raised a devout Catholic, Gober explored the subject of religion in one of his earliest works, *Prayers Are Answered* (1980–81), a model of a church. In *Slides of a Changing Painting* (1982–83), the artist painted a series of images on a board and, using a camera, created a photographic record of the painting's changing appearance. Over the course of the project, Gober painted fragmented bodies, water, furniture, and drains—all deeply personal subjects that would continue to appear in his work. In 1985, he exhibited the first of his meticulously crafted signature sink sculptures at Paula Cooper Gallery in New York. He continued to explore the subject for several years, and his installations gradually grew more complex. He introduced actual drains as an element in his work in 1987. In 1989, he exhibited *Wedding Dress*, a wedding gown (designed to fit the artist's absent body) that stood in the center of a gallery wallpapered with images of male and female genitalia. That same year, Gober created *Untitled Leg* (1989), the first in a series of wall-mounted wax limbs. In 1992, he installed an environment at the Dia Center for the Arts, New York, featuring piles of fabricated newspapers, wall-mounted sinks with running water, and prisonlike windows set within walls painted to resemble a verdant forest. In 1994, Gober exhibited *Untitled (Man in Drain)* (1993–94), a sculpture of a male torso with a drain in his chest lying underneath a storm

drain grate, at Paula Cooper Gallery. He returned to the subject of the church for his most ambitious work, an environment installed in 1997 at the Museum of Contemporary Art, Los Angeles. The installation, which took nearly four years to prepare, featured a life-size concrete statue of the Virgin Mary, impaled by a drainage pipe and standing over a grate in the center of the gallery. Two open suitcases with interior grates flanked the statue while water cascaded down a staircase into a grate on the floor. Beneath the gallery, and visible through the grates, was a tide pool complete with rocks, small marine creatures, coins, and the legs of a man and an infant.

Gober has collaborated on projects with artists Christopher Wool, Meg Webster, and Sherrie Levine, and he has been featured in numerous exhibitions in the United States and abroad. Among his most notable group exhibitions are the 43rd Venice Biennale (1988); the 1989, 1991, and 1993 *Biennial Exhibitions* at the Whitney Museum of American Art, New York; *The Readymade Boomerang: Certain Relations in Contemporary Art* (1990) at the Eighth Biennale of Sydney; *Metropolis* (1991) at the Martin-Gropius Bau in Berlin; *Documenta IX* (1992) in Kassel, Germany, and the *1995 Carnegie International* in Pittsburgh. He has had important one-person exhibitions at the Art Institute of Chicago (1988); the Galerie Nationale du Jeu de Paume in Paris and the Museo Nacional Centro de Arte Reina Sofía in Madrid (1991–92); the Serpentine Gallery, London, and the Tate Gallery, Liverpool (1993); and the Museum für Gegenwartskunst, Basel (1995). In 1999, the Walker Art Center

organized *Robert Gober: Sculpture + Drawing*, which traveled to the Rooseum Center for Contemporary Art in Malmö, Sweden, San Francisco Museum of Modern Art, and the Hirshhorn Museum and Sculpture Garden, Washington, D.C.

SELECTED REFERENCES

Benezra, Neal. "Plumbing Robert Gober." In *Distemper: Dissonant Themes in the Art of the 1990s*, pp. 40–47. Washington, D.C.: Hirshhorn Museum and Sculpture Garden, 1996.

Hickey, Dave. *Robert Gober*. New York: Dia Center for the Arts, 1992.

Flood, Richard, Gary Garrels, and Ann Temkin. *Robert Gober: Sculpture + Drawing*. Minneapolis: Walker Art Center, 1999.

Joselit, David. "Poetics of the Drain." *Art in America* (December 1997), pp. 64–71.

Schimmel, Paul, and Hal Foster. *Robert Gober*. Los Angeles: Museum of Contemporary Art, and Zurich, Berlin, and New York: Scalo, 1997.

ANN HAMILTON

born 1956, Lima, Ohio
lives and works in Columbus, Ohio

Ann Hamilton studied geology and literature in 1974–76 at St. Lawrence University in Canton, New York, where she became interested in weaving. She transferred to the University of Kansas to study with weaver Cynthia Schira and earned a B.F.A. in 1979 in textile design. After graduation, Hamilton moved to Canada, where she created her first large installation, *ground* (1981), using bundles of cut telephone wires, at the Walter Phillips Gallery in Banff, Alberta. Hamilton returned to the United States in 1983 to attend graduate school and earned an M.F.A. in 1985 in sculpture from Yale University. That same year, she moved to California to teach sculpture at the University of California, Santa Barbara. Hamilton left the university in 1991 to focus exclusively on installation work. She moved to Columbus, Ohio, and began working with Sean Kelly Gallery in New York, creating large-scale environments that reflected her interests in textiles, literature, the body, and performance. In 1992, Hamilton presented *aleph* at the MIT List Visual Art Center, an installation featuring a sheet of steel on the floor that visitors walked upon, a wall of books with stuffed wrestling dummies, and a video of a mouth continuously rolling small stones around inside. In *tropos* (1993), shown at the Dia Center for the Arts, New York, Hamilton carpeted the gallery's floor with horsehair and a performer singed lines of text from a book. In 1994, the Tate Gallery, London, organized *Ann Hamilton: mneme*. Hamilton was an artist in residence in 1994–95 at the Wexner Center for the Arts, which organized the traveling exhibition *the body and the object: Ann Hamilton 1984–1996* (1996). In 1997, the Musée d'art contemporain, Lyon, organized *Ann Hamilton:*

Present–Past, 1984–1997, for which Hamilton created two major new environments. In *bounden* (1997), she installed a seventy-two-foot-long wall that seeped droplets of water from its surface. Nine white silk panels with embroidered text veiled the gallery's large windows; where they met the floor, the silk panels were stretched on angled frames that rested on chairs used for prayer. In *mattering* (1997), Hamilton installed a billowing canopy of orange silk from the ceiling of an empty gallery where five male peacocks roamed freely. In the center of the gallery, a man perched on a pole and wrapped his hand in blue typewriter ribbon, which over time stained his hand and created a mitten-like form. He periodically dropped these forms onto the floor beneath him before starting the process over. Hamilton used the theme of the weeping wall and an attendant performing a continuous task in *kaph* (1997), exhibited at the Contemporary Arts Museum in Houston. Most recently, Hamilton represented the United States at the 48th Venice Biennale (1999), where she installed a large wall of distorting glass in front of the American Pavilion. Inside the 1920's era neoclassical structure, fuschia powder gently drifted from the ceiling and collected on Braille text covering the walls. A recording of the artist reciting a coded speech by Abraham Lincoln played in the background.

Hamilton has created nearly sixty installations, including three permanent commissioned projects. She represented the United States at the 21st São Paulo International Bienal (1991) and showed her work at the *1991* and *1999/2000 Carnegie International* in Pittsburgh; at *Sonsbeek* (1993) in Arnhem,

The Netherlands; and at *Future, Past, Present 1965–1997* at the 47th Venice Biennale (1997). Hamilton collaborated with Meg Stuart and Damaged Goods on the dance performance *appetite*, which premiered in 1998 in Brussels. Hamilton has been awarded a Guggenheim Memorial Fellowship (1989), the Louis Comfort Tiffany Foundation Award (1990), the College Art Association Award (1992), an NEA Visual Arts Fellowship (1993), a MacArthur Fellowship (1993), and the Larry Aldrich Foundation Award (1998).

SELECTED REFERENCES

Cooke, Lynne, Bruce Ferguson, and Dave Hickey. *Ann Hamilton: tropos*. New York: Dia Center for the Arts, 1995.

Herbert, Lynn M. *Ann Hamilton: kaph*. Houston: Contemporary Arts Museum, 1998.

Lauterbach, Ann, and Nancy Princenthal. *Ann Hamilton: whitecloth*. Ridgefield, Conn.: The Aldrich Museum of Contemporary Art, 1999.

Nesbitt, Judith, and Neville Wakefield. *Ann Hamilton: mneme*. London: Tate Gallery Publications, 1994.

Rogers, Sarah J. *the body and the object: Ann Hamilton 1984–1996*. Columbus, Ohio: Wexner Center for the Arts, The Ohio State University, 1996.

JIM HODGES

born 1957, Spokane, Washington
lives and works in New York

Jim Hodges earned a B.F.A. in 1980 from Fort Wright College in Spokane, Washington and an M.F.A. in 1986 from the Pratt Institute in Brooklyn, New York. During graduate school, he worked for the Nancy Hoffman Gallery in Soho and later cared for the art collection of the Dannheiser Foundation, which provided him with a studio in return. Although Hodges trained as a painter, he was dissatisfied with his work in the medium and began to experiment with a variety of everyday materials and found objects. At his first one-person exhibition at CRG Gallery in New York, *A Diary of Flowers* (1994), the artist covered the walls with 565 drawings of flowers made on crumpled paper napkins. As part of the exhibition, he also showed *Possible Cloud* (1993), a long, white gauze curtain laden with colored silk flowers and draped from the ceiling to the floor; *Untitled (Broken)* (1993), a small, silvery spiderweb made from metal chain, and *Not Here* (1994), a cluster of colored silk and plastic flowers pinned to the wall. Hodges created a number of ephemeral flower curtains of varying sizes for museum and gallery exhibitions before branching out to new materials. In 1997, he began to attach mirrors to canvases in mosaic patterns, or as panels that he would shatter with a hammer. In 1998, Hodges showed another series of works at CRG, including *Landscape*, an autobiographical work comprising a number of tailored shirts layered inside one another from the largest to the smallest size, and *He and I* (1998), a series of colored concentric circles based on the dimensions of the artist and his companion and drawn directly on the gallery's wall.

Hodges' work has been featured in numerous exhibitions throughout the 1990s, including *In a Different Light* (1995) at the University Art Museum in Berkeley; *Present Tense: Nine Artists in the Nineties* (1997) at the San Francisco Museum of Modern Art; *Abstract Painting, Once Removed* (1998) at the Contemporary Arts Museum, Houston; *Regarding Beauty: A View of the Late Twentieth Century* (1999) at the Hirshhorn Museum and Sculpture Garden, Washington, D.C.; and *Part II* of *The American Century: Art and Culture, 1900–2000* (1999) at the Whitney Museum of American Art, New York. Hodges has had one-person exhibitions at The Fabric Workshop and Museum, Philadelphia (1996); SITE Santa Fe (1997); The Kemper Museum of Contemporary Art, Kansas City, Missouri, where he was also an artist in residence (1998); the Museum of Contemporary Art, Chicago, and the Institute of Contemporary Art, Boston (1999); and the Miami Art Museum (1999).

SELECTED REFERENCES

Cruz, Amada. *Jim Hodges: every way.* Chicago: Museum of Contemporary Art, 1999.

Dobrzynski, Judith H. "Taking the Ordinary and Finding the Beautiful." *The New York Times*, March 24, 1999, pp. E1, 5.

Friis-Hansen, Dana. "Jim Hodges." In *Abstract Painting, Once Removed*, pp. 19–20, 62–63. Houston: Contemporary Arts Museum, 1998.

Garrels, Gary. "Jim Hodges." In *Present Tense*, p. 22. San Francisco: San Francisco Museum of Modern Art, 1998.

Self, Dana. *Jim Hodges: Welcome.* Kansas City, Mo.: Kemper Museum of Contemporary Art, 1998.

WILLIAM KENTRIDGE

born 1955, Johannesburg, South Africa
lives and works in Johannesburg

William Kentridge earned a B.A. in politics and African studies in 1976 from the University of Witwatersrand in Johannesburg. In 1976–78, Kentridge studied fine art at the Johannesburg Art Foundation, where he later taught etching, and in 1981–82 he studied mime and theater at L'Ecole Jacques LeCoq in Paris. Beginning in the mid 1970's, Kentridge became active in theater and film, working as a writer, director, actor, and set designer for numerous productions. He was a founding member of the Junction Avenue Theatre Company, based in Johannesburg and Soweto from 1975 to 1991, and of the Free Filmmakers Cooperative, established in 1988 in Johannesburg. In 1979, Kentridge had his first one-person exhibition at The Market Gallery in Johannesburg. He would continue to exhibit his drawings and prints throughout the 1980's. In 1989, Kentridge made *Johannesburg, 2nd Greatest City After Paris*, the first in a series of short animated films about Soho Eckstein, a white businessman from Johannesburg, and Felix Teitlebaum, his alter ego. Created from the artist's successively reworked drawings, the film premiered at the Weekly Mail Film Festival in Johannesburg and was later screened at the Institute of Contemporary Art, London. Subsequent films in the series include *Monument* (1990), *Mine* (1991), *Sobriety, Obesity & Growing Old* (1991), *Felix in Exile* (1994), *The History of the Main Complaint* (1996), *Weighing . . . and Wanting* (1998), and *Stereoscope* (1999). Kentridge collaborated in 1992 with the Handspring Puppet Company to stage *Woyzeck on the Highveld*, based on an unfinished work by German playwright Georg Büchner. The production won numerous theater awards and later toured Europe. The artist and the Handspring

Puppet Company also created the multimedia theater productions *Faustus in Africa!* (1995), *Ubu and the Truth Commission* (1997), and *Il Ritorno d'Ulisse* (1998), based on the opera by Claudio Monteverdi.

Kentridge has been featured in numerous one-person and group exhibitions. In 1990, his work was featured in *Art from South Africa* at the Museum of Modern Art, Oxford, England. In 1993, the Edinburgh International Film Festival presented a retrospective of Kentridge's films, and The Museum of Modern Art, New York, and the Centre Georges Pompidou in Paris both screened *Sobriety, Obesity, and Growing Old*. That same year, Kentridge represented South Africa at the 45th Venice Biennale. In 1995, he exhibited *Memory and Geography*, a multimedia collaborative project, at *Africus*, the first Johannesburg Biennale. He was featured in *Jurassic Technologies Revenant* (1996), the 10th Sydney Biennial; *Documenta X* (1997) in Kassel, Germany; and *Truce: Echoes of Art in an Age of Endless Conclusions* (1997) at SITE Santa Fe in New Mexico. In 1998, the Museum of Contemporary Art, San Diego, and the Palais des Beaux-Arts in Brussels both presented one-person exhibitions of Kentridge's work. That same year, he was a finalist for the Solomon R. Guggenheim Museum's second Hugo Boss Prize. In 1999, Kentridge presented *Stereoscope*, his eighth animated film, at The Museum of Modern Art, and he was included in *dAPERTutto* at the 48th Venice Biennale. He was awarded The Carnegie Prize at the *Carnegie International 1999/2000* in Pittsburgh.

SELECTED REFERENCES

Cameron, Dan, Carolyn Christov-Bakargiev, and J. M. Coetzee. *William Kentridge*. London: Phaidon, 1999.

Christov-Bakargiev, Carolyn. *William Kentridge*. Brussels: Société des Expositions du Palais des Beaux-Arts de Bruxelles, 1998.

Enwezor, Okwui. "Truth and Responsibility: A Conversation with William Kentridge." *Parkett* (Winter 1998), pp. 165–70.

Godby, Michael. "William Kentridge: Retrospective." *Art Journal* (Fall 1999), pp. 74–85.

Ollman, Leah. "William Kentridge: Ghosts and Erasures." *Art in America* (January 1999), pp. 70–75, 113.

RICK LOWE

born 1961, Russell County, Alabama
lives and works in Houston, Texas

DEBORAH GROTFELDT

born 1950, Urbana, Illinois
lives and works in Houston, Texas

Rick Lowe attended Columbus College in Columbus, Georgia, from 1979 to 1982, where he took his first formal art classes and became interested in painting and sculpture. In the early 1980s, after relocating to Houston, Lowe became closely involved with the city's African-American community and merged his interests in art and community activism. He presented his first public exhibition in 1985 at an anti-apartheid rally outside Houston's city hall, where he showed politically charged paintings and cutouts addressing issues of racial and social injustice. In 1987, Lowe presented an installation commemorating victims of war and police brutality at Diverse-Works ArtSpace in Houston. After appearing in the *Texas Triennial* (1988) at the Contemporary Arts Museum in Houston, Lowe renewed his commitment to community activism. In 1990, he created an installation of painted figures at the Self-Help for African People through Education (S.H.A.P.E) Community Center in Houston. Conceived as a means of raising awareness of political and social struggles in Houston's inner city, the installation was the site of a press conference held by the Ida Delaney/Byron Gillum Justice Committee, formed in response to recent killings by Houston police officers. Lowe is best known for his involvement in Project Row Houses (PRH), a community-based public art project in Houston, which was conceived in 1992 and opened two years later under the direction of Lowe and arts administrator Deborah Grotfeldt. In recognition of its leadership in neighborhood revitalization, PRH has been awarded, among other prizes, the National Trust Preservation Award in 1998 and the American Architectural Foundation Keystone Award in 1999.

With the success of PRH, Lowe's activism expanded beyond the city of Houston. In 1997, Lowe and Grotfeldt teamed with the Mill Creek Artists' Collaborative and the Fairmount Park Art Association on "May Street: A Place of Remembrance and Honor," a community-wide effort to rehabilitate an abandoned block in West Philadelphia. That same year, Lowe and Grotfeldt began to work with the Friends of the Watts Tower Arts Center on the Watts House Project, Los Angeles. Lowe has worked collaboratively with other artists and organizations, frequently serving as a facilitator, curator, administrator, and teacher. He has been involved in numerous community and cultural advocacy groups in Houston, including the Houston/Harris County Cultural Task Force, S.H.A.P.E Community Center, and the Municipal Art Commission. He co-founded the Commerce Street Artists Warehouse in 1995 and the Union of Independent Artists in 1990, and served as board president for the National Association of Artists' Organizations from 1995–97. Lowe has exhibited nationally and internationally throughout the 1990s. He created a billboard-sized mixed-media mural outside the Phoenix Art Museum as part of *Contemporary Identities: 23 Artists, The 1993 Phoenix Triennial*. In 1996, he participated in an exhibition and symposium at the Kumamoto State Museum in Kumamoto, Japan, and presented a project at Space 111 in Birmingham, Alabama. In 1997, he was featured in *Uncommon Sense* at the Museum of Contemporary Art, Los Angeles, as well as exhibitions at the Neuberger Museum in Purchase, New York, and the Kwangju Biennial in Kwangju, South Korea.

Deborah Grotfeldt attended Southern Illinois University, Carbondale, 1968–69, Eastern Illinois University, Charleston, in 1971, and the University of Houston in 1979. A practicing photographer, Grotfeldt has worked as a curator and arts administrator, serving in 1986–93 as the assistant director for Diverse-Works ArtSpace in Houston. In 1993, she joined with Rick Lowe to open Project Row Houses (PRH) in Houston's Third Ward. Building on the success of PRH in Houston, Grotfeldt established the Project Row Houses Foundation in 1998, a multidisciplinary urban think tank that provides financial and administrative support for innovative community development organizations throughout the United States.

SELECTED REFERENCES

Dewan, Shaila. "Project Row Houses: Art in the House." *High Performance* (Spring–Summer 1995), pp. 74–77.

Finkelpearl, Tom, Julie Lazar, and Marita Sturken. *Uncommon Sense*. Los Angeles: The Museum of Contemporary Art, 1997.

Goldberg, Vicki. "In Houston, Rebuilding by Creating." *The New York Times*, July 16, 1995, pp. 26–27.

Thomas, Cynthia. "Lowe and Behold." *Houston Chronicle*, October 13, 1996, pp. F1, F4.

Tucker, Sheryl G. "Reinnovating the African-American Shotgun House." *Places* (Summer 1995), pp. 62–77.

SHIRIN NESHAT

born 1957, Qazvin, Iran
lives and works in New York

Shirin Neshat left her native Iran at age 17 to attend school in the United States and earned a B.A. in 1979 and an M.A. in 1981 from the University of California, Berkeley. In 1979, while Neshat was in the United States, the Ayatollah Ruhollah Khomeini's Islamic revolution dramatically transformed Iran's social, political, and economic fabric. Neshat returned to Iran in 1990 for the first time in twelve years and was shocked by the many cultural changes she witnessed, particularly the new laws affecting women, who were now required to wear traditional Muslim veils. She continued to make regular visits to Iran and in 1993 received an M.F.A. at Berkeley. That same year, Neshat began *Unveiling*, a series of photographic portraits of the artist and other women dressed in traditional Muslim garb, which were shown at the artist's first one-person exhibition at Franklin Furnace in New York. Revealing only the subjects' eyes, hands, and feet, the photographs were inscribed by Neshat in Farsi script with various texts, including poetry by an Iranian feminist writer and essays by supporters of the Islamic revolution. In 1994, Neshat photographed herself, dressed in traditional Islamic clothing, holding guns and rifles for her *Women of Allah* series. The Iranian government disapproved of these images and in 1999 declared Neshat an enemy of the state. She continued to explore the experiences of women in Muslim society in a series of dual-screen films started in 1997. *Turbulent* (1998), shown at the Whitney Museum of American Art at Philip Morris, New York, featured two Iranian musicians—a woman performing in an empty auditorium and a popular male singer playing to a packed house. In 1999, The Art Institute of Chicago premiered *Rapture* (1999), filmed

on location in Morocco in 1998, and the Carnegie Museum of Art included Neshat's most recent film, *Soliloquy* (1999), which was shot in Turkey, as part of the *Carnegie International 1999/2000*. In the latter work, Neshat appears as both a modern woman and a traditional woman of Islam.

Neshat has been included in numerous group exhibitions, including *Orientation* (1995) at the Fourth Istanbul Biennale; *TransCulture* and *Campo '95 (1995)* at the 46th Venice Biennale; *Jurassic Technologies Revenant*, the 10th Biennale of Sydney (1996); *Trade Routes: History and Geography* (1997) at the Second Johannesburg Biennale; *On Life, Beauty, Translations and Other Difficulties* (1997) at the Fifth Istanbul Biennale; *Unfinished History* at the Walker Art Center, Minneapolis (1998) and Museum of Contemporary Art, Chicago (1999); *Looking for a Place* (1999) at SITE Santa Fe; and the 48th Venice Biennale (1999). She has had one-person exhibitions at Centre d'Art Contemporain Kunsthalle, Fribourg, Switzerland (1996); Museum of Modern Art, Ljubljana, Slovenia (1997); Whitney Museum of American Art at Philip Morris, New York (1998); and the Tate Gallery of Modern Art at St. Mary-le-Bow Church, Cheapside, London (1998). Neshat was awarded a grant from the Louis Comfort Tiffany Foundation (1996), and she received an International Award at the 48th Venice Biennale (1999).

SELECTED REFERENCES

Bertucci, Lina. "Shirin Neshat: Eastern Values." *Flash Art* (November–December 1997), pp. 84–87.

Miller, Paul D. "Motion Picture, Shirin Neshat's Turbulent." *Parkett* (1998–99), pp. 156–60.

Naficy, Hamid. "Veiled Vision/Powerful Presences: Women in Post-revolutionary Iranian Cinema." In *In the Eye of the Storm: Women in Post-revolutionary Iran*. pp. 131–150. New York: Syracuse University Press, 1993.

Rondeau, James. *Shirin Neshat: Rapture*. (brochure). Chicago: The Art Institute of Chicago, 1999.

Zaya, Octavio. "Shirin Neshat." *Interview* (September 1999), pp. 164–66.

FRED WILSON

born 1954, Bronx, New York
lives and works in New York

Fred Wilson earned a B.F.A. in 1976 at the State University of New York (SUNY) at Purchase, where he studied art and dance. During college, he worked in the education department of the Metropolitan Museum of Art and as a guard at the Neuberger Museum of Art at SUNY. Wilson made trips to Europe, Africa, and South America, which reinforced his interest in third world cultures. He gained further experience in arts administration and education while organizing art programs for children in East Harlem and working for the American Museum of Natural History and the American Crafts Museum. In 1981, he began working as an administrative assistant at the Just Above Midtown Gallery in New York, which showed work by emerging African-American artists. He exhibited in a number of group exhibitions throughout the 1980s and began to curate his own exhibitions. Wilson established the Longwood Arts Project, housed in a former public school in the Bronx, where he presented the installation *Rooms with a View: The Struggle between Culture and Content and the Context of Art* (1987). For this work, he transformed three rooms into different types of exhibition spaces—a modern art gallery, an ethnographic museum, and an opulent salon—in order to draw attention to the ways that museums manipulate the history and meaning of displayed objects. In the late 1980s, as part of his *Platform* series, Wilson produced sculptures featuring portraits of famous historical figures such as Paul Gauguin and John James Audubon. In 1991, he presented *The Colonial Collection* at Gracie Mansion Gallery, New York, which featured contemporary African masks wrapped in French and British flags and others ficti-

tiously labeled as historical museum pieces stolen from particular tribes. That same year, he created *Guarded View*, an installation of four mannequins dressed in guard uniforms from New York museums. Wilson transformed an entire museum into a work of art in 1992 when he presented *Mining the Museum* at the Maryland Historical Society in Baltimore. For this installation, sponsored by the arts organization The Contemporary, Wilson carefully studied the collections, archives, and exhibitions of the Historical Society and, using its holdings, created an exhibition that drew attention to the absent or misrepresented histories of both African-Americans and Native Americans.

Since that time, Wilson has continued to work with museums and galleries, often creating new installations based on their particular collections, locations, and missions. He presented *The Museum: Mixed Metaphors* (1993) at the Seattle Art Museum and has had other one-person exhibitions at the Museum of Contemporary Art, Chicago (1994), and the Richard L. Nelson Gallery and the Fine Arts Collection of the University of California at Davis (1997). He has participated in numerous group exhibitions, including *Past Imperfect: A Museum Looks at Itself* (1992) at the Parrish Art Museum, Southampton, New York; *1993 Biennial Exhibition* at the Whitney Museum of American Art, New York; *Western Artists/ African Art* (1994) at the Museum for African Art, New York; *Black Male: Representations of Masculinity in Contemporary American Art* (1994) at the Whitney Museum; *Cocido y crudo* (1994) at the Museo Nacional Centro de Arte Reína Sofia, Madrid; *New Histories* (1996) at the Institute of Contemporary Art,

Boston; *Cultural Economies: Histories from the Alternative* (1996) at The Drawing Center, New York; and *The Museum as Muse* (1999) at The Museum of Modern Art, New York. Wilson has also worked on collaborative projects with other artists and curators and has served on the boards of a number of arts and community organizations.

SELECTED REFERENCES

Berlin, Ira, Lisa G. Corrin, and Leslie King-Hammond. *Mining the Museum: An Installation by Fred Wilson.* New York: The New Press with The Contemporary, Baltimore, 1994.

Golden, Thelma. *Black Male: Representations of Masculinity in Contemporary American Art.* New York: Whitney Museum of American Art, 1994.

Karp, Ivan and Fred Wilson. "Constructing the Spectacle of Culture in Museums." In *Thinking About Exhibitions.* edited by Reesa Greenberg, Bruce W. Ferguson, and Sandy Nairne, pp. 251–267. London and New York: Routledge, 1996.

Stein, Judith. "Sins of Omission." *Art in America* (October 1993), pp. 110–15.

Wilson, Fred. "Silent Messages." *Museums Journal* (May 1995), pp. 27–29.

CONTEMPORARY ARTS MUSEUM

CATALOGUE

Publication Coordinator: Paola Morsiani
Editor: Polly Koch
Design: Don Quaintance, Public Address Design, Houston
Production Assistant: Elizabeth Frizzell
Typography: Public Address Design; composed in Adobe Caslon (text) and Avenir (display)
Color Separation/halftones and printing: Technigrafiks, Inc., Houston

PHOTOGRAPHY

David Allison; courtesy Janine Antoni and Luhring Augustine Gallery, New York: pls. 5, 6, and 8

Courtesy American Visionary Art Museum, Baltimore: fig. 25

Courtesy Janine Antoni: pl. 1

Associated Press Photo/Diane Bondareff: fig. 47; Adil Bradlow: fig. 18; John Chadwick: p. 77; Mark Elias: fig. 6; Ruth Fremson: fig. 34; Greg Gibson: fig. 15; Bruno Mosconi: fig. 14; Liu Heung Shing: fig. 4

Erika Barahona; © Guggenheim Bilbao Museoa: p. 76, and fig. 35

Larry Barnes; courtesy Shirin Neshat and Barbara Gladstone Gallery, New York: pl. 50

Richard Barnes; courtesy San Francisco Museum of Modern Art: fig. 24

Patrick Barth; courtesy Sean Kelly Gallery, New York: p. 9

Courtesy Bellagio, Las Vegas: figs. 42–43

Ben Blackwell; courtesy Janine Antoni and Luhring Augustine Gallery, New York: pls. 2–4, 7, and 9

Ben Blackwell; courtesy University of California, Berkeley Art Museum: fig. 22

Niggi Bräuning; courtesy Fondation Beyeler, Riehen, Switzerland: fig. 36

Courtesy Cai Guo-Qiang: pl. 16

Courtesy Carnegie Museum of Art, Pittsburgh: fig. 48

Jenni Carter; courtesy Sean Kelly Gallery, New York: pls. 29–30

© 1993 Todd Eberle; courtesy The Chinati Foundation: fig. 17

Daphne Fitzpatrick; courtesy Robert Gober: pl. 21

Kevin Fitzsimons; courtesy Wexner Center for the Arts, Columbus, Ohio: fig. 2

Rick Gardner, Houston; courtesy Contemporary Arts Museum, Houston: p. 10, fig. 5, pls. 48–49

Alan Gilbert; courtesy United States Holocaust Memorial Museum Photo Archives: fig. 13

John F. Guess; courtesy Rick Lowe, Deborah Grotfeldt, and Project Row Houses: pl. 47

Christine Guest; courtesy Musée des Beaux-Arts de Montréal: fig. 46

Tim Hailand, New York: pl. 31

David Heald; © The Solomon R. Guggenheim Foundation, New York: fig. 40

Hickey-Robertson; courtesy The Menil Collection, Houston: fig. 21

© 1991 George Hirose, New York: pl. 57

Atelier Hollein, Vienna: fig. 7

© Timothy Hursley; courtesy Museum of Contemporary Art, San Diego: fig. 30

Aaron Igler; courtesy The Fabric Workshop and Museum, Philadelphia: pls. 32–33

Institute of Contemporary Art, University of Pennsylvania; Robert Mapplethorpe, *Calla Lily*, 1986 © The Estate of Robert Mapplethorpe: fig. 1

Thibault Jeanson; courtesy Sean Kelly Gallery, New York: pl. 28

Steven Jo; courtesy Queens Museum of Art, Queens, New York: fig. 45

Russell Kaye; courtesy Robert Gober: pls. 23–26

Courtesy William Kentridge and The Goodman Gallery, Johannesburg: pls. 35, 37, 38, 46

Courtesy William Kentridge and Marian Goodman Gallery, New York: pls. 34, 36, 39–45

Courtesy Martin Kippenberger and Metro Pictures, New York: fig. 33

Lucretia Knapp; courtesy Sean Kelly Gallery, New York: pl. 27

Joseph Kugielsky; courtesy Robert Gober: pl. 22

Ellen Labenski; © The Solomon R. Guggenheim Foundation, New York: fig. 41

Larry Lamé; courtesy Matthew Barney and Barbara Gladstone Gallery, New York: frontispiece, pls. 11–13

Marcus Leith; courtesy Tate Modern, London: fig. 49

© Sara Mayman: fig. 3

Elio Montanari; courtesy Cai Guo-Qiang: pls. 15, 19–20

© 2000 The Museum of Modern Art, New York: fig. 9

© The NAMES Project Foundation, San Francisco: fig. 31

Mark Nelson; courtesy Project Row Houses, Houston: p. 11

Courtesy Shirin Neshat and Barbara Gladstone Gallery, New York: pp. 12–13, and pls. 51–56

Michael James O'Brien; courtesy Matthew Barney: pl. 10

John Parnell; © The Jewish Museum, New York: fig. 29

David Regen; courtesy Matthew Barney and Barbara Gladstone Gallery, New York: pl. 14

Courtesy Regen Projects, Los Angeles: fig. 8

Marc Riboud, Paris: fig. 38

Paul Rocheleau; courtesy The Andy Warhol Museum, Pittsburgh: fig. 19

Stefan Rohner, St. Gallen, Switzerland: courtesy Andrea Rosen Gallery, New York: fig. 28

© 1994 Philipp Scholz Rittermann; courtesy inSITE, San Diego/Tijuana: fig. 20

© Suzanne Shaker: fig. 11

Courtesy Cindy Sherman and Metro Pictures, New York: fig. 27

© Teri Slotkin Photography: fig. 10

Lee Stalsworth and Ricardo Blanc; courtesy Hirshhorn Museum and Sculpture Garden, Smithsonian Institution, Washington, D.C.: fig. 32

John Stephens; © J. Paul Getty Trust: fig. 37

Jussi Tiainen; courtesy Nykytaiteen museo Kiasma, Helsinki: fig. 39

Norihiro Ueno; courtesy Cai Guo-Qiang: pls. 17–18

© Gert-Jan van Rooij; courtesy Kunsthal Rotterdam, Rotterdam: fig. 12

Wolfgang Volz: fig. 23

Stephen White; courtesy Jay Joplin, London: fig. 26

© Nicholas Whitman; courtesy MASS MoCA, North Adams, Massachusetts: fig. 44

Geoffrey Clements; © 1993 Whitney Museum of American Art, New York: fig. 16; © 1998 Whitney Museum of American Art, New York: pls. 59–63

© 1992 Ellen Page Wilson; courtesy Metro Pictures, New York: pl. 58